HOLY WELLS: Wales

a photographic journey

PHIL COPE

foreword by Jan Morris

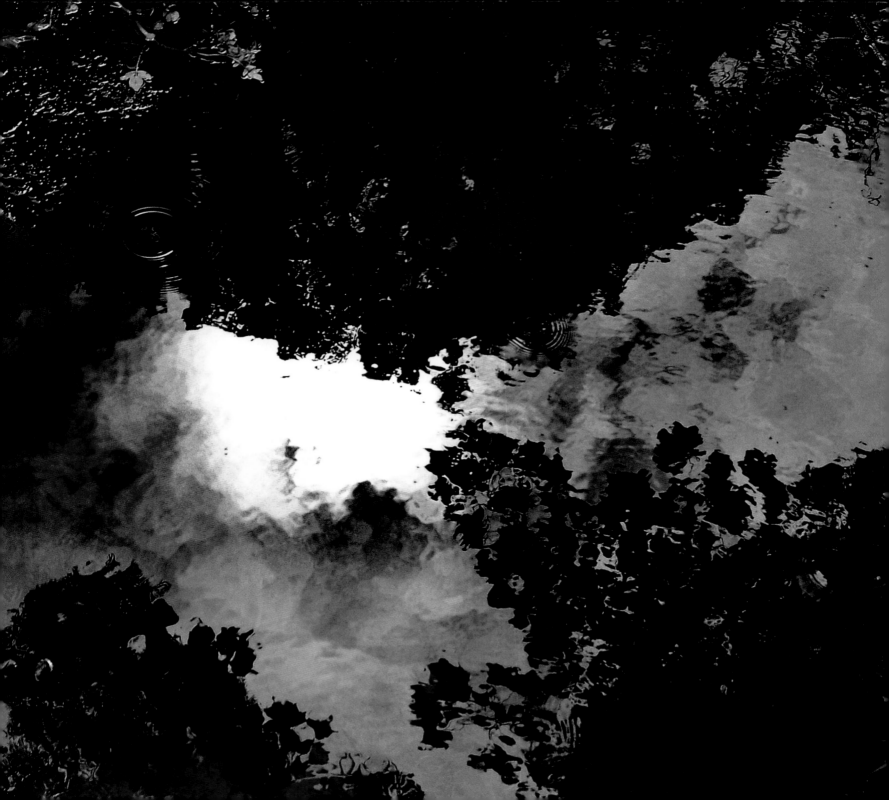

HOLY WELLS: Wales

a photographic journey

PHIL COPE

foreword by Jan Morris

poems by Ruth Bidgood, Gillian Clarke, Anne Cluysenaar, Phil Cope, Tony Curtis,
Dafydd ap Gwilym, Graham Harthill, Gerard Manley Hopkins, Hilary Llewellyn-Williams, Phil Maillard,
Lewis Morris, Rhisiart ap Rhys, Susan Richardson, R S Thomas and Rowan Williams

seren

Seren
57 Nolton Street, Bridgend, CF31 3AE
www.seren-books.com

A CIP record for this book is available from the British Library.

First published 2008

ISBN 978-1-85411-485-3

Designed by Ian Findlay
www.ianfindlay.co.uk

Printed in Wales

Dedication

This book is dedicated to my
parents, who gave me the thirst ...

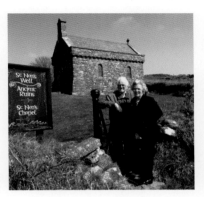

Doris and Lawrence Cope at
St Non's Well, Pembrokeshire

Acknowledgments

I should like to thank the following for assisting during the research period
of this book, for suggesting new out-of-the-way wells and providing translations,
and for their general belief in and support for my project over the past five years:
Graham Harthill, Dewi Roberts, Vanessa Horne, Stephen Thomas, David Ambrose,
Miranda James, Darren Dobbs, Professor Helen Wilcox, the Wellspring Fellowship
and Ian Findlay.

The poems of Ruth Bidgood, Gillian Clarke, Anne Cluysenaar, Phil Cope,
Tony Curtis, Graham Harthill, Hilary Llewellyn-Williams, Phil Maillard,
Susan Richardson, R S Thomas and Rowan Williams are reproduced
by permission of their authors or literary representatives.

Contents

Foreword

To loving romantics like me all Wales is holy, in several different kinds. Its landscapes are divine, of course, and so is the inherent goodness of its native people – kindness amounting to a sort of generic cordial, as the poet Gerard Manley Hopkins thought, "fetched fresh ... off some sweet wood". There is a truly transcendental beauty to the survival of the Welsh language, still strong, strange and lyrical against all odds. There is something God-given to the generous enthusiasm of a Welsh rugby crowd (especially when their team is winning ...). And most evocative of all, for my tastes, is the sense of recondite sanctity that attends the ancient wells of Wales, captured as it has never been caught before by the photographs in this book.

Phil Cope tells us that in Wales not so long ago many hundreds of ancient wells were revered for their supposed holiness (and occasionally feared for their evil powers). More than a thousand were listed in 1954. Far fewer remain, but even so in this little country you are never far from a water-source of legendary significance, still bubbling, oozing or gushing out of the soil. Whether they are holy depends upon what you think is holy, but it is certainly true that many of them have been regarded down the centuries as transmitters of energies beyond human explanation – magical energies, blessed energies, energies from somewhere altogether else.

Like Phil Cope, I love to discover these arcane messengers from other times, perhaps from other realities. Many of them, being of such elemental suggestion, have effortlessly survived the interpretations of various religions – carrying with them, as they emerge from the lower darkness, memories of elaborate Catholic rites, ascetic devotions of Celticism, pagan genuflections

or mazy superstitions from the years before history began. If they were not genuinely holy to begin with, they are certainly holy now, when so much human emotion and devotion has been expended on them, and I know of no cathedral or mosque that so moves me with other-worldly numen as does one of these old shrines, with their lichened stones, their worn steps, the mossy moisture all around them and – yes, some innate suggestion of that cordial kindness.

They are not all sweet modesty, as this lovely volume shows us. A few are grand, like the miracle-working spring of St Winefride at Treffynon, the Lourdes of Wales. Some stand defiant amidst the ravages of industry, like the well and shrine of St Mary at Penrhys, in the heart of the Rhondda. I know of one in Clwyd which still seems to me, as it seemed to the ancients, a place of innate malevolence, and I like to imagine something bucolically reassuring in the air around the well at Llanbadarn Fynydd in Powys, whose boggy water was at least until our own time famous for the healing of cattle.

And often and again I have come across wells which evidently still possess, in the minds of their own people, some powers of comfort or reconciliation: and then the glint of a pin in the clear water, or a wilting bunch of wild flowers, perhaps, on a ledge beside the spring, makes me feel that all time is one, that the very same liquid flows and eddies from one century into another, and that all our own minds, perhaps, are merely tributaries of some more majestic union, nourished by clear water, sustained by the honest earth.

Jan Morris

Introduction

"we are face to face ... with living forms of the oldest, lowest, most primitive religion ... one which would seem to have been once universal, and which, crouching close to the earth, lets other creeds blow over it without effacing it, and outlives one and all of them"
Charles Squire, *Celtic Myth and Legend*

This, for me, is one of the most constantly attractive appeals of my visits to wellsprings: their ability to take us on a journey that travels from the water cult belief systems of earliest times, through the coming of Christianity to these shores, through the discovery of seemingly more rational and scientific explanations, and back again, today, to a more holistic, more open, and hopefully more sympathetic relationship with water, rock and earth.

My intention in photographing the wellsprings of Wales goes far beyond the simple location and recording of these holy places. I am trying to capture something of their spirit and truth. I often fail. Mine will be a lengthy pilgrimage. Some wells I have returned to on many occasions, at different times of the day, in different seasons and weathers, only to be disappointed by the results, as if they were resisting description, or, perhaps, gently implying that I don't yet have the necessary tools of knowledge and understanding required.

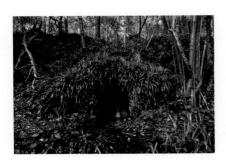

Gilli's Well, near Cosherton, Pembrokeshire

The First Mirror

"As a place of the sun at night, the well symbolizes the inner light of life as contrasted with the outer light of the visible world. The abyss from which the waters issue represents the hidden source of wisdom in the unconscious, which we can tap if we relinquish our egotism. The well itself is the channel from the unconscious to the conscious."
Nigel Pennick, *Celtic Sacred Landscapes*

The photographer reflected in the waters of Ffynnon Fair, Bryncroes

I've asked myself many times what special characteristics these well sites possess that have captured my interest so strongly. There is probably more than one answer.

The earth scientist provides a simple explanation: water evaporating from the oceans rains on to the land and, where faults appear, falls to lower harder rock where it collects, dissolving its minerals until sufficient pressure pushes it to the surface on its way back to the sea. In the process of this beautifully-balanced perpetual liquid dance, however, an infinite number of potential journeys are undertaken – physical, mental, creative, spiritual – stimulating a multitude of alternative explanations for the mystery.

As Georg Hartwig says in *The Harmonies of Nature*: "How truly wonderful is the chain of processes which first raises vapours from the deep and eventually causes them to gush forth from the entrails of the earth, laden with blessings and enriched with treasures more inestimable than those the miners toil for."

Water is, of course, one of the most profound of our necessities, both for our physical health as well as, just as importantly I think, for the 'well-being' of our imaginations.

The still water in a natural spring was probably the first mirror within which our ancestors saw themselves – a vision, if you think about it – that is usually accompanied by a view of the sky ... constantly moving. Perhaps there's something in that. I don't know.

Perhaps it's the fact that water is the only substance that can exist in all three states – solid, liquid and gas – as ice, liquid water and vapour. Or that water is the most yielding of substances, yet nothing is better at wearing away that which is resistant and hard, and that it has the capacity to hold something in its solution of almost all of the bodies through which it passes. Jacques Benveniste was one of the first to claim that all water contained the memory of what had earlier been dissolved in it, and Masaru Emoto in *The Hidden Messages in Water* demonstrates through ice crystal micro-photography how the molecules of water are effected by our thoughts, words and actions.

Or maybe it's because the word 'well' in English points to an absence of illness, a state of 'well-being', in addition to a water source, or that the word 'spring' also refers to the season of new beginnings. Or, that the eruption of water from the earth was the principle determinant of the original geography of human settlement, and that visiting wellsprings that have been in continuous use for millennia offers the possibility of hearing a faint echo of the stories they once told. Or, perhaps, it's the fact that the

Nine Wells, Pembrokeshire

ultimate destination of all water is a rendezvous with the sea from whence it, and we, came; or that water connects all the shores of the earth, and that we ourselves, like the planet, are made up predominantly of this essential life liquid.

Or, perhaps it's because the water we enjoy today is the same water that existed on Earth millions of years ago, enjoyed by dinosaur and cave dweller, constantly recycled in a seemingly-miraculous self-sustaining closed system. Or maybe it's all of these things.

Hazel / Coll
St. Beuno's Well, Clynnog

*After last night's rain
light gathers on hazel leaves
with their three-clumped nuts,
and a wide-angled sun
shapes precise hills and stones.*

*I drag my hand through water.
Cresses stroke my skin,
which shrinks from their fleshiness.
I cup, and scoop to drink
what runs through my fingers.*

*A cold, sweet-metal taste:
water reflected on stone.
Myself reflected in water
shadowed and blurred, a dark
disturbance within the pool.*

*Tendrils of water spill down
inside me, tracing cool paths.
I splash my forehead and lids,
and wish for knowledge, for solid
sense, for a way through.*

*Knowledge and clarity
I need so much; I've let so
much slip by. In a hidden place
there's a well with my face in it,
smudged silver, flickering,*

*and hazels growing thick
overhead: and there
my eyes look out from depths
of past and future, watching
the hazel ripples lift and spread.*

Hilary Llewellyn-Williams
The Tree Calendar (Seren, 1987)

What's in a Name?

"bearing the taste of the place, the deep rock, sweetness out of the dark ..."
Wendell Berry, *The Springs*

Holy Wells: Wales contains just 44 of the more than 200 holy wells that I have located, explored and photographed over the past five years, many on more than one occasion, and most with the names of saints attached to them.

My definition of what constitutes a holy well is a rather fluid one, mirroring this generous conjunction to wellsprings of a saint's name for any especially kind, wise or devout personage. (Only two of the hundreds of Welsh 'saints' of the so-called Age of Saints between the fifth and seventh centuries AD – St Winefride and St David – were officially recognised as such, and, notwithstanding this acknowledgement, in the case of the former *The Penguin Dictionary of Saints* states that "Written information is too late and fanciful to allow reliable data about her life or death to be established.")

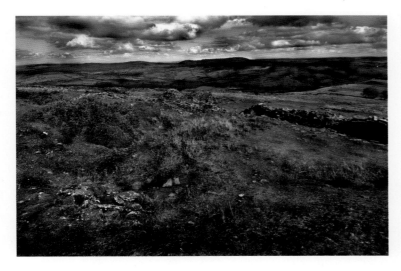

The Castle Well, Hatterral Hill, Monmouthshire

The attributes of the holy wells of Wales, beyond their naming, are equally diverse, though some patterns are discernible. Most never freeze or run dry, while some are said to ebb and flow, make strange noises, or seem to be bottomless. Most are believed to predict the future, grant wishes, and offer cures and sometimes curses. Some have the ability to turn objects into stone; others to erupt with milk or blood. Some were said to be haunted by ghosts and guarded by monsters, to be home to fairies and doorways into their underground dwellings, "borderland places" where, in the words of Janet and Colin Bord, "this world and the hidden Otherworld meet".

Their usage and significance, both alimentary and religious, was recognised by the earliest inhabitants of Wales, predating Christianity's arrival by many centuries. Resanctified by the church, through the act of a saint sometimes praying for water, or hitting the ground with his staff in the manner of the old Testament prophet Moses, or just pointing to a rock or striking it with his horse's hoof, the legends of holy wells were the spiritual story books of the oral tradition. At some sites, the wells were made curative by a saint's severed head, or its later washing (often leaving permanent marks of the blood on the stones or a redness in the water). Some wells magically appeared at the places where a saintly body had rested on its journey to burial; some where a saint's tears fell.

While all of these 'explanations' offer depth to the layers of our recognition of the value and importance of these special places, we should not need these stories, inspiring as they still can be, to acknowledge water's holiness and to revere these original sites of the water of life.

Water is *the* essential necessity for all human, animal and plant existence and this alone should be sufficient reason to make us respect and cherish it – to name it holy.

The Oldest Music

"Water that plays the oldest music."
Tony Curtis, from his poem *'At Gumfreston Church'*

Water has provided the inspiration for many of our most engaging beliefs, legends and tales. Many traditions include the belief that springs issue from the supernatural underworld, the spiritual womb of the Earth that leads through the world's rivers to the sea in a metaphor for the course of human life. Celtic mythology places the Well of Wisdom at the centre of its Otherworld, the spiritual source from which all waters flow. The Zuni people of the south-western United States believe that the first humans, the Daylight People, emerged from the waters of a spring.

As the main source of all existence, springs are often seen as symbols of love, sexuality, procreation, creativity, and sometimes eternal life.

Supply and Demand

"By means of water we give life to everything."
The Koran

Water is, alongside air and food, the only essential for our existence. We can only live for a few days without it. It covers almost three-quarters of the earth's surface and supports billions of creatures. Although it often appears a gentle force, it has the power to dramatically reshape our landscape and our lives.

In our privileged part of the world we take water for granted. It nearly always flows easily at the turn of a tap for us, while more than a billion people worldwide lack a regular and safe supply and two and a half billion men, women and children – a staggering two-fifths of the world's population – don't have access to adequate sanitation.

Village Well, Corntown, near Bridgend

An average London family spends about a fifth of one per cent of its income on a clean safe water supply while for their equivalent in Accra, Ghana, the figure is 22 per cent, and that for water of doubtful quality. In Ethiopia – according to WaterAid – only 24 per cent of the population has access to safe water and 15 per cent to adequate sanitation; infant mortality there exceeds 10 per cent. Worldwide, every 15 seconds a child dies from water-related diseases.

"As soon as the sun rises at 6am, we go to fetch water. We take whatever containers we have down to the dry river bed and dig for water, there. It can take three hours to dig deep enough to reach water and we have to go three times a day," says Segueda Zouga, a woman from Burkina Faso in West Africa.

"I have had six children and yet only two of them have survived. My only choice is to give them water which is not safe to drink, or no water at all. I worry about the water I give them constantly. All of us get ill often. My children and I get fevers, stomach cramps and diarrhoea.

"Water is the overwhelming problem in my life and in the lives of the other families in this village. All day, I think about nothing else. At night, I go to sleep worrying about fetching water and about what will happen if there is no water for us to fetch tomorrow.

"All of us go, old women, young women, pregnant women – even the children. We all have to do our bit. I know the children should go to school but what choice do we have? What use is education if I can't give my children enough water to drink?"

This desperate necessity, alongside water's growing scarcity, is becoming an ever greater attraction for business, seeking big profits both in this country as well as throughout the world, aided and abetted by Western Governments, including our own.

The new / old struggle for water rights will in the very near future – in the view of many commentators – eclipse the wars for oil in which we are currently engaged, as a pure water source becomes the new global battleground.

This situation is unlikely to improve. As Peter Swanson says in *Water: The Drop of Life*: "Six billion now inhabit Earth. By the year 2050, that figure may double. Yet the planet's available water supply will remain the same."

But the ownership of drinkable water and wells – in physical as well as intellectual terms – has always been an area of enormous contention. Explanations of the real meanings of wells have changed with time and with belief.

A Dialogue

"… what we call 'superstition' in the modern Welshman is, in reality, survival of the religious convictions of his earlier ancestors. The pagan gods did not die: they were not allowed to."
Francis Jones, *The Holy Wells of Wales*

In pre-Christian times, water appearing naturally, unaided and unbidden from the hard rock or the dry soil of the earth's belly, had a magical significance for our ancestors, as a place where nature spirits resided and where a dialogue with other realities was possible. Here were centres for elaborate ceremonies, story telling, and the presenting of gifts – coins, pins, keys, clothes, buttons, buckles, flowers, cups, semi-precious stones, human hair, birds, and sometimes even animals, all of which were thrown into wells.

The rituals associated with successfully receiving well cures or messages were often complex. There were times of the year that promised more powerful results than others; water had to be drunk from a limpet shell or a special cup or even a skull; the correct offering had to be made; words had to

be chanted, and rhymes recited; rags had to be hung on trees or bushes.

Sometimes the hopeful recipient had to sleep in the well guardian's cottage, or on a tombstone in a nearby graveyard, or in a church, or on a menhir – a practice known as 'incubation'. This is thought to recall the early Celtic belief that the sun sank beneath the waters at night, emerging again at sunrise. During its dark journey, the sun's healing powers were absorbed by the waters. Incubation, therefore, offered the possibility of attracting the nurturing strengths of the underground sun, especially on New Year's Day or the Winter Solstice, the times of the longest nights when the sun spent the most time in the waters and, therefore, provided the spring with its greatest authority to cure and communicate. As the sun rose, so would the patient, renewed like the new day.

A belief in the importance of 'circumambulation', walking around the well, usually 'sunwise' or clockwise, was also common, as John Irwin, the respected writer on religion, relates: "… the rite was primarily cosmogonic in origin and it reflected the need once universally felt to live in harmony with cosmic

Gumfreston Wells at Easter

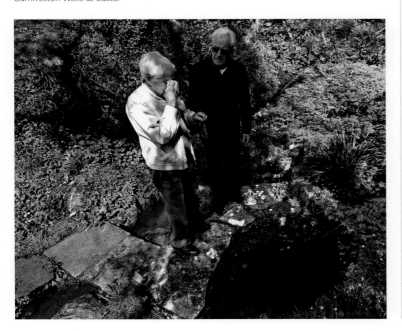

forces, represented in this case by the sun as ultimate generator of life. To circumambulate clockwise was to identify with the sun's diurnal course, regarded as life-enhancing and bringing luck. Anti-clockwise circumambulation was regarded as an identification with the sun's nocturnal course, and also with death and misfortune."

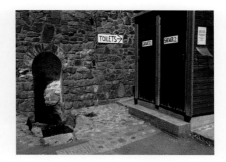

Solva Well and toilets!

In return for these complex rituals, the waters offered the favours of good health, love and fertility. There were wells specialising in cures for warts, blindness, deafness, scurvy, jaundice, leprosy, rheumatism, epilepsy, gout, skin disease, cancer, drunkenness, indigestion, rickets, piles, cancer, toothache, mental illness – and even baldness, bruises, melancholy and broken hearts. Rags were often hung on branches of trees and bushes near holy wells, as proof that cures had been successfully achieved. Some believed that an illness washed by well water from such rags would wither and die in synchronicity with the exposed cloth.

Some wells predicted and sometimes even influenced the future. The behaviour of fish or eels was read as omens; the movement of a handkerchief on the water's surface was believed to foretell a future relationship's faithfulness and fertility. Some could provide the name of a thief, while others could also be used to lay curses.

Some wells were the focuses for annual celebration. Dancing, singing, feasting, the lighting of bonfires, the scattering of flowers and the drinking of well water mixed with sugar, as well as sometimes something a little stronger, were all common.

In Pembrokeshire, children would sprinkle the first water drawn on New Year's Day over people and their houses, with sprigs of holly. Some well water collected during the last hour of New Year's or Easter's Eve would conveniently turn into wine. Drunken festivals were regularly reported to take place at Ffynnon Beris, near Llanberis in Snowdonia, and on the seventh Sunday after Easter, young people would congregate to splash each other in the waters and dance through the night at Taff's Well, near Cardiff.

Conversion ...

*"For the itch and the stitch,
Rheumatic and the gout,
If the devil isn't in you
The well will take it out."*
written to extol the
virtues of Marcross Well
in Glamorgan

Discarded crutches at St Winefride's Well, Holywell

When Christianity spread across Wales (from the third century onwards), the missionaries were instructed to destroy the pagan Celtic wells, alongside all other reminders of their 'hydrolatrous' beliefs. It was at this time that the predominantly female nature of the well spirit was made masculine; the druid and the bard became the monk and the priest; and pagan magical springs became Christian holy wells.

Such were the sites' strength within the popular imagination, however, that this was rarely fully successful, and an alternative strategy was adopted – common to all new imperial faiths – of 'converting' the pagan sites and their ceremonies to a Christian usage. As Francis Jones, the great authority on the holy wells of Wales, wrote in 1954, "the older deities of well, hill, and megalith survived in a new guise".

Churches were built over wells and Christian saints replaced pagan deities as the spiritual benefactor, often at the places where a severed martyred head fell, mirroring the much earlier head cult of the Celts. In addition, new Christian well sites were also developed, often associated with a saint's visit, a

Llandaf Village Well, Cardiff

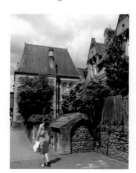

miracle or martyrdom. The red stain of iron found in chalybeate wells provided evidence for believers of a saint's violent and bloody death – and a deeper reference all the way back to Christ's suffering – at the same time as reminding them of the well's original Celtic occupant, the female Earth Spirit, and her responsibility for procreation and birth. The healing properties of the well remained, but praise was now due for its services to a new religious master or mistress. The red water in chalybeate wells now became Christ's blood instead of that of the menstruating Goddess.

... and Destruction

The second major period of threat to the holy wells of Wales came during the Protestant Reformation (in the second half of the sixteenth century) when Henry VIII's break with Rome signalled the suppression of all activities considered idolatrous.

But, again – despite the prohibitions – the natives were reluctant to roll over for their new masters. In 1590, it was reported that the Welsh "doe still goe in heapes one pilgrimage to the wanted welles and places of superstition", and so the tension between pagan tradition and the new imposed faiths continued.

Running Back Home

The prospects for the wells of Wales and elsewhere improved dramatically in the late eighteenth century, when the craze for spas gave them a new lease of life, as well as the towns that housed and developed them.

The popularity of 'taking the waters' – arising out of a new scientific recognition of the beneficial properties of natural mineral springs – saw those rich enough flocking in their thousands to Llandrindod, Trefriw, Llanwrtyd, Llandudno, Aberystwyth, Builth and elsewhere to drink and immerse themselves in the saline, sulphur, iodine, alum, magnesium, barium chloride and chalybeate waters.

Llandrindod Hall, once a deserted farmhouse, was turned into a luxury hotel described as having "accommodation for the invalid of whatever rank and distinction, field amusements for the healthy, while balls, billiards and regular assemblies varied the pastimes of the gay and fashionable".

Accounts of the medicinal successes of these wells were common. A 1774 journal reports: "An old man who lives near the spring ... told me that he was ill for several years and so windy and costive that his life was a burden to him. He applied to

'Free Chalybeate Spring', Llandrindod Wells

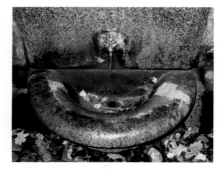

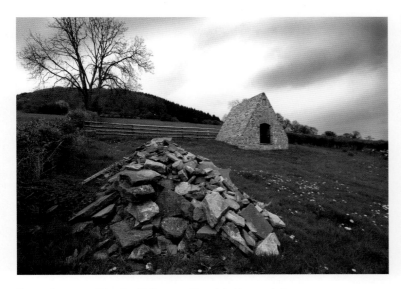

The newly-renovated New Inn Wellhouse at Cross Ash, Monmouthshire

The Prize of Pure Water

"Probably the class of antiquities the most overlooked are the holy wells of almost all countries, and in almost all cases their examination will amply reward the investigator, for they afford evidences of remote antiquity and traces of folklore not to be met with elsewhere." E P Loftus, *The Cistercian Abbeys of Cymmer and Basingwerk, with Notes on the Holy Wells of Wales*

Today, only a tiny percentage of the 1,179 holy wells of Wales noted by Francis Jones in 1954 can still be found, and he was aware of hundreds more that had been totally destroyed prior to his own research.

A few – such as those at St Winefride's in Holywell, St Anne's in Trellech, Ffynnon Mair at Penrhys in the Rhondda, and Gumfreston and St Non's in Pembrokeshire – remain on the pilgrimage trail, for both Christian and pagan believers. But these are the exceptions.

Mine is an exploration both of the fascinating history of holy wells in Wales as well as of the symbolism and significance of water in our and other peoples' lives throughout the world.

My own efforts to track down these places has been based upon research in many books, hints and suggestions from other well seekers, place names and old map references – sometimes to be entirely disappointed, and sometimes to be made furious at their sad destruction, or, even worse I think, sometimes at their so-called 'renovation'.

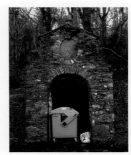

Ffynnon Gwyfil, Garreg, near Portmadoc

But, on a few wonderful occasions – after fighting through head-high overgrowth or wading through ankle-deep mud – I am inspired by finding a totally neglected but still intact well with its prize of clear pure water, and a contact with people and beliefs long overlooked but still offering some, albeit vague, answers to questions that I haven't yet quite been able to formulate.

Phil Cope

Steps leading down to Ffynnon Gybi, Llangybi, near Lampeter

several apothecaries and physicians who gave him no relief. He at last took to the waters of which he drunk 23 pints which brought from him an excrement so hard as could make little or no impression on when stamped with the heel of a shoe! This man is upwards of 70 years old and has drank the water frequently after and hath never has a sick day since that time and looks though very grey the healthiest man I have seen of his age."

In 1823 an anonymous poet wrote of his visit to St Winefride's at Holywell in North Wales: "On the banks are hundreds of sick folk who have arrived on crutches, but who can run back home ..."

In time, however, the treatments on offer at these spas were to be replaced by a new kind of hydropathy, available now at seaside resorts and offering a saltier immersion, alongside the added benefits of sunlight, aromatic pines and bracing sea air. In addition, local authorities were beginning to provide more easily accessible and cheaper alternatives to the spas in municipal baths and swimming pools. The advances in medical knowledge that culminated in the creation of the National Health Service in 1948 were now offering effective treatments for all the ailments that the spas claimed to relieve, resulting in the decline and closure of many establishments.

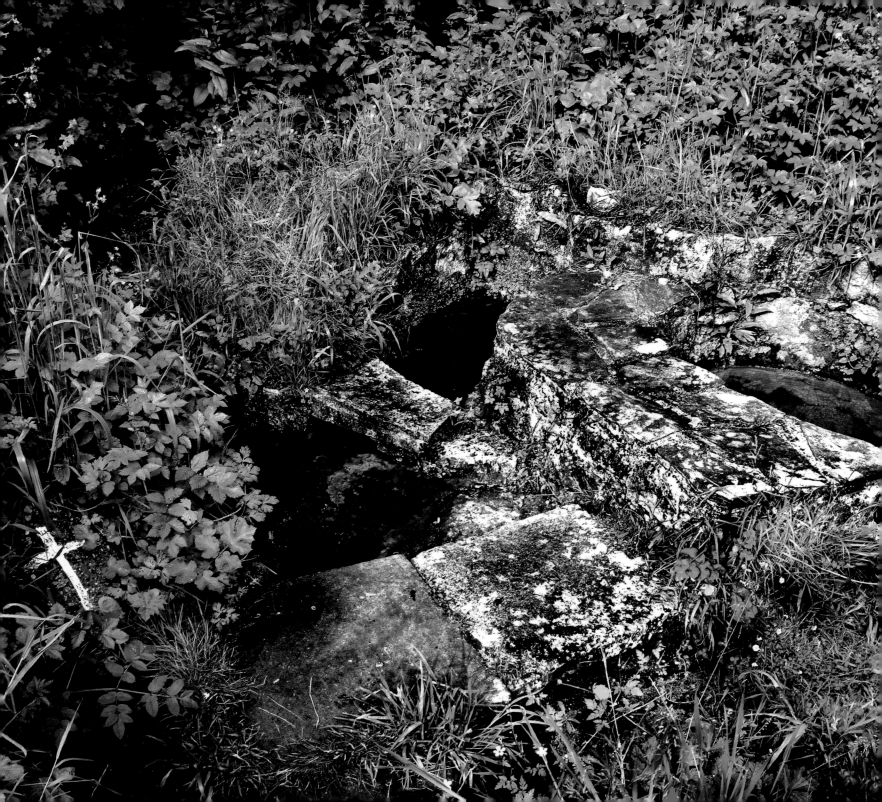

Ffynhonnau Eglwys Gumfreston
Gumfreston Church Wells

Gumfreston

near Tenby

Pembrokeshire

*OS Landranger
Map No 158
SN 109 011*

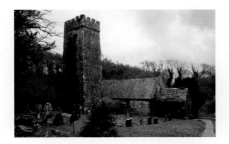

Top
The fourteenth-century church
of St Laurence

Opposite
The three Gumfreston wells

All three of the wells below Gumfreston's fourteenth century church of St Laurence have for many centuries been held to possess great medicinal properties. Though closely grouped, each one provides distinctly different water and each was held to offer a different remedy to the sick. The highest well of pure water was believed to cure ailments associated with the legs, and is in the shape of a leg; the middle well was chalybeate and assisted the hands and the arms, and is sculpted accordingly; while the lower circular pool was sulphurous and brought sight to blind eyes.

*"Here we bring new water from the well so clear,
For to worship God with, this happy new year;
Sing levy dew, sing levy dew, the water and the wine,
With seven bright gold wires, the bugles that do shine;
Sing reign of fair maid, with gold upon her toe,
Open you the west door, and turn the old year go;
Sing reign of fair maid, with gold upon her chin,
Open you the east door, and let the new year in."*

Francis Jones tells us in his seminal 1954 book, *The Holy Wells of Wales*, of the custom in Gumfreston and the other wells of South Pembrokeshire of the 'New Year's Water' which children drew and carried to local houses to sprinkle on their front doors with sprigs of evergreen or box. The song they sang has clear Christian as well as pagan resonances – the 'fair maid' representing both the Virgin Mary and the Earth Goddess.

Even still today, on Easter Sunday each year, in one of the most serene and awe-inspiring places in Wales, Gumfreston Church's new small congregation throws nails into the three wells to symbolise the crucifixion of Jesus, in a practice recalling its equivalent with pins, known as 'throwing Lent away', as well as in a telling and deeper reflection of the crooked pins and other metal objects that were offered to pagan spirits in much earlier times.

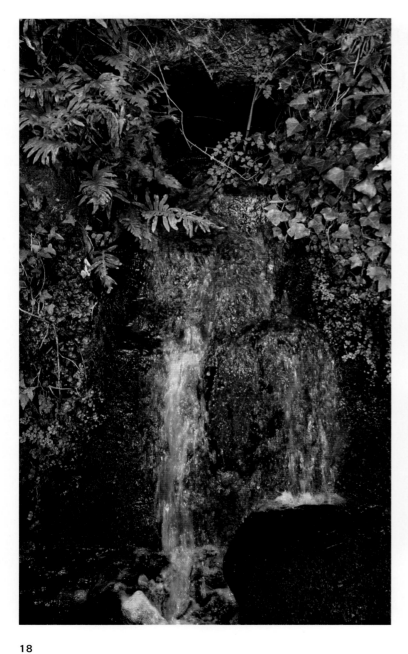

Left
Altar painting in church

Left
Candles in church niche

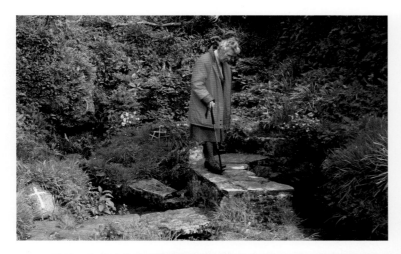

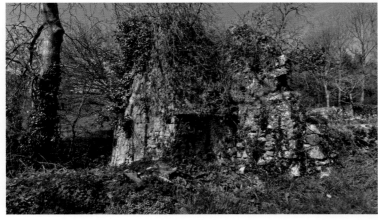

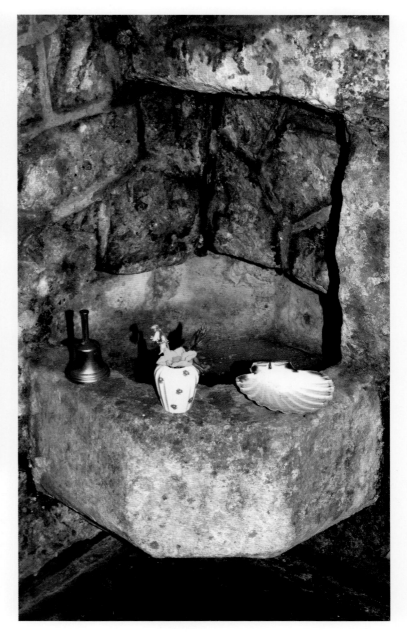

Top
Pilgrim at the eye well

Above
Ruins of an earlier chapel at Gumfreston

Right
Font with pilgrims' shell and bell in the church porch

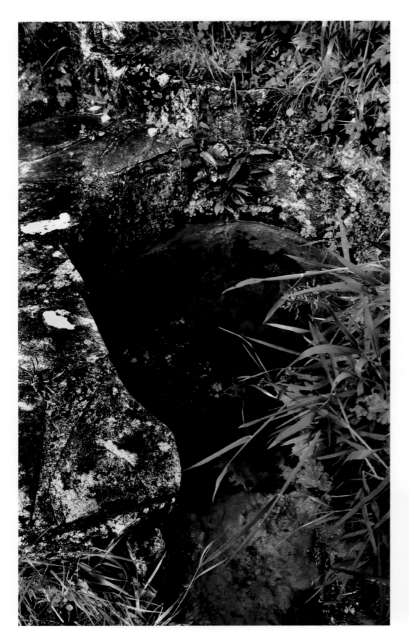

At Gumfreston Church

That evening, after a hard, hot drive,
The dark lane's coolness of trees
Was like water walked into,
Calm and quiet – no traffic,
Deep shadows,
All the gulls out at sea.

Augustus and Gwen's father
Walked the two miles from Tenby
Every Sunday to play the organ here.
I search for his headstone and find no-one
But Ken Handicott the grocer
I worked for one school summer holiday
Forty years ago.

They leave the church door unlocked:
There is no congregation but the curious passing folk.
And inside is the simple splendour of stone font,
Low wooden roof, draped altar, Norman-built
On earlier significance – St Teilo, St Bridget.
The place shivers in the dusk
And moves into another night.

Left
The Gumfreston eye well

Below
The iron / blood-stained water of Gumfreston wells

Here were the early missions, saints and sinners
Crossing the Irish Sea, moving east
With their crosses and swords.
Here was a quay, a village the river Ritec
Joined to the sea that led to the world.

And here, behind the church, before the woods
Where the Magdalens brought their lepers,
Still flow the three springs of purity
And healing, coming to us from a depth.
Water that plays the oldest music.

Without thinking
I take a handful
And with wet, cool fingers
Cross myself.

Tony Curtis
Crossing Over (Seren, 2007)

Below
Pilgrims cast nails into Gumfreston wells, Easter Sunday, 2006

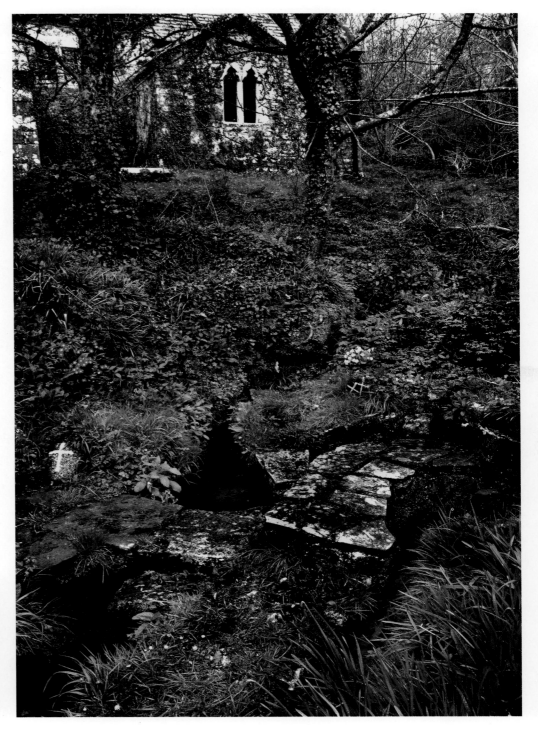

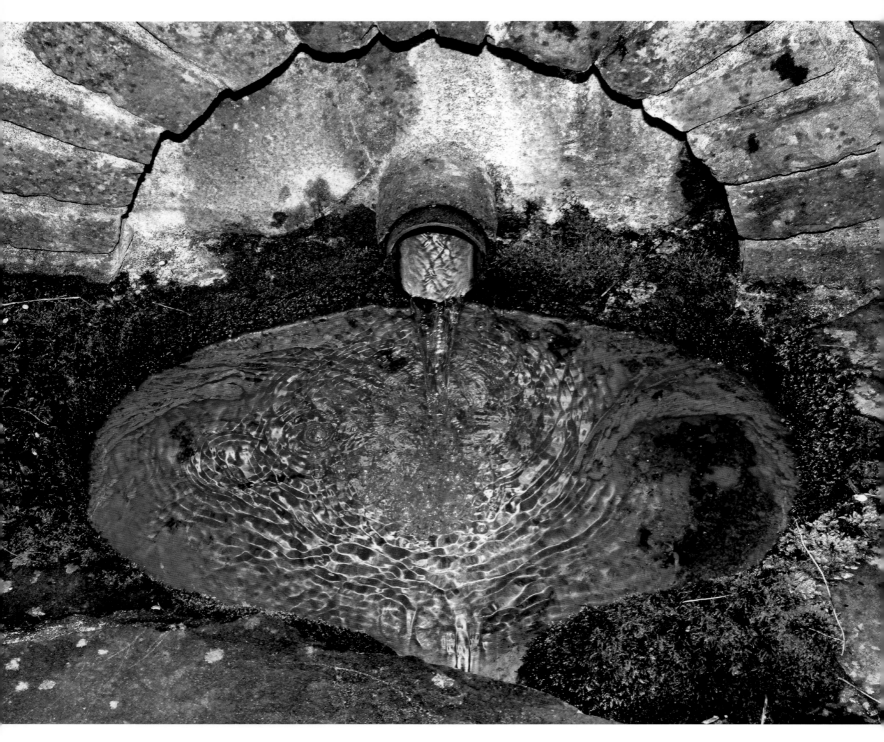

Ffynnon Ddrewllyd
The Stinking Well

Cwmtwrch-isaf

near Merthyr Tydfil

OS Landranger
Map No 160
SN 764 104

Ffynnon Ddrewllyd – 'The Stinking Well' – gets its unappealing name from the strong presence of sulphur in its waters. It was popular with the Victorians who drank, bottled, washed and bathed in it. In the 1870s, a Dr D Thomas sent samples for analysis to confirm the efficacy of its sulphur compounds and iron salts in the alleviation of rheumatism, gout, skin troubles, blood impurities and diuretic and urinary diseases.

This is one of the few wells in Wales whose very real medicinal attributes were not claimed and named for Christianity. The grassy area in front of the well, known locally as Maes-y-Ffynnon, became a focus for community activities of all kinds, including providing the site for choir practices, religious meetings and political gatherings, as well as the annual Cwmtwrch Eisteddfod.

The well was restored in 1920, and then again in April 1993 by Ystalyfera Community Council with the help of grants from The Prince of Wales Trust and Dŵr Cymru, the latter renovation, it must be said, being a real stinker!

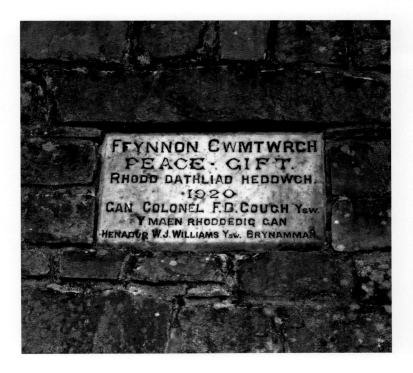

Left
1920s restoration plaque

Opposite
The blood-red waters of Ffynnon Ddrewllyd

23

Opposite

The unsympathetic renovation and signage
at Ffynnon Ddrewllyd

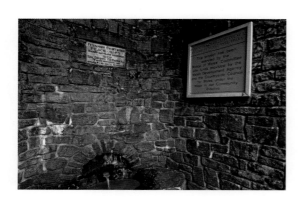

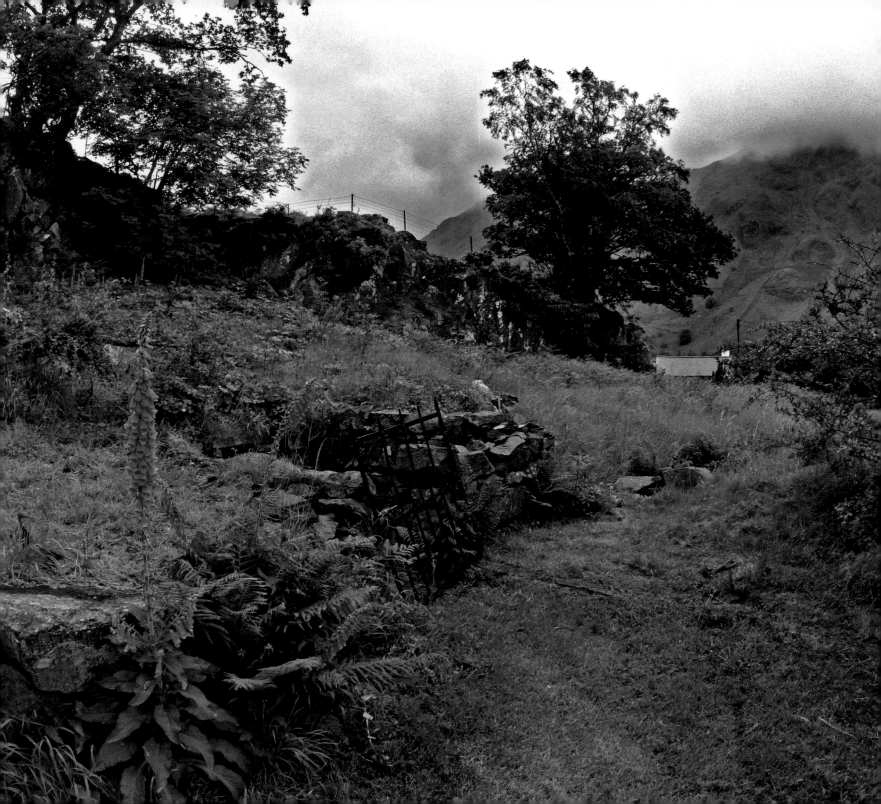

Ffynnon Beris
Peris's Well

Nant Peris

near Llanberis

Gwynedd

OS Landranger
Map No 115
SH 609 584

The symbol of the fish, which represented wisdom, knowledge and fecundity in ancient Welsh mythology, was borrowed later (along with much else) as a symbol of Christ.

The sacred trout, seen by the lucky few in Ffynnon Beris, situated at the bottom of the Llanberis Pass, was believed to be an omen of good luck for pagan and Christian bathers alike, and would indicate a successful cure for those with the ailments of scrofula, warts, tumours and rheumatism. The well was believed to be particularly efficacious for children suffering from rickets.

In November 1896, the *Liverpool Mercury* newspaper reported on the installation of two new fish into the pool following the death of its fifty-year-old previous occupant. The report included the following: "Invalids in large numbers came, during the last century and the first half of the present century, to this well to drink of its 'miraculous waters'; and the oak box, where the contributions of those who visited the spot were kept, is still in its place at the side of the well."

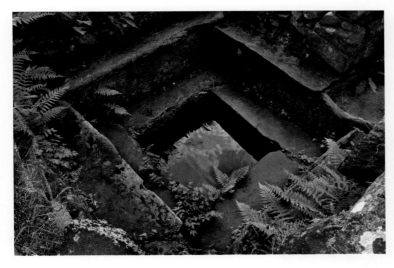

Above
The rectangular well pool constructed
entirely of local Snowdonia slate

Opposite
Ffynnon Beris, surrounded by the mountains of Snowdonia

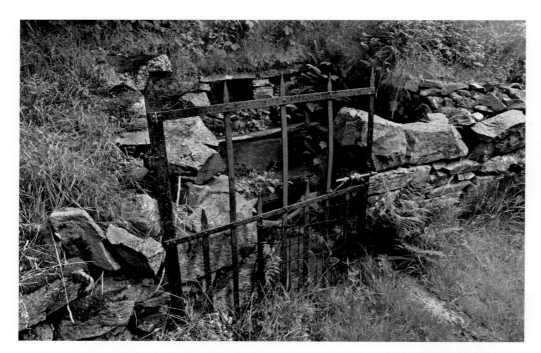

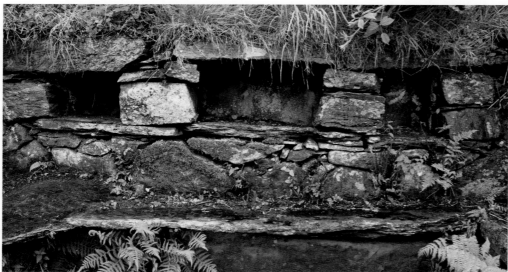

Above
The photographer reflected in the well pool

Left
Well-side niches for the placing of offerings to the spirits of the waters

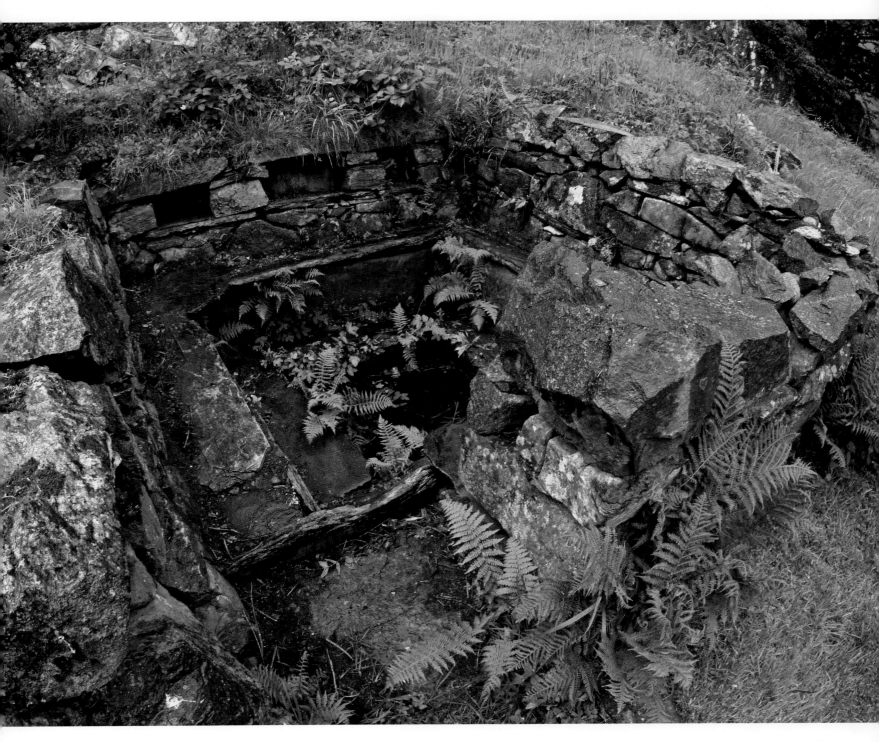

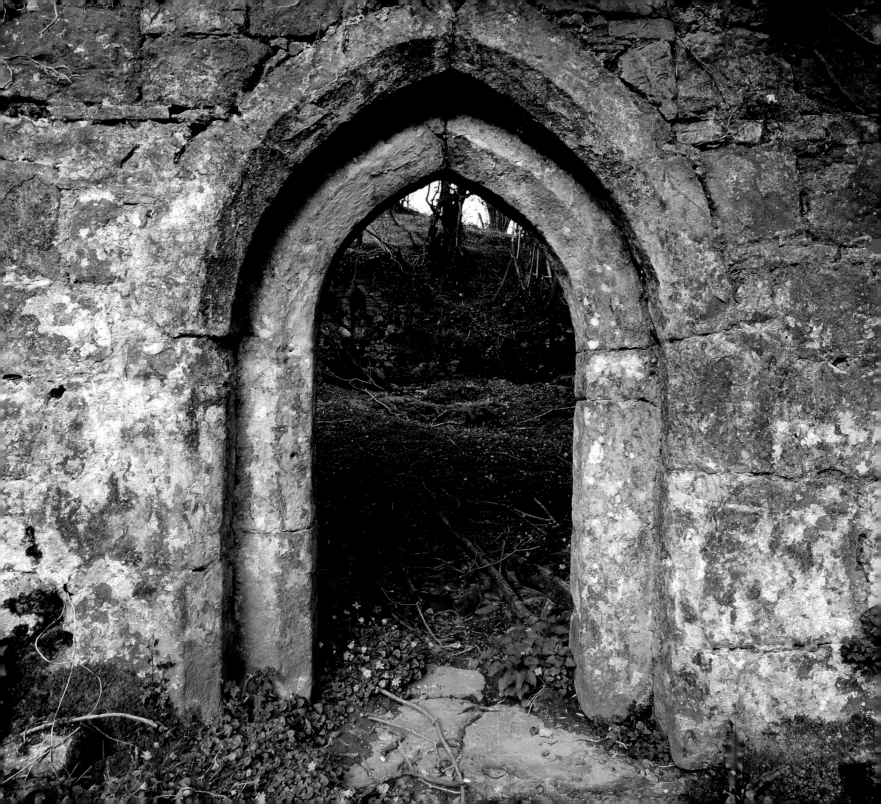

near Porthrhyd

Carmarthenshire

*OS Landranger
Map No 159
SN 529 147*

Capel Erbach
Erbach Chapel

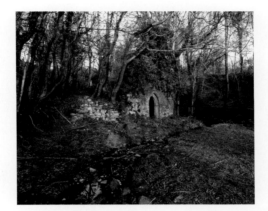

Along with Capel Begawdin (a more difficult find, though also near Porthrhyd, see pages 52-55), these two ruined structures are amongst the most impressive well chapels in Wales, though little is known of their origins and histories.

Capel Erbach specialised, it seems, in the relief of sprained or broken limbs when they were held under its cooling stream. From the evidence of the objects excavated from the drain, offerings of quartz pebbles were favoured.

Opposite
The doorway to Capel Erbach – notice the niche on the far wall

Right
The holy spring passes along a slab-covered channel under the chapel's floor, through the wall next to the entrance and into the stream below.

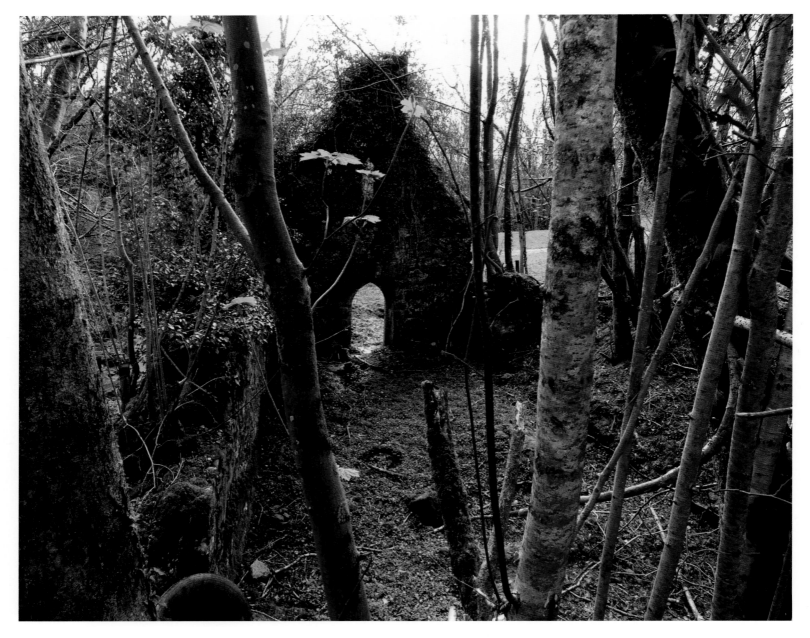

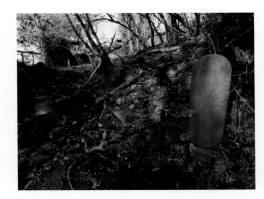

Top
The stream on the banks of which Capel
Erbach stands and into which its waters flow

Opposite
The roofless ruins of Capel Erbach

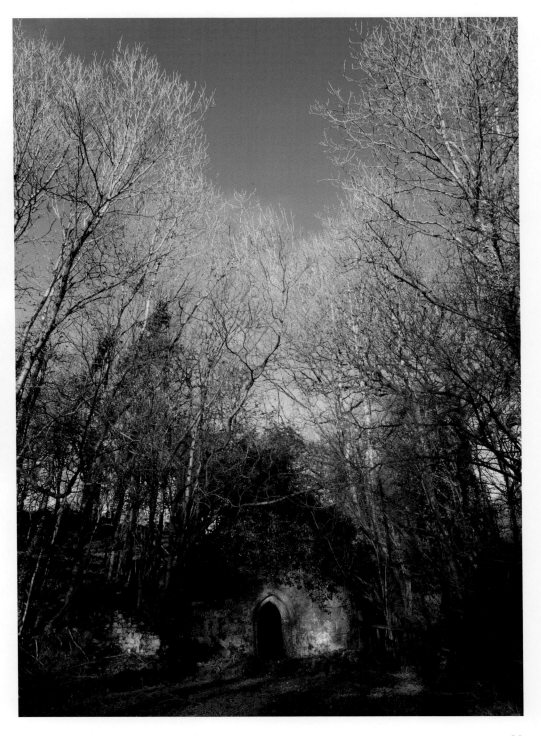

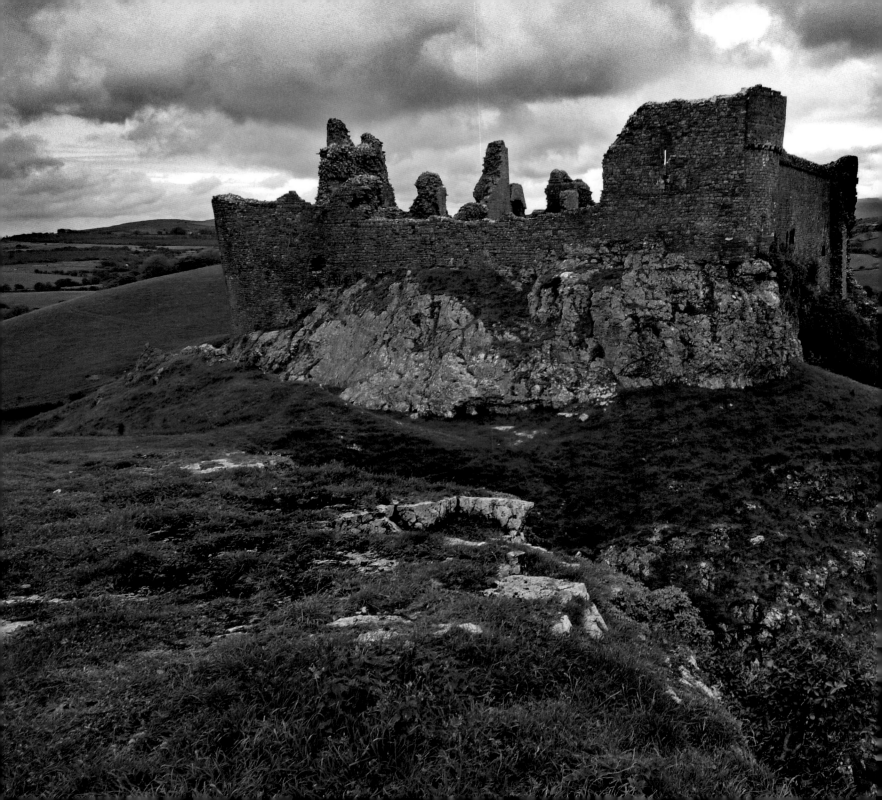

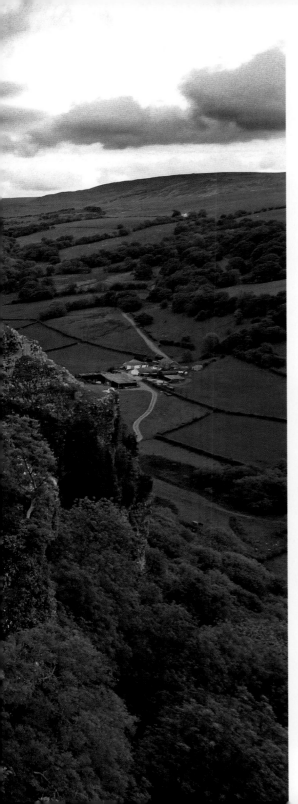

Ffynnon Castell
Castle Well

Carreg Cennan Castle

near Llandeilo

Carmarthenshire

*OS Landranger
Map No 159
SN 665 192*

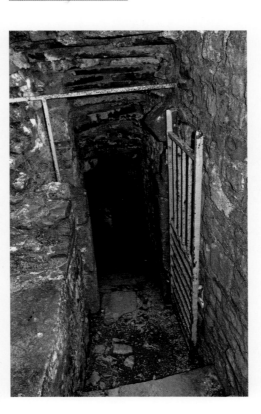

Carreg Cennan's situation, perched some 300 feet above the valley of the River Cennan on a precipitous limestone crag, made it an ideal spot to both survey the surrounding countryside and discourage invaders. In addition, the gift of water in its ancient well, set deep within a natural grotto beneath its outer ward and accessed only via a dark 200-foot-long passage, was another powerful argument for the castle's establishment here.

Although the picturesque remains of Carreg Cennan that are visible to us today are of late thirteenth and early fourteenth century construction, the site is thought to have been continuously occupied since the Iron Age. It regularly changed hands between the Welsh and the English from the twelfth century until its eventual and violent demolition by supporters of the Yorkist king, Edward IV, in the summer of 1462.

Left
Gateway to the steep passage leading down to the well grotto

35

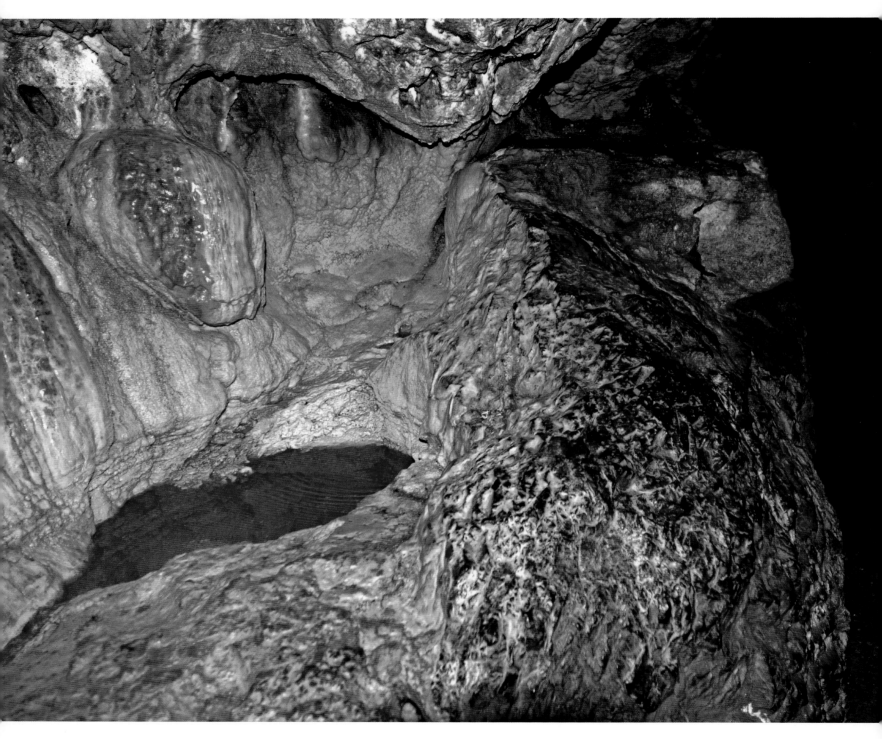

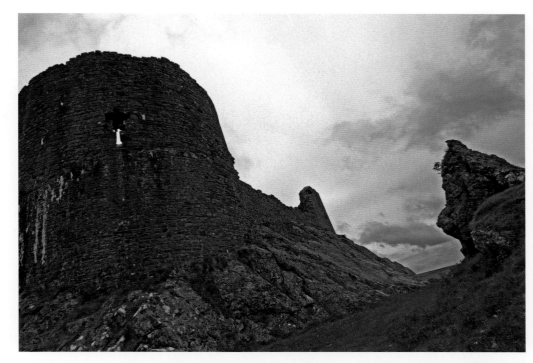

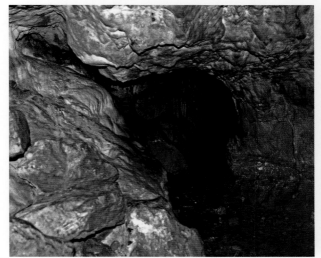

Top
Modern graffiti

Opposite
The Carreg Cennan well

Right
The dark passage to the well

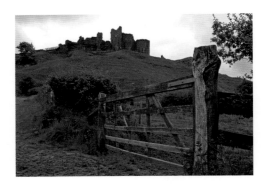

Above
Carreg Cennan Castle, perched on a
300-ft limestone cliff overlooking the
River Cennan

Opposite
Nineteenth-century pilgrims' graffiti

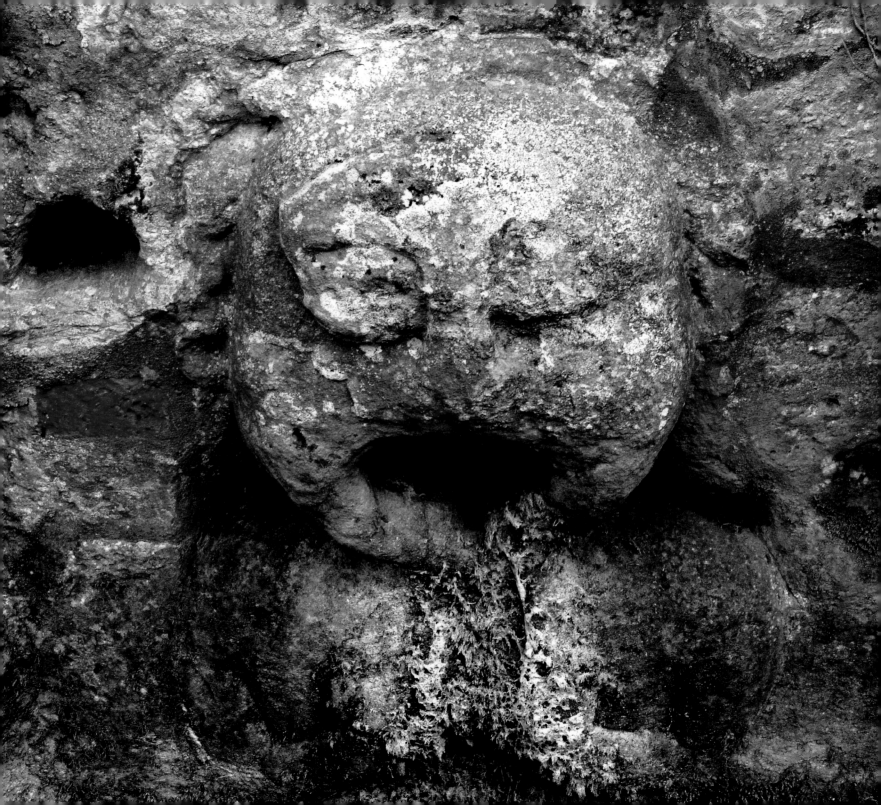

Tremeirchion

near St Asaph

Denbighshire

*OS Landranger
Map No 116
SJ 083 723*

Ffynnon Beuno
St Beuno's Well

S t Beuno is considered by some to be the patron saint of North Wales. He is reputed to have restored the life (as well as the head) of St Winefride at Holywell (see St Winefride's Well, pages 212-219), and it may be through the gaping mouth of her head here at Tremeirchion that water spouted from a large walled reservoir, in a clear reference back to the ancient Celtic cult of the head. The spring's pagan connections are further suggested by the presence of Stone Age caves in a small valley beyond the old wellhouse.

The water from the well was believed to have had strong restorative properties, healing rheumatism, sore eyes, warts, eczema, epilepsy and paralysis if drunk or immersed within. The large one-metre-deep bathing pool, the metal hand-pump, and the substantial adjacent house – which was once a pub and a shop – all attest to the importance of the site for pilgrims and those in need of a cure.

Right
Kneeling cushion from St Beuno's church, embroidered with an image of the saint's well

Right
Stained glass windows in the church

Opposite
The gaping mouth of St Winefride?

Above
St Beuno represented in the
Tremeirchon cross

Above
Windows in St Beuno's church

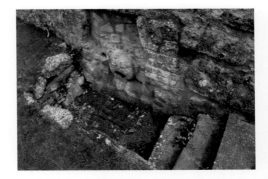

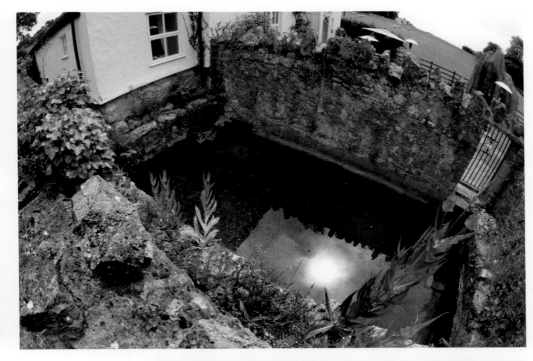

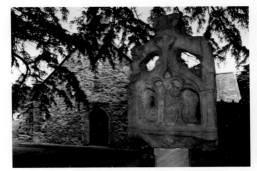

Top
Steps leading down to St Winefride's head

Above
The fascinating history of the ancient pilgrims' cross in the grounds of St Beuno's church in Tremeirchion reflects the ebbs and flows of Christianity in Wales. Like the well, it was also 'celebrated for its miracles'. It is thought to have been carved and erected in the fourteenth century or earlier, and was toppled in the mid-seventeenth century as part of the Puritan purge of 'Monuments of Superstition and idolatry'. In 1862, J Youde Hinde of Rhyl found the crosshead neglected beneath a yew tree in the churchyard. It has recently been restored and was rededicated in September 2004.

Top right
The well pool and house

Right
1613 tombstone in the church

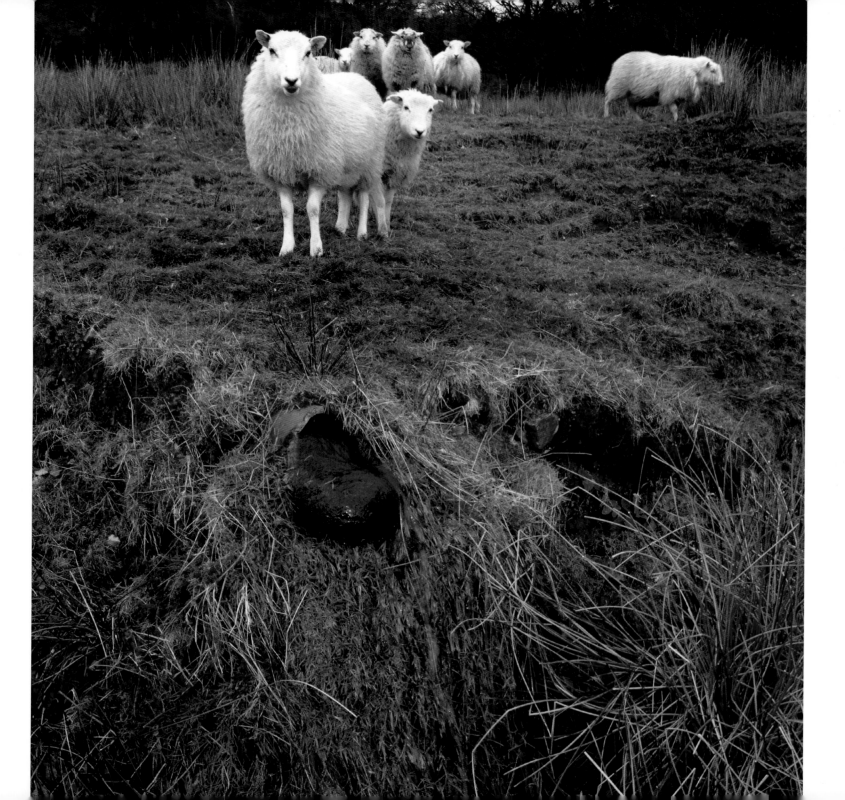

Ffynnon Dewi
St David's Well

Abergwesyn

near Llanwrtyd Wells

Powys

OS Landranger
Map No 147
SN 852 529

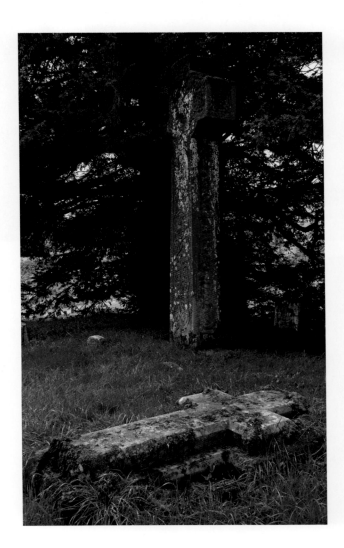

Whether this is the holy well associated with the now totally-ruined church of Wales's patron saint here in the tiny settlement of Abergwesyn is not at all certain. The presence of two finely-crafted metal bowls below the crude red clay pipe from which the cool and pure liquid issues – the water gently dropping from one bowl to the other – its situation close to the old vicarage, and the graveyard nearby suggests that it is, but we cannot be sure, like so much else connected to the hunting of holy wells.

What is certainly true is that this is a magically-charged area situated within the majestic Irfon Valley dwarfed by the Berwyn Mountains, and, if you follow the road up past the well, leading to the spectacular Devil's Staircase and Llyn Brianne.

Left
The huge cross in the graveyard
of St David's church

Far left
The man-made falls of Llyn Brianne reservoir

Above
Gravestones in the neglected church
graveyard

Left
Old gatepost to the church

Below
The old vicarage, Abergwesyn

Bottom
All that remains of St David's church are its
foundations.

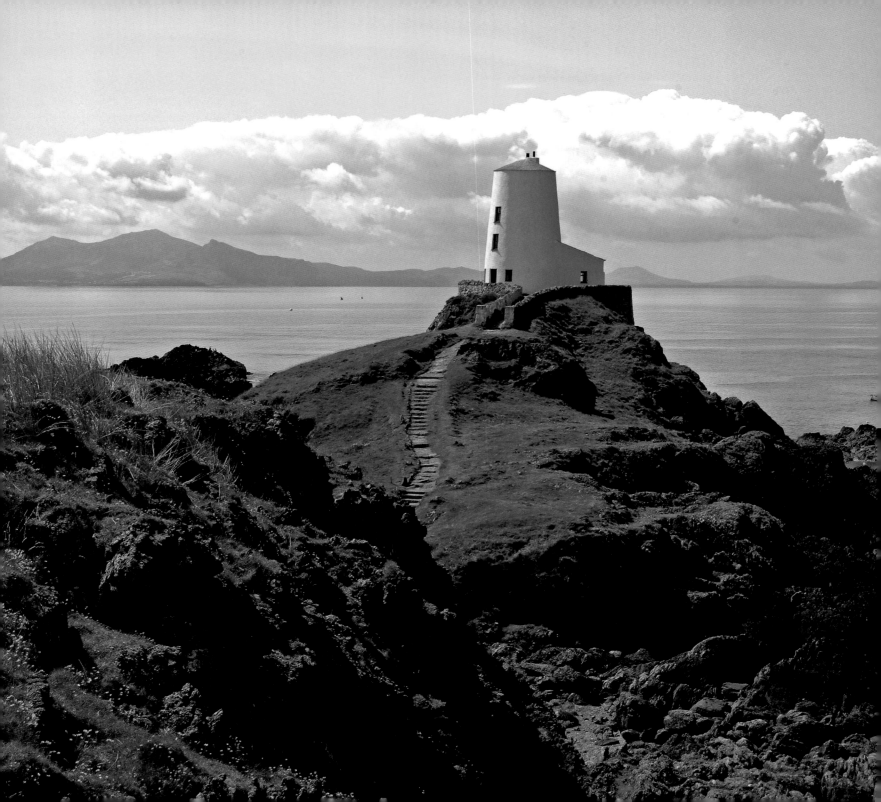

Ffynnon Dwynwen
St Dwynwen's Well

Llanddwyn Island

near Newborough Warren

Isle of Anglesey

OS Landranger
Map No 114
SH 387 626

Left
The old lighthouse at the furthest point
of Llanddwyn Island

Legend tells that Dwynwen was one of the twenty-four children of king Brychan Brycheiniog … and the most beautiful! But this is the only element of her story that attracts consensus. In one tale, she is pursued by the tyrant Maelgwyn Gwynedd and flees from Ireland to Wales. In another, her desperate journey is reversed. Some say she crossed the water on foot, an action that established the belief in her ability to protect seafarers.

Another tale tells of her falling in love with the prince Maelon Dafodrill at a feast arranged by her father, but again there are variations concerning the rest of the story. In one version, Dwynwen's father forbids the union as he has already offered her hand to a rich prince from the next town; in another, Maelon is unfaithful: and in yet another, the young prince attacks and tries to seduce Dwynwen. Either way, Dwynwen is distraught and asks her god to erase her and Maelon's love for each other, a plea he grants. Dwynwen is then offered three wishes. Her first is that Maelon, who has been turned into a block of ice, be released; her second is that she might never fall in love again; and her third, that from thenceforth every lover's dream comes true.

Your holy parish is your straggling flock:
(a man) sorrowful and worn with care I am;
because of longing for my mistress
my heart is swollen up with love,
deep pangs grounded in anxiety,
as I well know – this is my malady –
unless I can win Morfudd
if I remain alive, it is but life in vain.
Make me be healed, (you) most deserving of all praise,
from my infirmity and feebleness.
For one year be both messenger of love
as well as mediatrix of God's grace to man.
There is no need for you, unfailing golden image,
to be afraid of sin, the body's ever-present snare.
God does not undo what he has once done,
good is his peaceful disposition, you will not fall from Heaven.
…
Dwynwen, if you would once cause
under May's trees, and in long summer days
her poet's reward – fair one, you would be good,
for, Dwynwen, you were never base
prove, by your gifts of splendid grace
that you are no prim virgin, prudent Dwynwen.

Dafydd ap Gwilym
Translated by Rachel Bromwich in *Dafydd ap Gwilym:* Poems (Gomer, 1982)

Above
One of the many crosses dedicated to St Dwynwen on
Llanddwyn Island and all that remains of her church

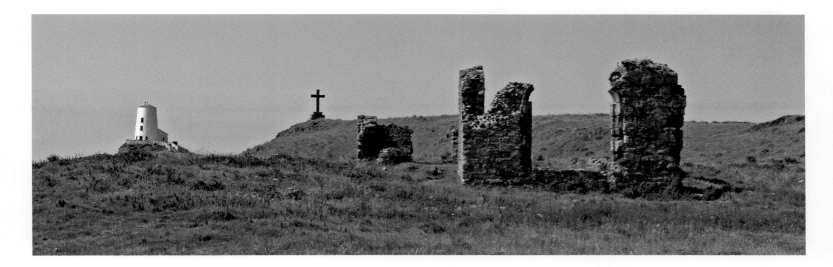

Dwynwen established her church on an isolated rocky island on the most south-westerly point of Anglesey and lived the rest of her life as a nun. Her well was a favourite destination for the crippled in body and heart, and her cult spread widely. Some said that there was a fish in the well that could provide the name of a future lover. Pilgrims would spend the night on Gwely Esyth, a high spot above the well, and carve their names in the turf when a cure had been successfully achieved.

Notwithstanding her earlier claims to calm the seas, Dwynwen's church, rectory and sacred well were all eventually engulfed by sandstorms and largely destroyed. Today, little of the well building remains visible, although the stunning site still retains much of its ancient spiritual allure.

Dwynwen has become Wales' patron saint of lovers, and 25 January is celebrated as St Dwynwen's Day, the Welsh equivalent of the feast day of the obscure Roman martyr, St Valentine.

Top
St Dwynwen's church and, in the distance, the cross erected in 1903 to celebrate the Dwynwen cult

Right
All that remains of St Dwynwen's Well

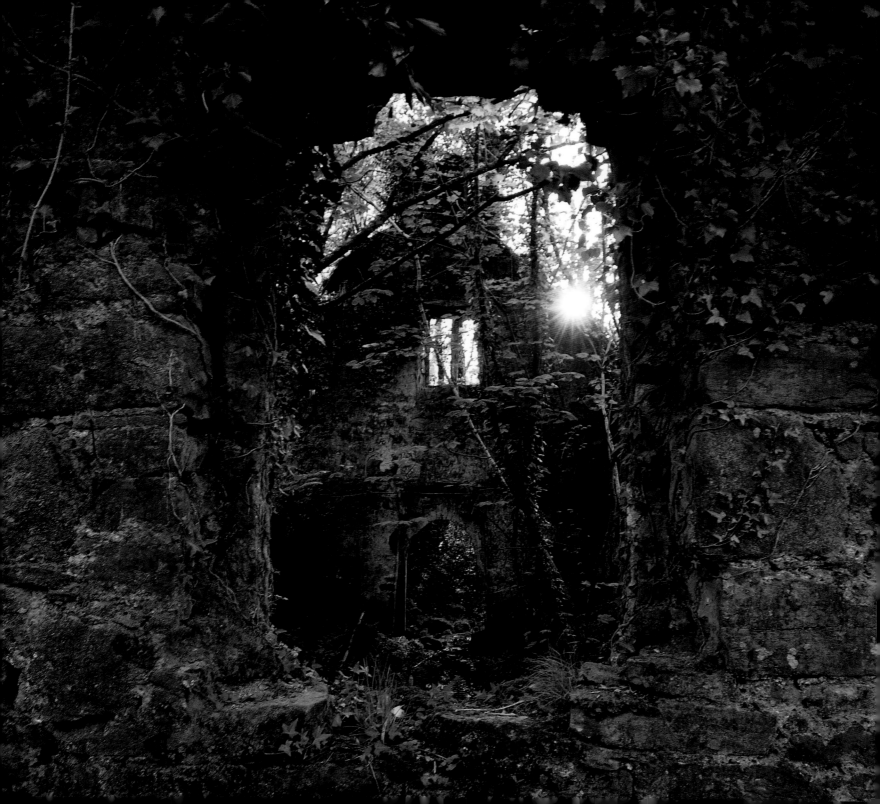

Capel Begawdin
Begawdin Chapel

near Porthrhyd

Carmarthenshire

*OS Landranger
Map No 159
SN 511 147*

Although its history is unclear, the magical Capel Begawdin is well worth the effort to find over fences, across fields, and into a swampy wood on private farmland. Its innocent enigmatic pull and promise has attracted me to return regularly.

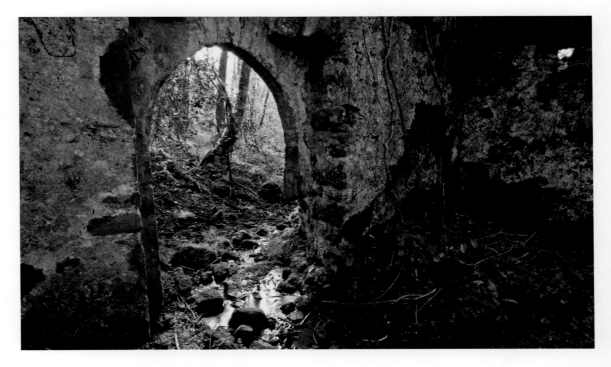

Opposite
The ruins of Capel Begawdin

Right
The Begawdin well water flows from beneath the floor of the chapel that was built to enclose it, and now escapes through its doorway.

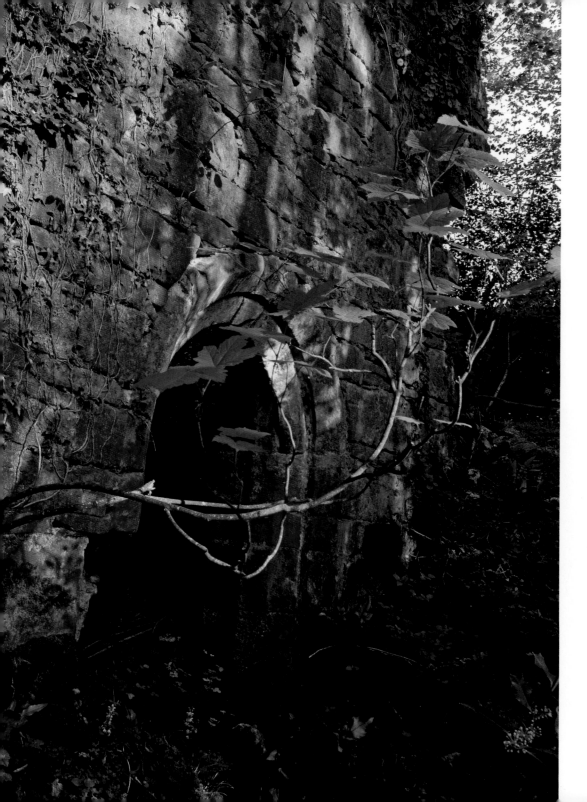

Fathoms

Young I visited
this pool; asked my question,
passed on. In the middle years
visited it again. The question
had sunk down, hardly
a ripple. To be no longer
young, yet not to be old
is a calm without
equal. The water ticks on,
but time stands, fingerless.

Today, thirty years
later, on the margin
of eternity, dissolution,
nothing but the self
looking up at the self
looking down, with each
refusing to become
an object, so with the Dane's
help, from bottomless fathoms
I dredge up the truth.

R S Thomas
No Truce with the Furies
(Bloodaxe Books, 1995)

Below
Niche for a statue or offerings inside
Capel Begawdin

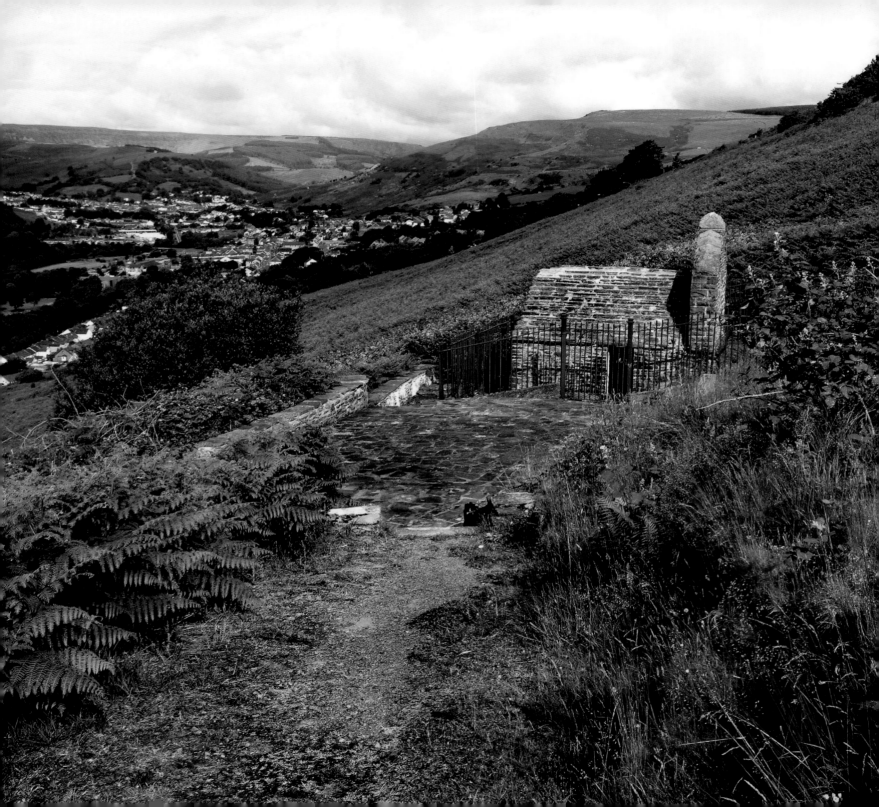

Ffynnon Fair
St Mary's Well

Penrhys

near Ferndale

Rhondda Cynon Taf

OS Landranger
Map No 170
ST 004 944

S acred trees and groves were a key feature of early pagan faiths. Hazel, rowan, ash, holly, mulberry, yew, oak and apple trees, and certain kinds of thorn bushes and briars growing near wells were regularly used within their rituals. Penrhys's more-recent fame rests largely upon the miraculous appearance sometime in the thirteenth century of a wooden statue of the Virgin and Child believed to have fallen from Heaven into an old oak tree near the well, an event that greatly improved its reputation for healing.

Penrhys, 1,100ft above sea level on a mountain route connecting Rhondda Fach and Rhondda Fawr, became *the* centre of Catholic devotion in South Wales, and one of the most famous pilgrimage destinations in Britain. The site boasted an array of fine buildings, including a monastic chapel, accommodation for guests, a bakehouse, brewhouse, malthouse, barns, stables, a smithy and a hostelry, as well as its wellhouse. The Virgin gave sight to the blind, made cripples walk, enabled the deaf to hear, and even raised the dead!

"There are rippling waters at the top of the rock.
Farewell to every ailment that desires them.
White wine runs in the rill,
That can kill pain and fatigue."
Rhisiart ap Rhys (1480-1520)

Left
The 1953 statue of the Virgin and Child

Far left
Ffynnon Fair on the hillside above Rhondda Fach

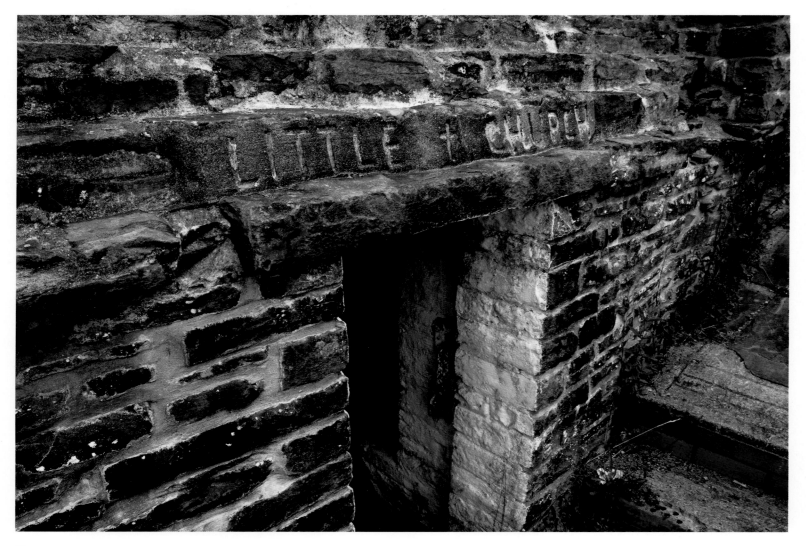

Above
The entrance to Ffynnon Fair, Penrhys

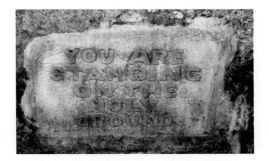

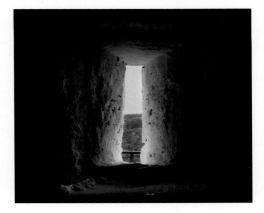

Above
Three images from inside the wellhouse; the top one reads 'You are standing on the holy ground', and the bottom one reads 'Baptize Holy Water Fire'

Penrhys' celebrity, however, made it a prime target for the iconoclasts of the Reformation, whose principle aim was to destroy everything they considered to be idolatrous; "effigies were removed, church wall-paintings obliterated, rood-lofts and shrines destroyed, pilgrimages to wells and sacred sites prohibited" – Francis Jones.

The effigy of Our Lady of Penrhys was forcibly removed on 14 September 1538 on the instruction of Thomas Cromwell "as secretly as might be", recognising its local and national importance and fearing an uprising of believers, and taken to Chelsea in London and burned.

For four long centuries, Ffynnon Fair's status was relegated to that of an ordinary local healing well. Then, in 1939, Rhondda Borough Council tidied the site and railed the wellhouse, and on 12 September 1947 on the Feast of the Nativity of Our Lady, some 4,000 Roman Catholics revived the pilgrimage to the famous waters of Mary's Well. On 2 July 1953, a carved Portland stone statue resembling the accounts of the original was erected on the site of the early chapel on the green above the wellhouse to replace that earlier destroyed.

"These days the view below is no longer of tranquillity and woodland but a valley full of industry and housing estates; the old pilgrim's route has been replaced by a new road and one has to use a certain amount of imagination to recapture the atmosphere of olden times."
Audrey Doughty, *Spas and Springs of Wales*.

While the Rhondda's principle industry of coalmining has now gone the way of the monastery and the chapel, the "imagination to recapture the atmosphere" is being successfully rekindled through a series of initiatives led by the dynamic Penrhys Partnership and a wide range of local organisations to re-establish the village as a major national shrine for Wales and a centre for pilgrimages of many faiths and none.

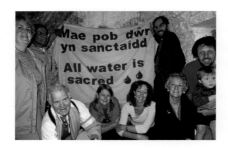

Penrhys

The ground falls sharply; into the broken glass,
into the wasted mines, and turds are floating
in the well. Refuse.

May; but the wet slapping wind is native here,
and not fond of holidays. A dour council cleaner,
it lifts discarded

Cartons and condoms and a few stray sheets
of newspaper that the wind sticks
across his face –

The worn sub-Gothic infant, hanging awkwardly
around, glued to a thin mother.
Angelus Novus:

Backing into the granite future, wings spread,
head shaking at the recorded day,
no, he says, refuse,

Not here. Still, the wind drops sharply.
Thin teenage mothers by the bus stop
shake wet hair,

Light cigarettes. One day my bus will come, says one;
they laugh. More use 'n a bloody prince,
says someone else.

The news slips to the ground, the stone dries off,
smoke and steam drift uphill
and tentatively

Finger the leisure centre's tense walls and stairs.
The babies cry under the sun,
they and the thin girls

Comparing notes, silently, on shared
unwritten stories of the bloody stubbornness
of getting someone born.

Rowan Williams
The Poems of Rowan Williams
(Perpetua Press, 2002)

Top left
In August 2005, the Nicaragua Solidarity
Campaign chose St Mary's Well to launch
its campaign to draw attention to plans to
sell off Nicaragua's water supply.

Bottom left
Housing on the Penrhys estate

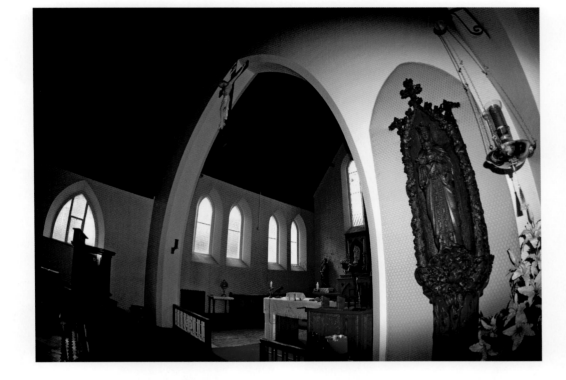

Right
The splendid carved oak Mary and Child statue at Our Lady of Penrhys Church in Ferndale, created in 1912 as a perfect copy of the 'miraculous' image

Right
Acorn and oak leaf details from the statue

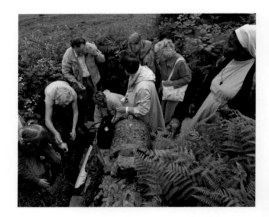

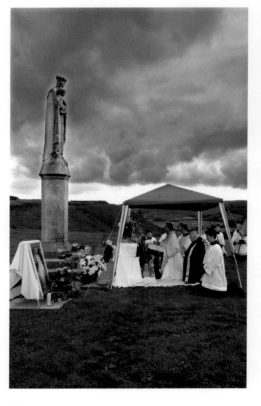

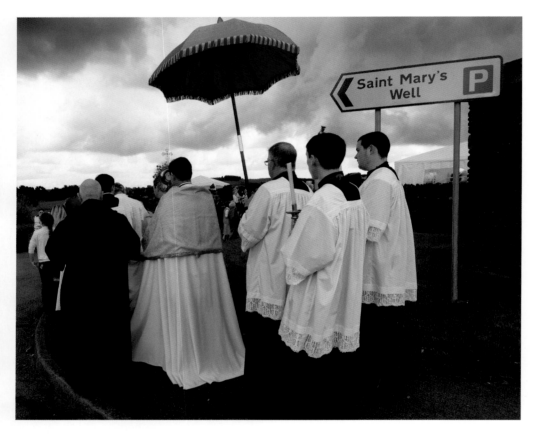

Above & Left

"And there on the mountain the water still flowed,
A witness to all of the blessings to God.
The centuries turned and the waters flowed on
With a message of hope, until Wales was reborn.
And here at Penrhys with the image restored,
Again Christ is worshipped and prayer is outpoured."
(from the hymn *Our Lady of Penrhys* by Father Clive Loosemore)

On 16 June 2007, a major pilgrimage to Our Lady of Penrhys
Shrine and Ffynnon Fair on the feastday of the Immaculate Heart
of Mary attracted pilgrims from all over Europe.

Opposite top
The lower wellhouse at Penrhys

Opposite middle
Cross carved font on the floor
outside upper St Mary's well

Opposite bottom
Niche for offerings inside wellhouse
at Ffynnon Fair

Ffynon Fair, Penrhys

A stone hut
 above the Rhonddas
 below the roundabout

Padlocked iron fence
 Pilgrims' patio
 2 supermarket trolleys
 Some struggling daffs

 Glimpse of a trough
 inside:
 a pin well
 to sharpen the eyes

 A pin in place of gold
A strip of cloth
 for animal sacrifice

The water squeezed out
 between the strata
Pennant series
 overlying the Coal Measures

Hospice and shrine
 Property of the white monks
 down in Llantarnam
 Offerings of alms and a taper

1538: Mary
 nursing Jesus
 for a kiss
 taken down by night
and burnt in London
 A jolly muster

In régime-change
 go for the statues:

Saddam's head
 swung onto a lorry

Stalin's ear
 now a paddling pool

 and the Taliban at Bamiyan
 blasting Buddhas
with tanks, mortars and artillery

At Smithfield
 the oaken image
 blue and gold
 drowns in fire
unflinching

At Penrhys
 the water
 trickles on
 down the hill

Phil Maillard

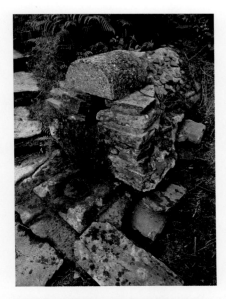

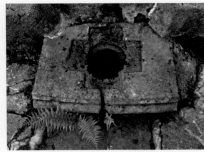

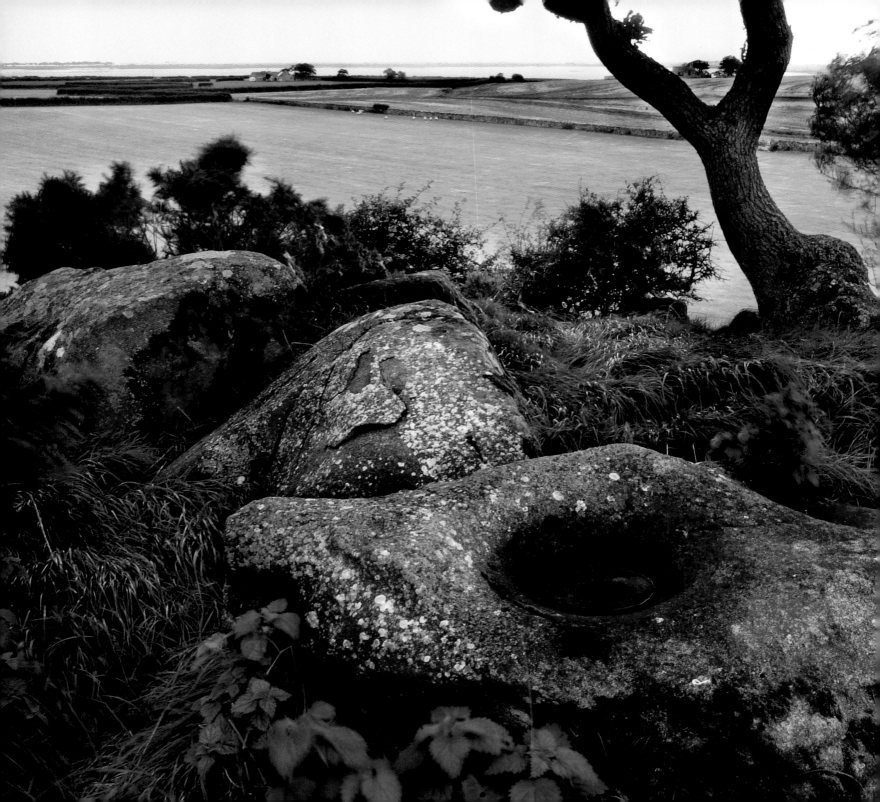

Ffynnon Faglan
St Baglan's Well

Llanfaglan

near Caernarfon

Gwynedd

*OS Landranger
Map No 115
SH 460 609*

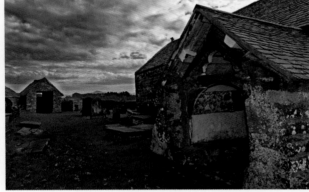

Opposite
Stone font above Ffynnon Faglan, probably used for baptisms

Top right
St Baglan's church, on the shores of the Menai Straits

Bottom right
All that is left of the well of St Baglan

Ffynnon Faglan is a well with a 1,400-year history of cures, specialising in the relief of eczema, eye problems, rheumatism and warts. The wart cure involved washing a pin in the well, then pricking the wart before bending the pin and throwing it into the water. Touching the pins of another was believed to transfer the wart. In the mid-nineteenth century, the well was cleaned out, revealing two basinfuls of bent pins.

St Baglan's church and well would have been resting places for pilgrims on their way to Bardsey Island at the end of the Lleyn Peninsula.

Although the church has survived, the elaborate well building to be found in historical description – a grand walled structure with seats and a masonry chamber – is today no more than an unimpressive pile of stones. Above the well, however, on an ancient forested tumulus overlooking the saint's church on the shores of the Menai Straits, is a perfectly-preserved baptismal font, scooped out of a large boulder.

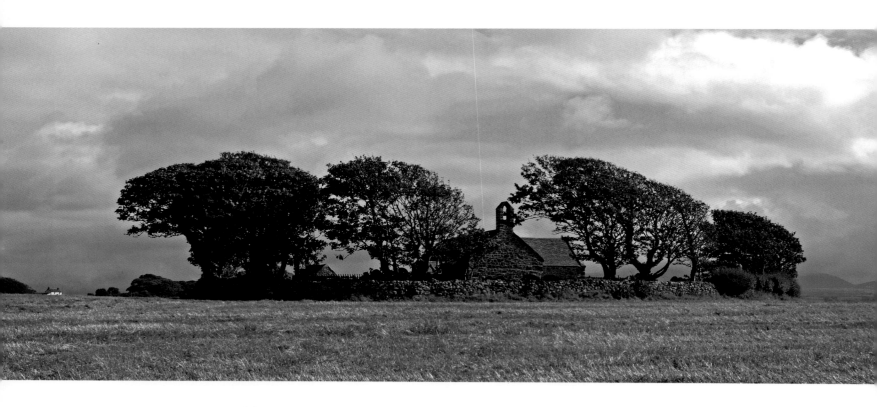

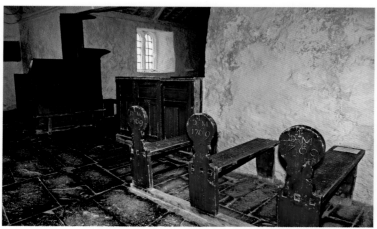

Above
The church of St Baglan is surrounded by a pre-Christian stone circle that has been incorporated into its graveyard wall.

Left
Interior of St Baglan's church with mid eighteenth-century pews

Above
The eye of the font

Right
Ancient trees on the Iron Age mound
where the font is to be found

near Bronant

Ceredigion

*OS Landranger
Map No 135
SN 675 622*

Ffynnon Drewi
The Stinking Well

The bleak and featureless landscape of this part of Mid Wales is enlivened by both these three tiny wells that hide in its hills and the impressive, inspiring wildlife gardens of Bwlch Y Geuffordd nearby, dug, planted, and nurtured by the new well guardians of Ffynnon Drewi.

Ffynnon Drewi seems so called not as a corruption of our patron saint's name but rather with reference to the waters' smell, 'drewi' in Welsh meaning a stench or stink.

Left
A cup left for visitors wishing to 'take the waters' at the isolated wells of Ffynnon Drewi

69

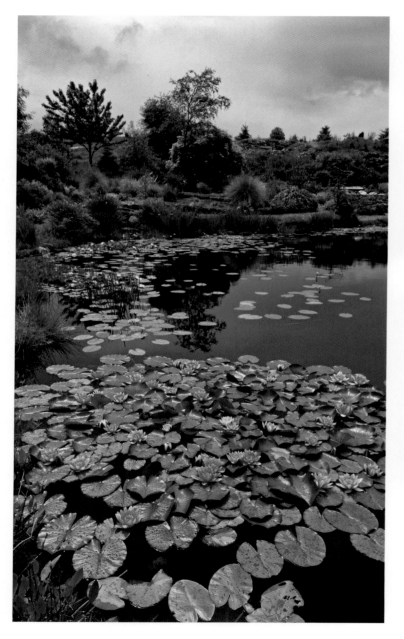

Left & Above
The magical wildlife gardens of Bwlch Y
Geuffordd, the starting point of the walk to
Ffynnon Drewi, were once waterlogged fields.

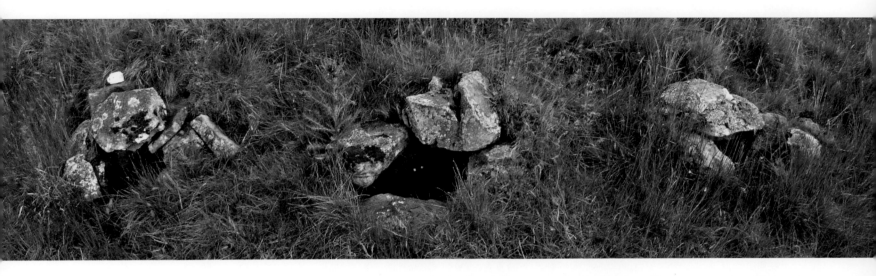

Above
The three wells of Ffynnon Drewi

Right
Burned wood sculpture at
Bwlch Y Geuffordd gardens

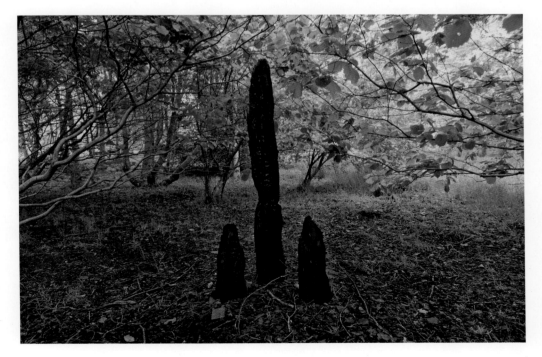

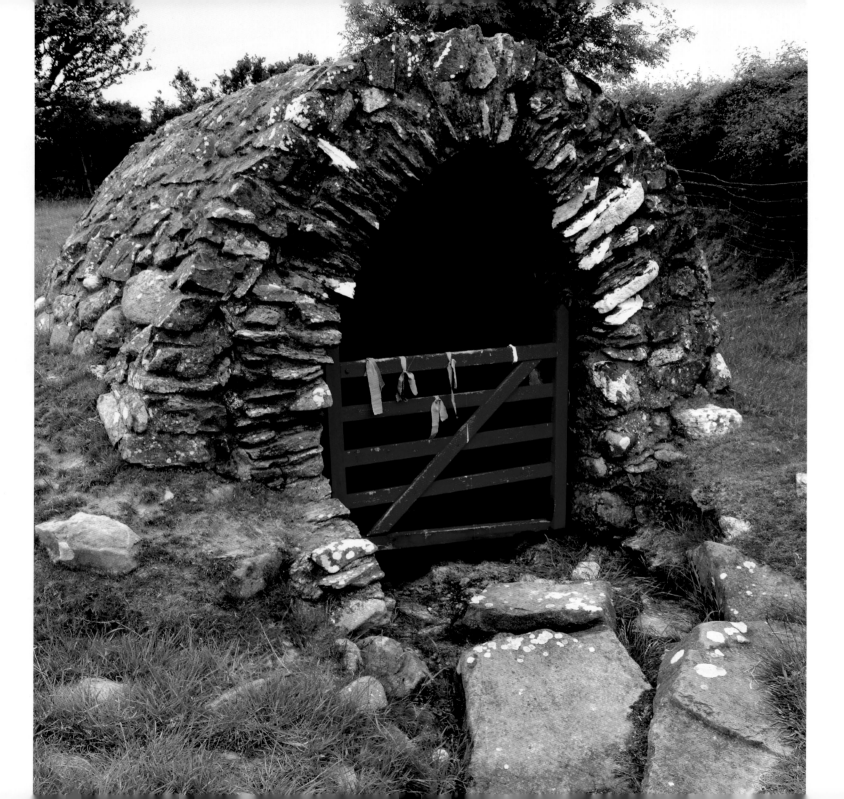

Llanllawer

near Fishguard

Pembrokeshire

OS Landranger
Map No 157
SM 987 361

Ffynnon Sanctaidd Llanllawer
Llanllawer Holy Well

ocal tradition suggested that the water from this finely-built, stone-vaulted, bubbling well, sometimes known as Ffynnon Gapan ('The Lintel Well'), situated above the Gwaun Valley, granted wishes both good and bad depending on whether the proffered pin was straight or bent. Richard Fenton described it as a healing well in 1810, especially efficacious for treating eyes.

The adjacent church, rebuilt in the nineteenth century but incorporating ninth- and tenth-century elements, lies within an elliptical enclosure, suggesting the Christian adoption of an originally pagan site.

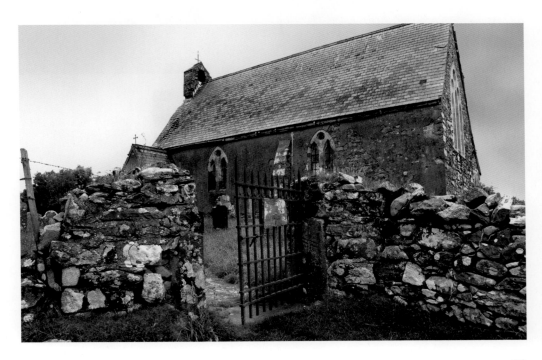

Opposite
The presence of ribbons hung on the gate of
Ffynnon Sanctaidd Llanllawer suggests that the well
is still used today by hopefuls seeking cures.

Right
The entrance to Llanllawer chapel and graveyard

73

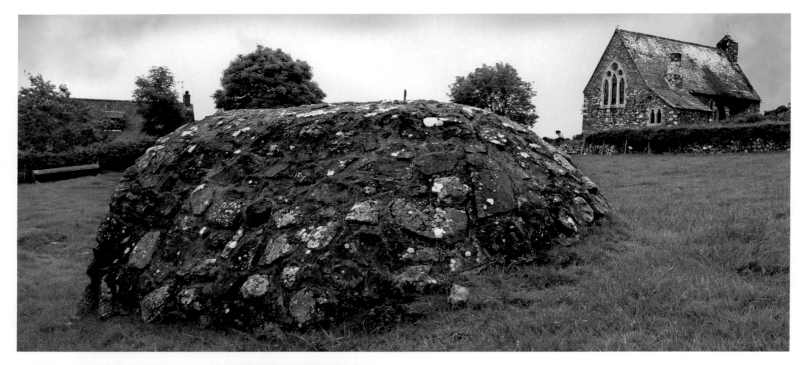

Above
The well and chapel

Left
One of the two seventh-century stone
crosses on either side of the gate to
Llanllawer church, erected to prevent
the entrance of evil spirits

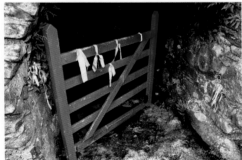

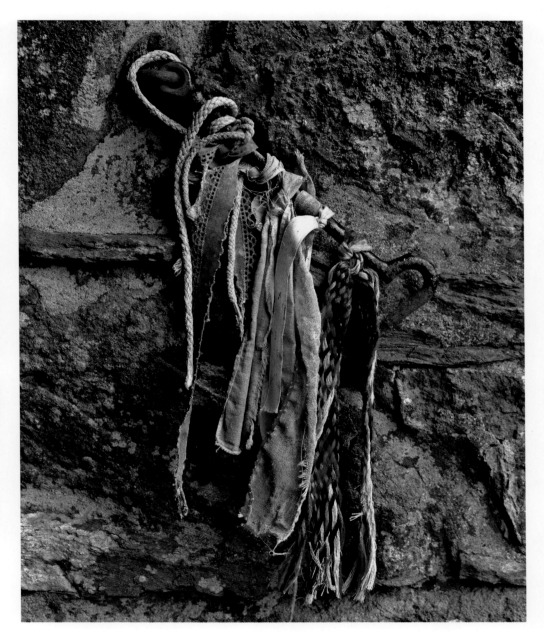

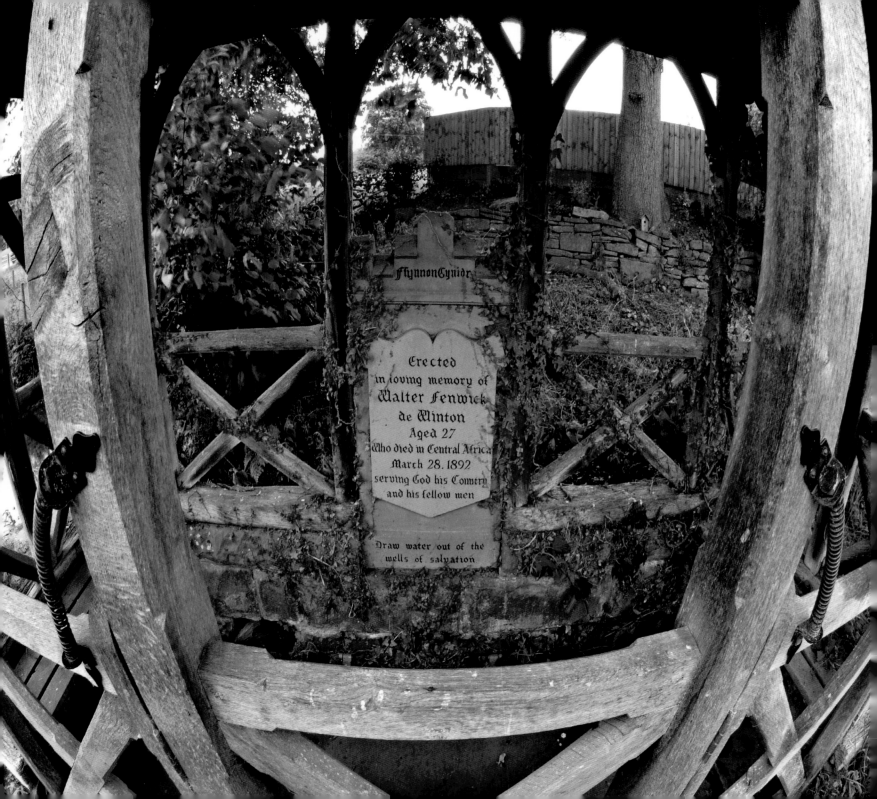

Ffynnon Gynidr
St Cynidr's Well

Glasbury

near Hay-on-Wye

Powys

OS Landranger
Map No 148
SO 164 413

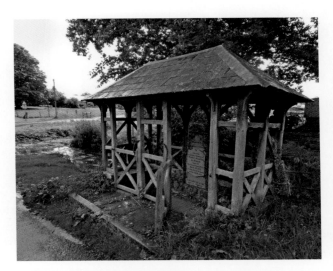

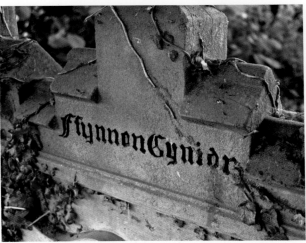

"Draw water out of the wells of salvation."

A 1653 record of a 'Ffynon Kynid' near Glasbury may not be the location of the present Ffynnon Gynidr, dedicated to the sixth-century saint who lived south of here at Llangynidr on the River Usk. What passes today for St Cynidr's Well is hidden under a trapdoor within an elaborately-constructed timber-framed canopy, erected in 1900 to the memory of Walter Fenwick de Winton of nearby Maesllwch Castle, who was "killed in action" in Africa in 1892.

This possible migration and redefinition of a holy well is a constant feature of all wellspring history (like everything else associated with religion), as we reinterpret the waters' meanings to satisfy our changing needs and understandings.

Top
The wooden wellhousing has the unusual
feature of gates in and out

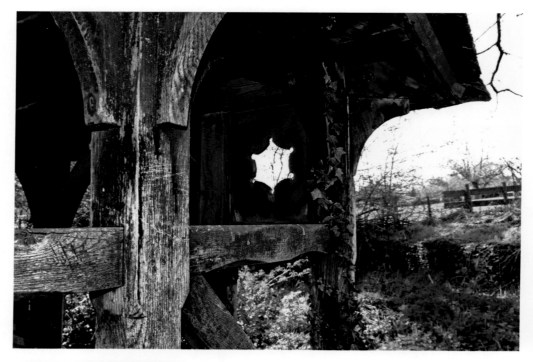

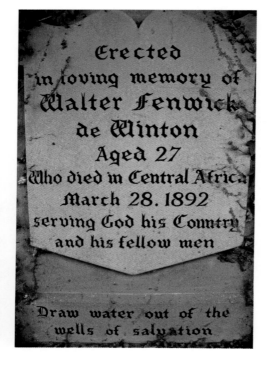

Erected
in loving memory of
Walter Fenwick
de Winton
Aged 27
Who died in Central Africa
March 28. 1892
serving God his Country
and his fellow men

Draw water out of the
wells of salvation

Above & Left
The star symbol appears regularly in the
design of holy wells throughout Wales.

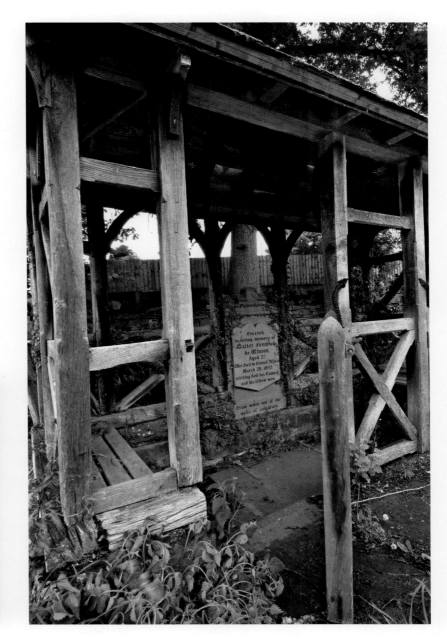

Right
Health and Safety strikes, covering the well
with a plain plank of wood.

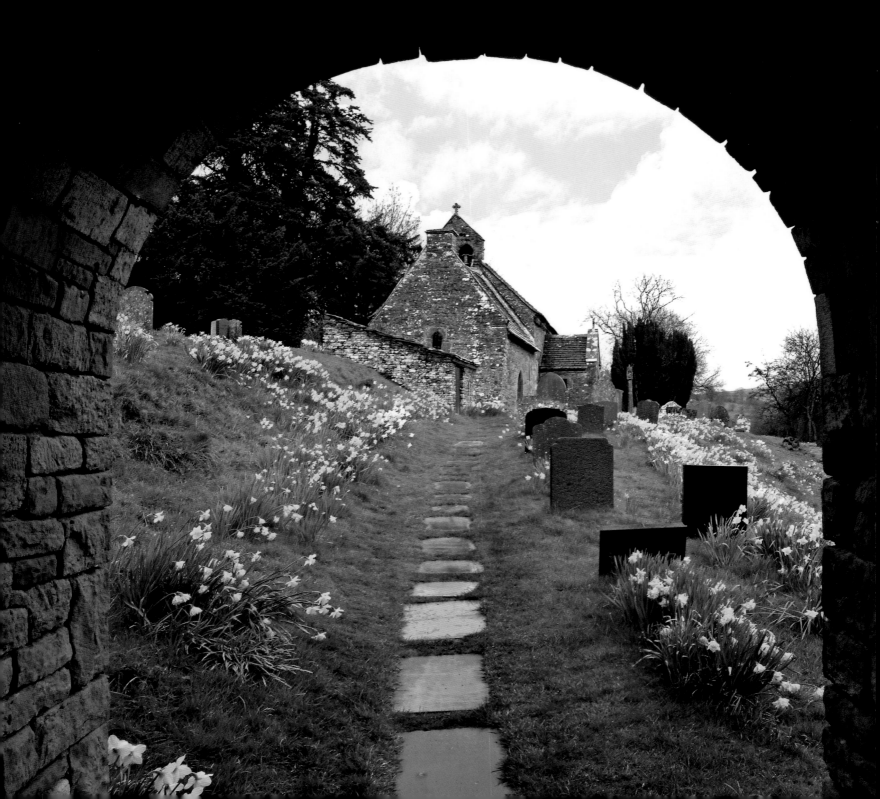

Partrishow

near Abergavenny

Monmouthshire

*OS Landranger
Map No 161
SO 282 225*

Ffynnon Isho
St Issui's Well

St Issui was a hermit who established his cell here in the Vale of Ewyas in the Dark Ages. Issui's Well, on the riverbank of Nant Mair ('Mary's Brook') in the beautiful Gwyrne Valley, only became curative after the saint was murdered by an ungrateful traveller for whom he had provided in his cell, and who subsequently dumped his body in its waters. (The name Partricio is thought to come from the Welsh '(m)erthyr' – meaning 'martyr' – and 'Ishow'.) From that day on, the well became a magnet for pilgrims seeking nourishment for both body and soul.

In the eleventh century, it was recorded that a French visitor successfully washed away his leprosy here and, in gratitude, was happy to pay "a hat-full of gold" for the first church to be built above the well. Today, votive coins are still offered, though in less abundance, now hammered into trees as a new form of contract with the spirit world – a payment in lieu of a hoped-for gift of healing or insight.

Above
A modern pilgrim's votive coin offering

Opposite
Lychgate entrance to the graveyard
and church of St Issui the Martyr

81

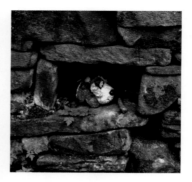

Left
Soft toy offering in well niche

Far left
The holy well, garlanded with crude hand-made wooden crosses of all shapes and sizes

Patricio 2001

*They have been bringing offerings
to the dark well, tying
rags to twigs in supplication, leaving
flowers to wilt in the chipped glass
uneasily perched on a dank ledge,
making crosses from bits of stick.*

*There seem so many of them, despite
the hiddenness of the place; as if
in a time of fear and hattering
these humble shapes are once more
valid – raw letters spelling out
helplessness, not yet
reshuffled into words of power.*

Ruth Bidgood
New and Selected Poems
(Seren, 2004)

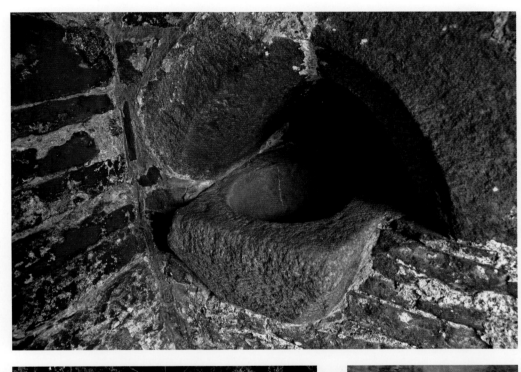

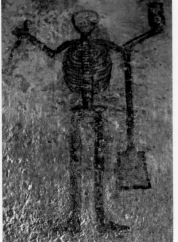

Top
Font in church porch

Right
The elaborately carved twelfth-century
Preacher's Cross at St Issui's church

Far right
The skeletal 'doom' figure armed with
spade and hourglass

Above
Molly at Ffynnon Isho

Opposite
St Issui's church and sloping field leading
down to the saint's holy well

Remains of Issui

My ochre is easily dug from the field,
my green from the finch's wing
when Spring is curative.

Lepers,
come.

Come everyone with rotten purse-strings
> *here on the rood-loft*
>> *vine-leaves sprout from the dragon's mouth,*
> *the dragon sucks*
>> *the shoots of vine –*
and find a hatful of gold on the hilltop:
stems and shoots to boil for colour;
ink from Issui's lamp-soot.

Come
to this, the Blue Hole –
> *below the sky, the hill,*
> *below the hill, his well;*
the warm-honey smell
> *of sawn grain,*
a heron,
perched beyond his cell.

Says Issui
to every leper:

come,
consumptives, paymasters, singers with rotted strings,
to where the ash and the holly break
> *from the dead bole of the yew*
> *– the leper's body:*
>> *clumps of hard red wood in knee and brow,*
> *spurts holly,*
>> *shining ash –*

and ask for a fish from the heron's bill.
No traveller leaves unwashed, unfed;
one may kill, another bequeaths
a hatful of gold
> *to build a church for Issui*
>> *up the hill.*

Vine-leaves sprout from the dragon's mouth,
the dragon devours
> *the limbs and veins of the vine.*

Says Issui:
my ochre is easily dug from the field,
my green from the woodpecker's wing,
my black from lamp-soot,
come

and see.

My toes may bump the crimson bones of the twisted yew,
my hair be snagged on fence-wire,
still my fingers burn this hole in the blue;

you lepers,
pursers,
hydrophobes,
verbicides,
come and feel.

Says Issui,
hear:
> *– comes*
> *the singer*
> *goes –*

his glee is struck from a fret of black and gold.

Graham Harthill

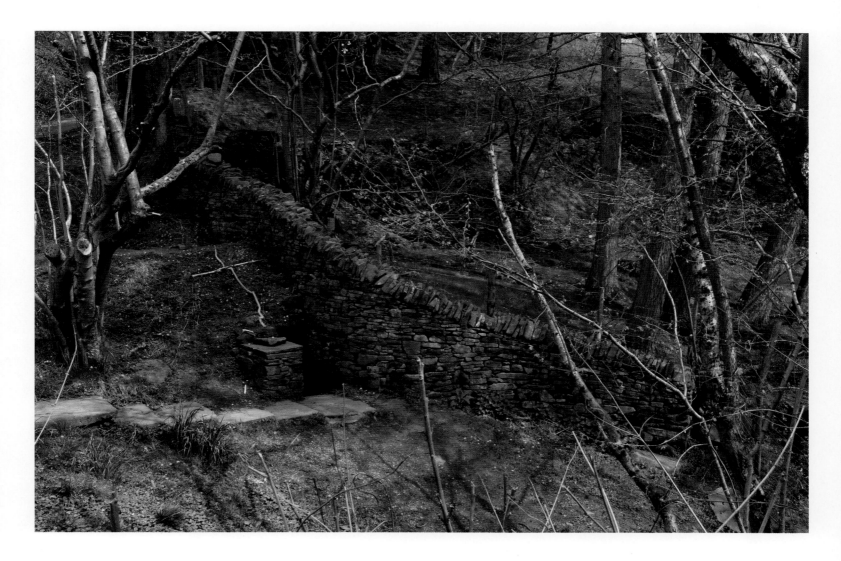

Above
Site of Ffynnon Isho, below the church,
and on the bank of Mary's Brook

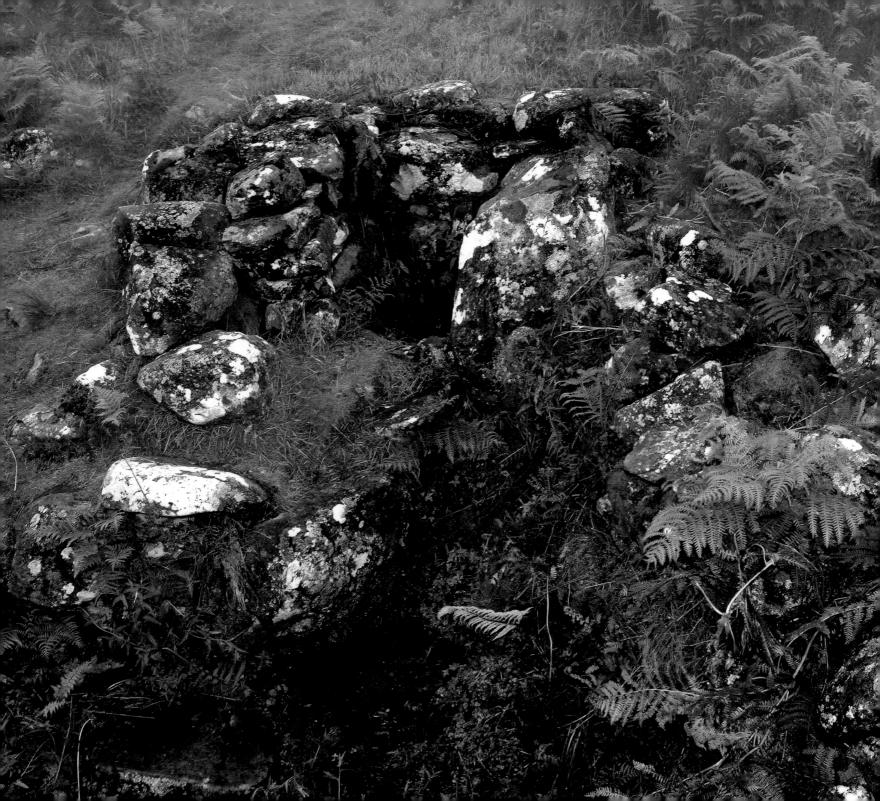

Ffynnon Enddwyn
Enddwyn's Well

near Dyffryn Ardudwy

Gwynedd

OS Explorer
Map OL18
SH 614 255

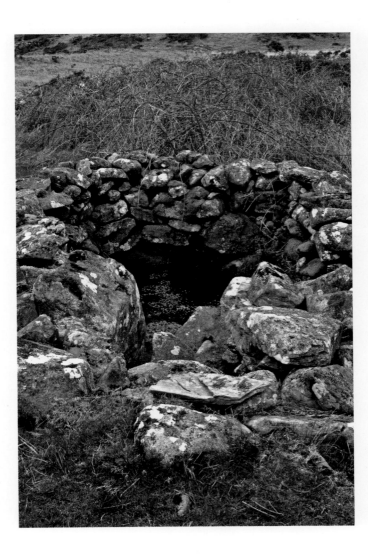

Most of my visits to the remote and impressive lichen-walled Ffynnon Enddwyn, situated in hills overlooking Tremadoc Bay, some 700m above sea level, have found the well shrouded in mist, giving the site a magical and dramatic feel, well worth the considerable effort of getting there.

Little is known of the female St Enddwyn: her feast day and even her gender are open to question. She was said to have been cured of an illness here after bathing in this spring, a custom adopted by countless other pilgrims in the years that have followed. The well's speciality seems to have been the relief of skin diseases, sore eyes, arthritis and scrofula (a form of tuberculosis) for which the water was drunk as well as applied directly as a poultice.

Opposite
Ffynnon Enddwyn, with views over Tremadoc Bay

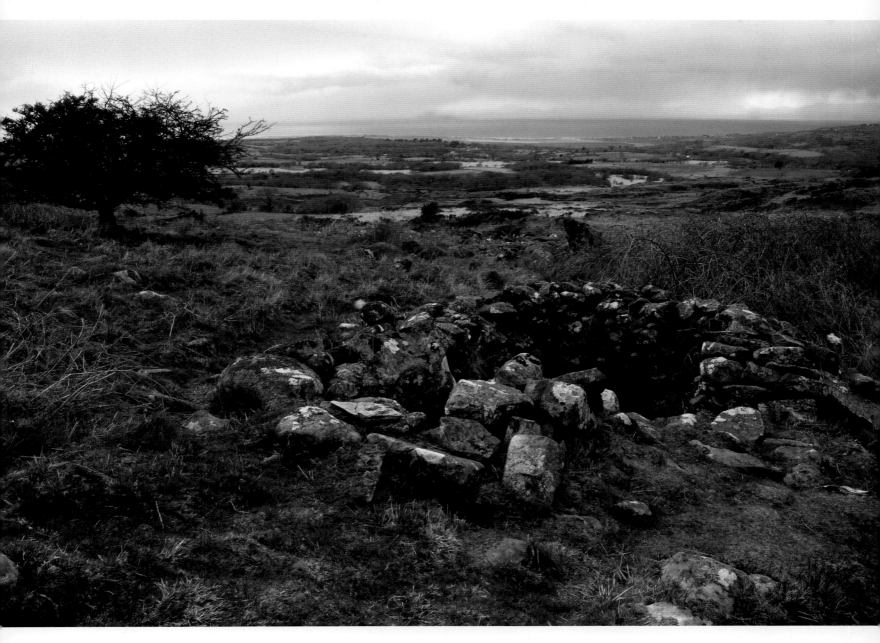

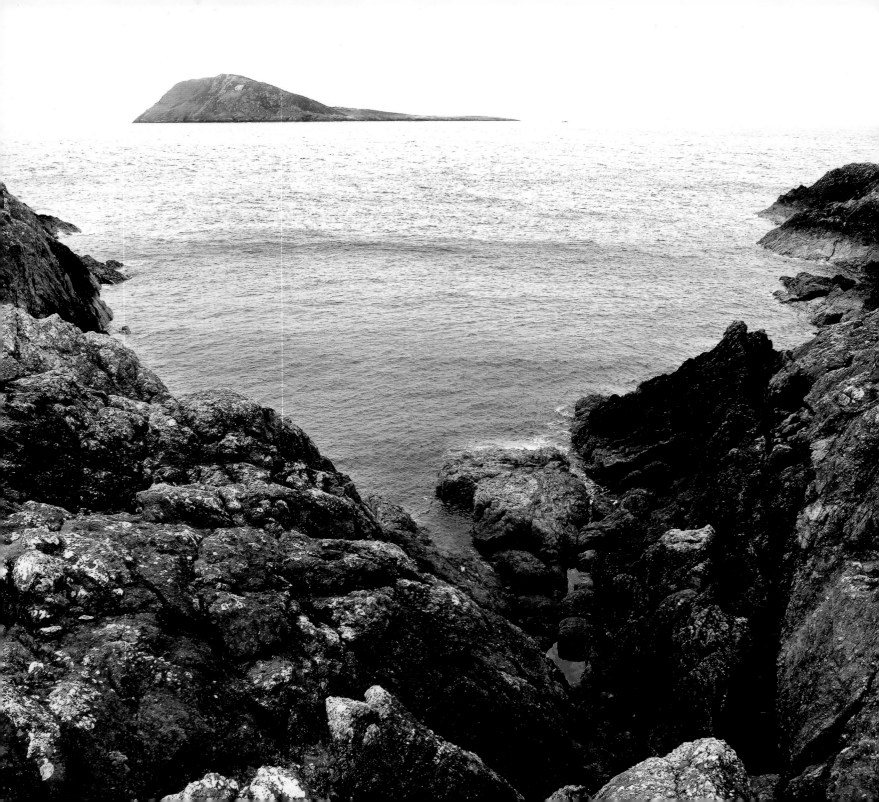

Ffynnon Fair
St Mary's Well

near Aberdaron

Lleyn Peninsula

Gwynedd

*OS Explorer
Map No 253
SH 139 252*

Opposite
The sacred island of Enlli (Bardsey)
from Ffynnon Fair

Below
Ffynnon Fair and the sea below

One of the most dramatically-situated of all of Wales' holy wells, Ffynnon Fair's natural basin is perched precariously among cliffs above the sea on the very tip of the Lleyn Peninsula, accessed only via a steep and slippery rock climb down Grisiau Mair or Ysgol Fair ('Mary's steps' or 'Mary's ladder'). The well is regularly covered by the tide but miraculously returns to its pure water state after each salty ingression. The ruins of the chapel of St Hywyn, a follower of St Cadfan, sit in the field above, overlooking the sacred island of Enlli (Bardsey), the final destination of many pilgrims who stopped and rested here.

Neither cures nor wishes were easy to gain here, however. The ritual involved taking a mouthful of liquid from the spring below, climbing up the rocks, and then walking around the chapel without spilling any of the water – a feat that seemingly could not have been achieved by any but the already fit and healthy.

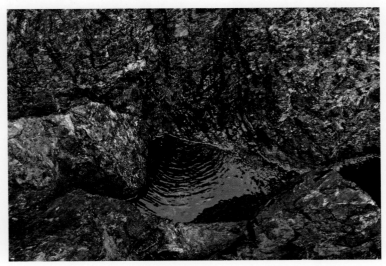

Ffynnon Fair

Grief has led her here
in its hooded goatskin cloak.
with its crooked staff,
its cussed devotion.

She stutters
down Grisiau Mair, each step
a slippery syllable on the stuck-out tongue
of cliff. The sea is a whip
that means to increase her suffering,
while Bardsey belongs to a bestiary,
hump-backed hulk, jaws frothing.

She supposes she should pray
but doesn't know the language –
and anyway, her voice is taut
as oxhide stretched
over a timber frame, unsteadied
by eddies of pain.

She turns, instead, to the well's whisper
of water, tinged
with a wish-glint of silver coins.

It will take more than one sip
to dispel her accidie
but already she can sense the squint
of a fresh beginning, the twitch
of a shearwater's wings.

Susan Richardson

Above
Stone sculptures left by modern-day pilgrims near the
ruins of the chapel of St Hywyn, above Ffynnon Fair

Opposite top left
The site of St Hywyn's chapel overlooking Bardsey Island

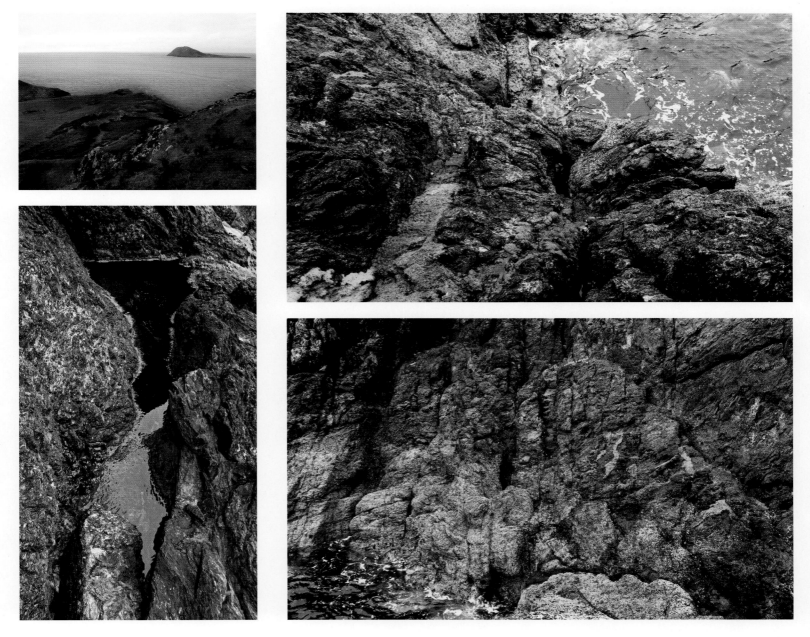

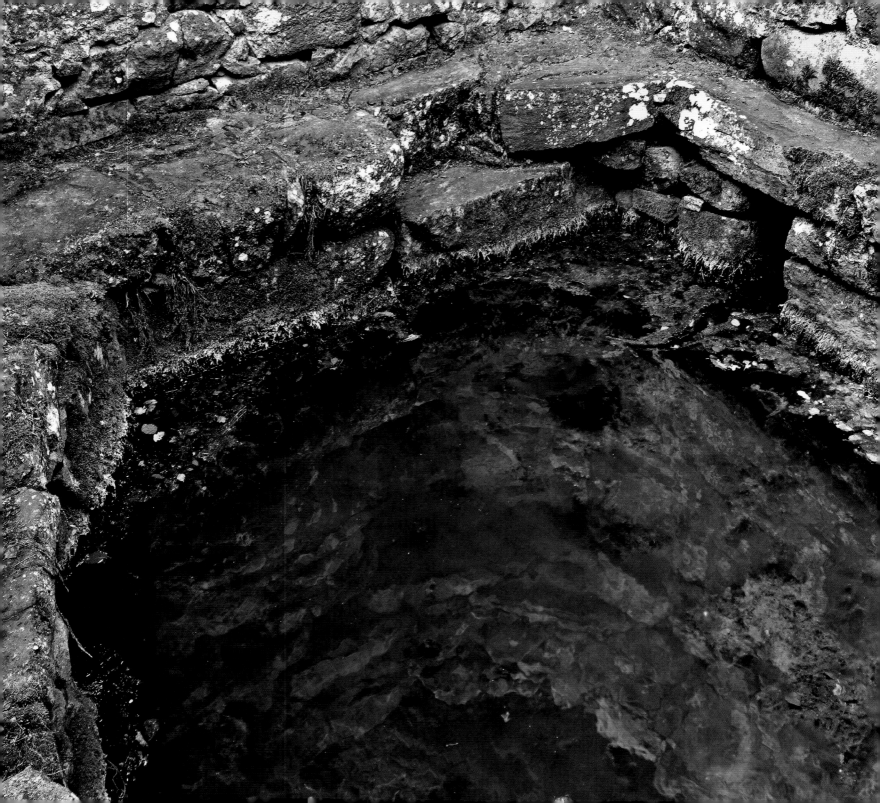

Llangybi

near Pwllheli

Lleyn Peninsula

Gwynedd

OS Explorer
Map No 254
SH 427 413

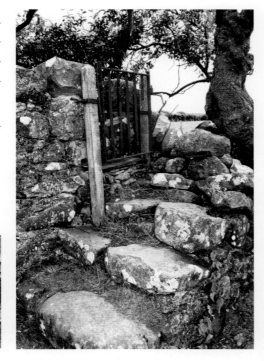

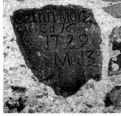

Above
1729 gravestone set into the
walls of the holy well

Opposite
Ffynnon Gybi pool, which
appears infinitely deep

St Cybi is reputed to have been born in Cornwall and died on the island of Holyhead in 555AD. He must have been a great traveller because he is said to have visited Ireland, the Holy Land and Rome, as well as most parts of Wales, the latter fact attested to by the number of wells and chapels that bear his name to be found in places as far apart as Gwent, Pembrokeshire, Mid and North Wales, and here on the Lleyn Peninsula.

Legend has it that the Lleyn well was created when the saint struck his staff on the ground. What remains is an ancient stone-walled spring and adjacent larger well chamber for bathing, plus a later caretaker's cottage built around 1750 where the well guardian would have lived, as well as a privy for the relief of pilgrims.

Cybi's waters cured warts, lameness, blindness, tumours and rheumatism. One of the treatments here demanded the drinking of well and sea water in equal measures, then bathing in the well and sleeping the night in the adjacent cottage. This act of incubation was thought to attract the saint back to his well to activate the healing process.

In addition to St Cybi's alleged curative properties, the well was believed to have had the power to foretell the romantic intentions, or otherwise, of men. On the eve of the pagan festival of Beltane, women dropped handkerchiefs or feathers (or sometimes even slices of bread) into the larger of the two pools and closely studied the direction in which they floated – southwards indicating their lover's future constancy, northwards his potential for infidelity.

Another belief associated with Ffynnon Gybi was that a cure would be successful if the large eel that was present in its waters coiled around a bather's legs. The well was said to have lost its power when someone removed the creature.

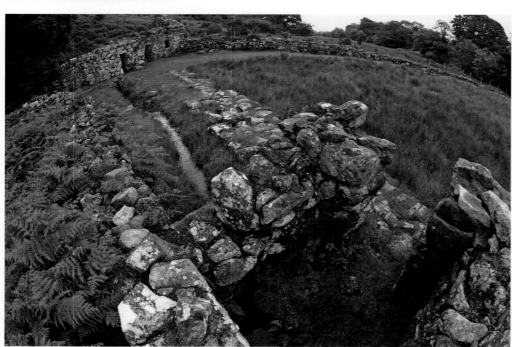

Opposite
The huge mortar-less stone construction of Ffynnon Gybi

Bottom left
The pilgrims' privy, with the well guardian's cottage in the background

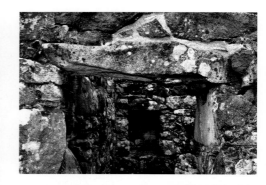

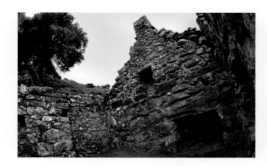

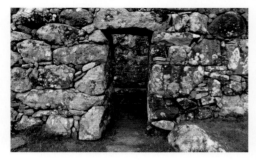

Ffynnon Gybi

Holy saint Gybi,
by your sacred well,
by your mercy to lovers, I ask
with the ancient ritual of divination,
spreading my handkerchief on the waters,
to float towards blest south or cursed north –
is my man honest, or will I weep?

I pray my offering
drifts to the south.
Oh God! It floats north!
No, no, there are leaves in the well –
I free them, nudging it south.
Wind in the gorse all around
sounds prickly and dry,
like an old man's laugh.

Ruth Bidgood
(previously published in *Poetry Scotland*)

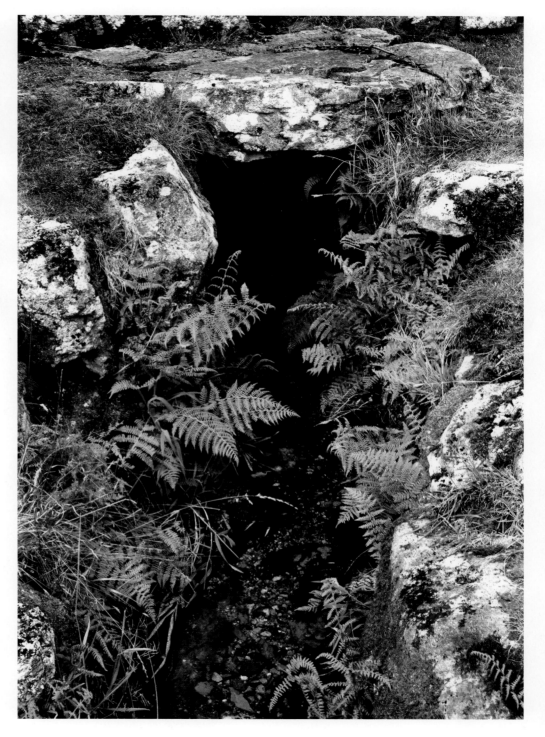

Ffynnon Wnda
Wnda's Well

Llanwnda

near Fishguard

Pembrokeshire

OS Landranger
Map No 157
SM 932 396

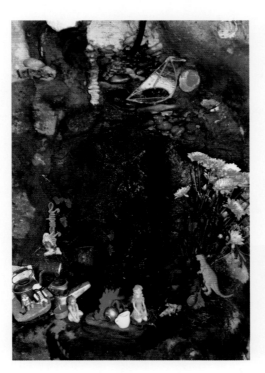

St Gwyndaf, "an irascible Breton", was a sixth century associate of St Aidan … until they fell out. It was reported that Gwyndaf, after a quarrel with Aidan, cursed the stream he was crossing not far from Fishguard when he broke his leg after being thrown from his horse, which was startled when a fish suddenly leapt from the water. The stream never again supported fish.

Ffynnon Wnda and Llanwnda, the well and church dedicated to the saint, were major resting places on the pilgrim road to Saint Davids, particularly for those arriving by boat from Ireland.

St Gwyndaf eventually retired to Bardsey Island, considered to be the burial place of 20,000 saints, where he died.

Above
Offerings decorating a fountain built into the fireplace at ecology charity usEnergy's offices in St Gwyndaf's Cottage next to the church and well

Opposite
Ffynnon Wnda

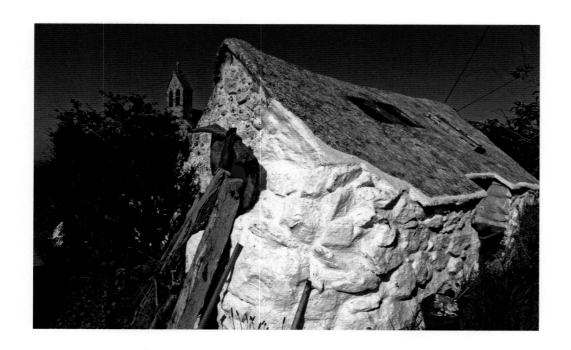

Left
St Gwyndaf's Cottage – usEnergy's base

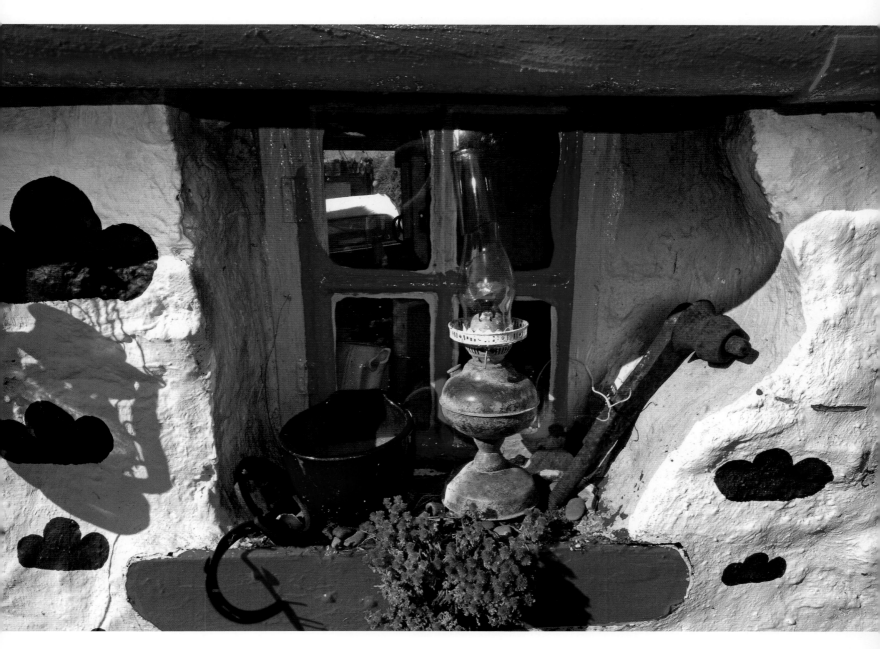

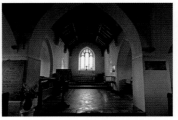

Above

A little way along the coast from
Llanwnda, on the cliffs above the sea at
Carregwasted Point is a memorial stone to
mark the place where the last invasion of
Britain took place

Above

St Gwyndaf's Church

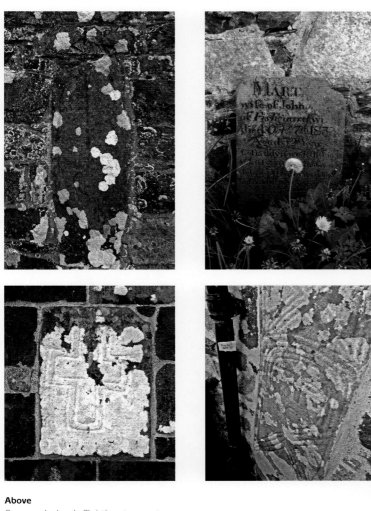

Above
Cross-marked early Christian stones set
into the church walls, uncovered during
restoration work in 1881

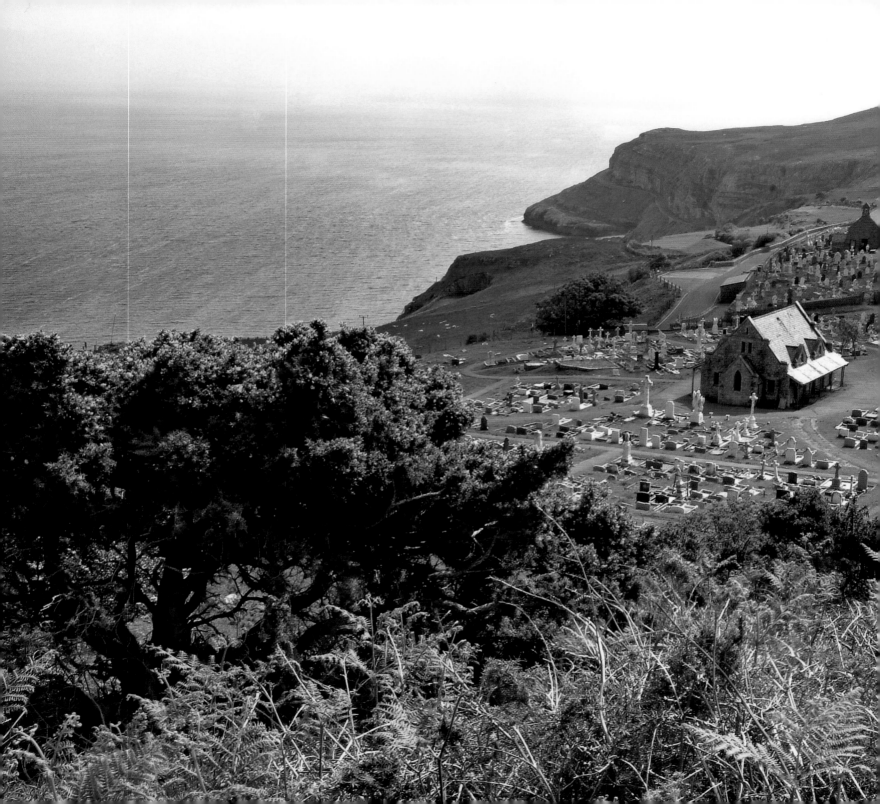

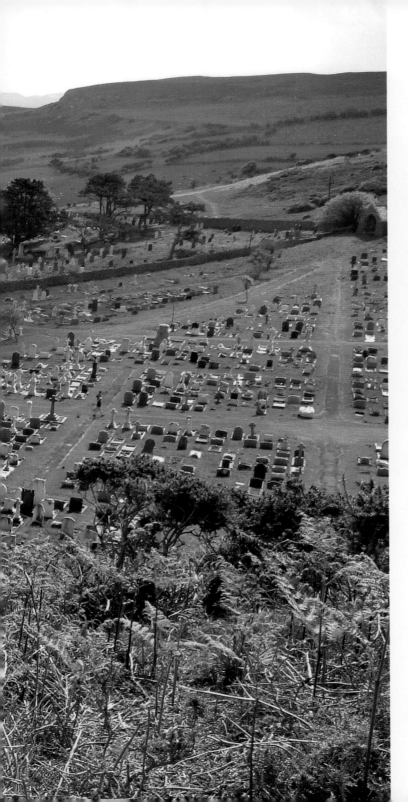

Ffynnon Tudno
St Tudno's Well

Great Orme

near Llandudno

Conwy

*OS Landranger
Map No 115
SH 771 838*

St Tudno was a Welsh sixth-century Christian hermit who lived in a cave, Ogof Llech, on the Great Orme on the North Wales coast. It was he who gave Llandudno its name. He is thought to have been buried with so many of his religious colleagues on Bardsey Island.

Although his holy well is situated a mere stone's throw from the site of the church he built (now occupied by a more modern construction), it is well hidden in the undergrowth, neglected by all except the very persistent pilgrim.

Left
St Tudno's Church, chapel and extensive graveyard on the Great Orme

Above
The rectangular trough that would have
been used for baptisms

Top left
The spot where the waters issue from
the mountainside

Left
Crucifix, St Tudno's church

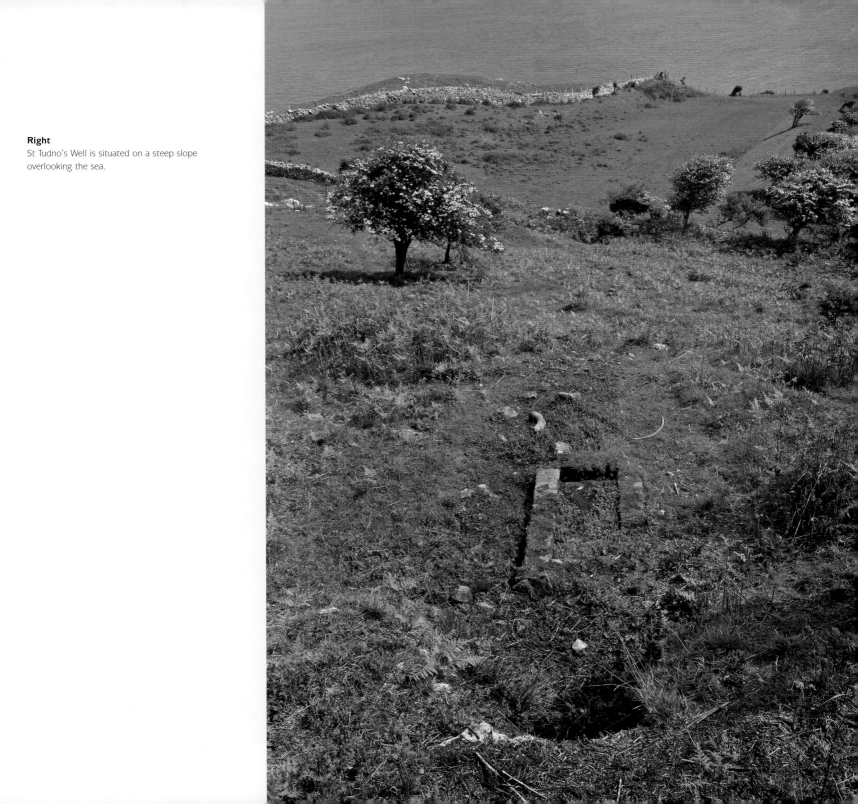

Right
St Tudno's Well is situated on a steep slope
overlooking the sea.

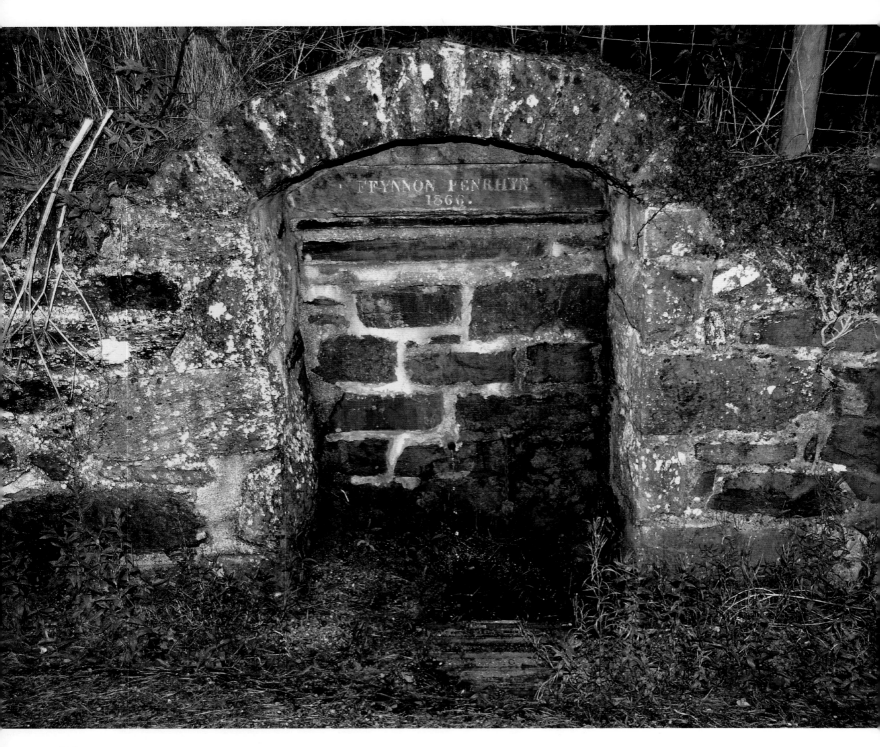

Ysbyty Ifan

near Betws-y-Coed

Conwy

OS Landranger
Map No 116
SH 842 488

Ffynnon Penrhyn
Lord Penrhyn's Well

Hospitium Sancti Ioannis was the ancient hospice founded at Ysbyty Ifan by the Knights of the Hospital of St John of Jerusalem to provide a place of safety, rest and refreshment for pilgrims travelling throughout Wales.

In later years, the spring here was known by local people simply as Pistyll-y-Llan, the parish fountain, until, in 1866, it was renamed Lord Penrhyn's Well by the wealthy slate, sugar and slave master of Penrhyn Castle near Bangor. The well was part of the model hospital village he established here to care for the ailments of his slate and farm workers, seemingly continuing the work of the Knights of St John but now with the maximising of profits through keeping his workforce strong and healthy uppermost in his mind.

Below
The historic village of Ysbyty Ifan

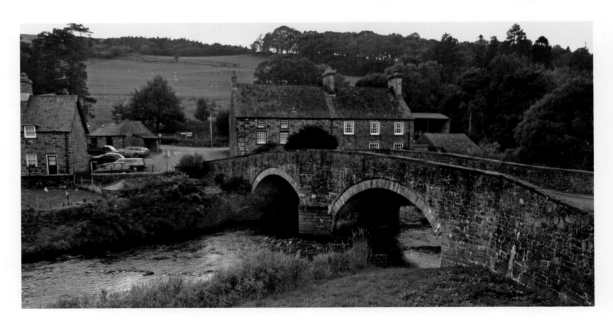

The Old Water

The old water keeps flowing
Leaving its fluid signature as we fret and fight
To give it a title and a purpose
Reflecting our changing ambitions.

Cleanser, quencher, irrigator, housebreaker
Vapour, steam, ice and stream
Ffynnon, fountain, force and flood
Cloud and rain, wave and blood,

As it rushes, falls, bubbles, spits and flows –
From pagan Mother to Christian saint
And therapeutic bath –

Only the water knows its name.

Phil Cope

Top left
The terraced workers' cottages
at Ysbyty Ifan

Bottom left
Discarded roof slates

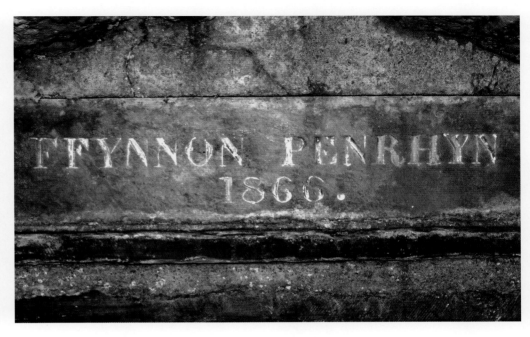

Right
The River Conwy running through
Ysbyty Ifan

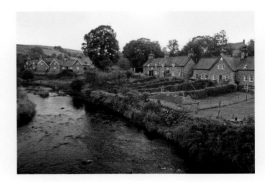

Derwen

near Ruthin

Denbighshire

OS Landranger
Map No 116
SJ 064 515

Ffynnon Sarah
Sarah's Well

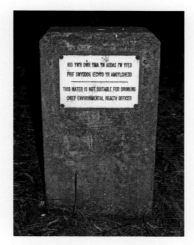

A well promising relief from rheumatism, skin diseases and cancer, Ffynnon Sarah lies peacefully within a grove of holly bushes and conifer trees beside the Mynian Brook whose trickling, gurgling music provides the soundtrack to every visit. Believers would fully immerse themselves in the waters here and offer pins to the well or money to the well-keeper to increase their chances of a successful cure. A guardian's cottage, burned down in 1860, once stood within the grounds.

The well is actually thought to be dedicated to the Irish saint, Saeran, Saeron or Saran, whose name seems to have been corrupted locally to that of Sarah. Saran was a missionary who travelled in this area of Clwyd in the sixth century. Her well was on the old Pilgrims' Way from St Davids in the south-west to Holywell in the north-east.

Top left
Health and Safety meets the holy wells
of Wales again!

115

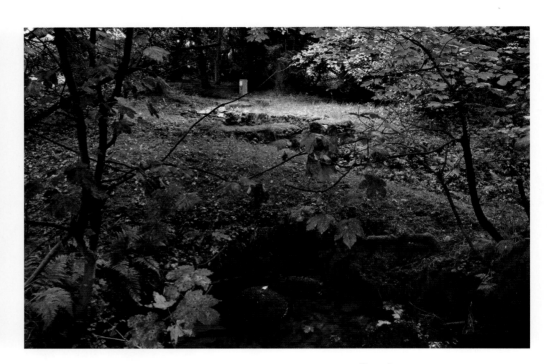

Opposite
The extensive deep pool of Ffynnon Sarah

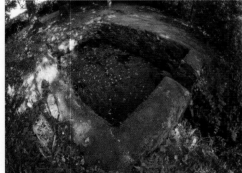

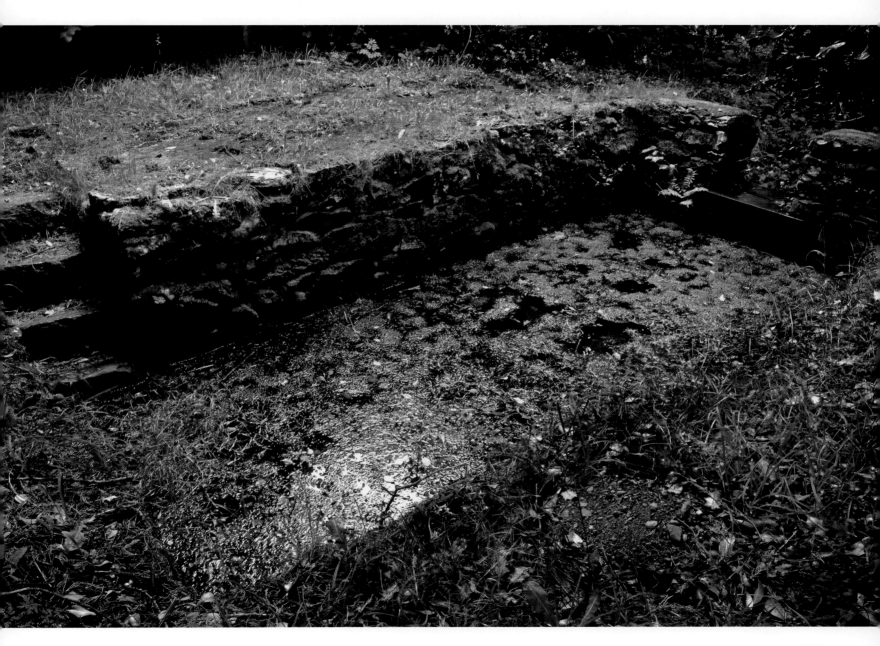

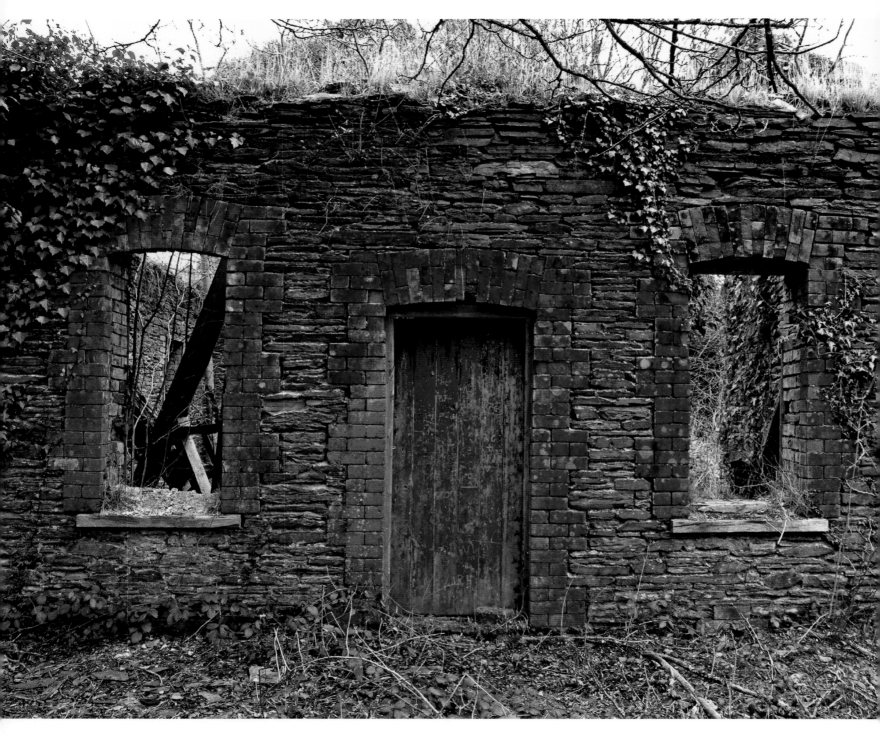

Ffynnon Ddurol Llangamarch
Llangammarch Spa

Llangammarch Wells

near Builth Wells

Powys

OS Landranger
Map No 147
SN 945 476

The sulphur and bromide spring situated on the banks of the river Irfon at Llangammarch was believed to have been 'discovered' in 1837 by a local farmer searching for a lost pig. The animal was eventually found wallowing in a muddy unpleasant-tasting pool, the medicinal value of which was later recognised and publicised far and wide. The water was unique in containing large quantities of barium chloride in its solution, particularly beneficial it was thought for the heart, the circulation and the complexion.

The 'discovery' transformed an ordinary Mid Wales village into a destination of choice for the rich, including European royalty.

The red-brick roofless ruins of the bath-house and pump room are sadly all that now remains of Llangammarch Spa's years of splendour, although the nearby Lake Hotel still has its water pumped to its rooms.

Opposite
The ruins of the once-thriving
Llangammarch Spa

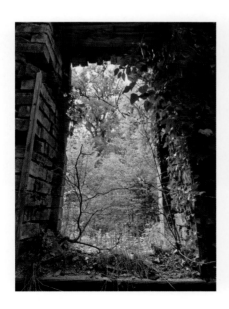

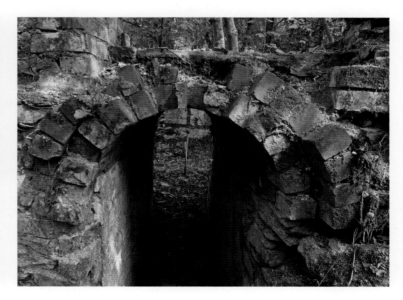

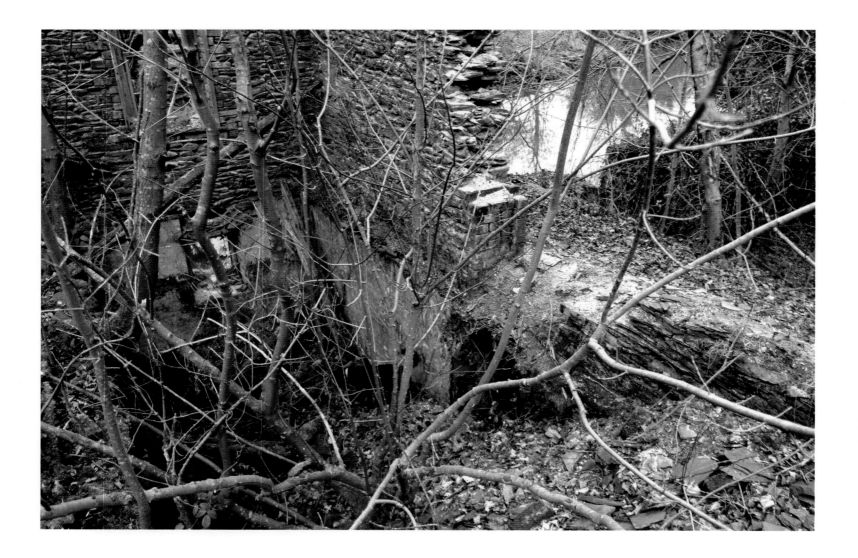

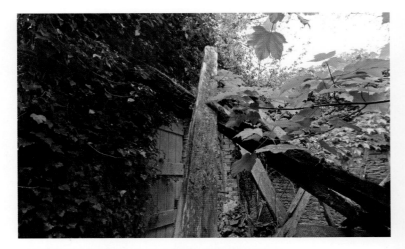

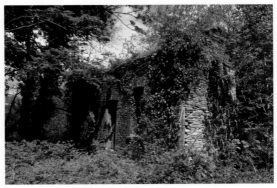

Opposite
All that remains of the spa house

Right
Broken and discarded bathtub at
Llangammarch

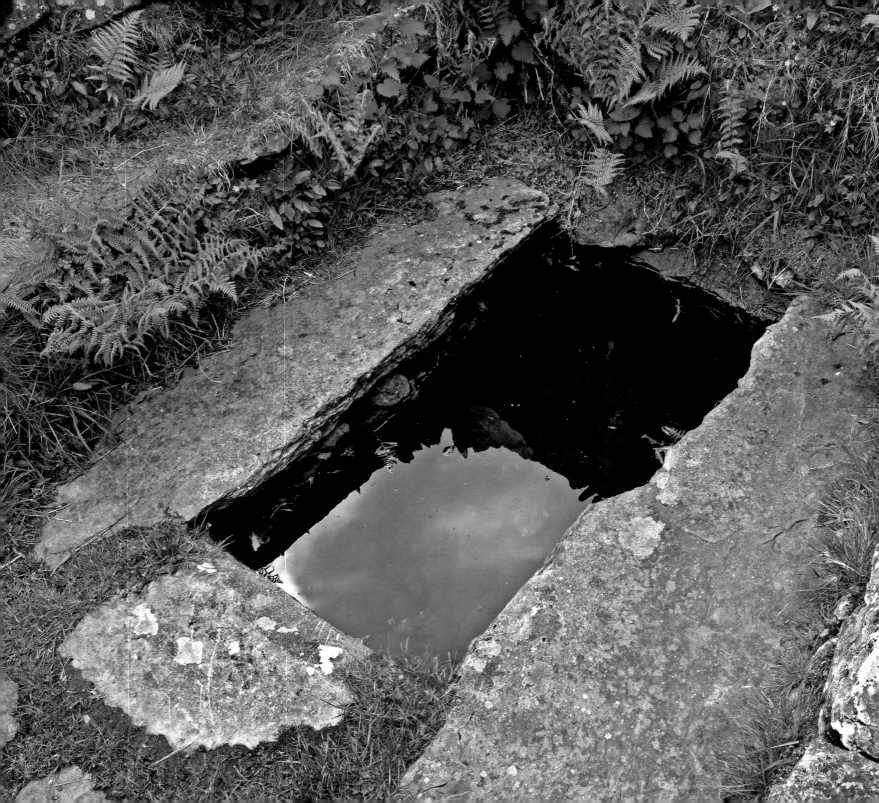

Ffynnon Gelynin
St Celynin's Well

near Conwy

Conwy

OS Landranger
Map No 115
SH 751 738

Opposite
St Celynin's well pool

The chapel and well of St Celynin, another sixth-century holy man, is hidden high up in the mountains above the Conwy Valley in one of the most isolated and peaceful positions of any chapel in Wales. The well, set into the south-west corner of the churchyard wall, specialised in treating sick children who were immersed in its waters. The success or otherwise of the cure could then be judged by placing an item of the child's clothing on the water: if it floated, the child would recover; if it sank, then the cure had failed and the child would most probably die.

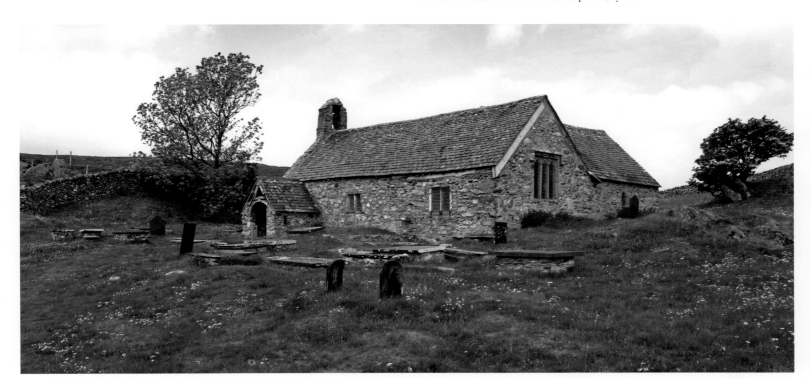

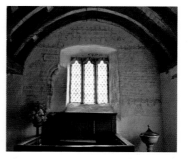

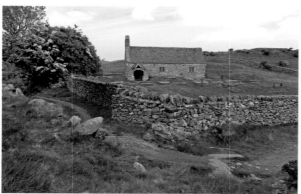

Above
"Fear God and honour the King"
wall painting, St Celynin's church

Left
The present church of St Celynin dates
from the twelfth century. The well stands
in the corner, foreground.

Top
The elaborate inscriptions behind the altar
are in English and Welsh.

Above
Holy water stoup

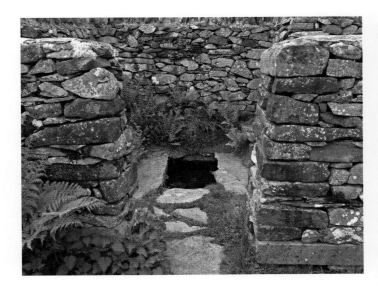

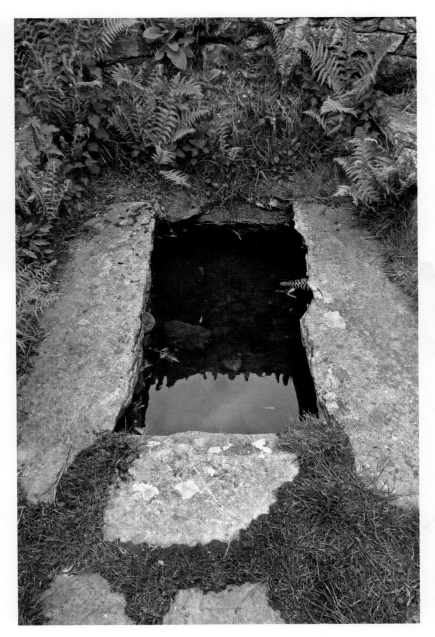

Top
Entrance to Ffynnon Gelynin built into the
churchyard's outer walls

Above
Skull-and-crossbones symbol, a reminder
of the inevitability of death, painted onto
the walls of the church

Llanwrtyd Wells

Powys

*OS Landranger
Map No 147
SN 872 470*

Ffynnon Ddrewllyd
Dolycoed Spa Well

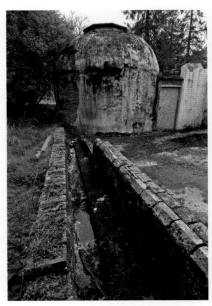

Top right
The unusual circular-domed spa house building

Bottom right
Remains of the spa house floor

Opposite
The milky-white well waters that issue from Ffynnon Ddrewllyd

Although the medicinal properties of Ffynnon Ddrewllyd – another 'stinking well' due to the very strong presence of sulphur within its waters – were most fully exploited during the mid-nineteenth century spa era, knowledge of the spring's ability to provide cures, particularly for ailments of the muscles and joints, was recognised many centuries before.

The rather-unlikely story is told of a local vicar, the Rev Theophilus Evans, who suffered among other things from scurvy. One day, in 1732, he witnessed a toad bathing in a roadside puddle and, noting the animal's extreme good health, decided to drink some of the same water ... and received an immediate cure! This, it is said, was the spur for the major investments that followed, with the building of pump rooms, bathhouses, luxury hotels and guest houses, transforming this once very ordinary rural hamlet into a prosperous centre for the health pilgrim.

The elaborate spa buildings are reached via a splendid avenue of trees, wide enough for horse-drawn coaches to carry their ailing patients to the treatment rooms.

The well water itself is white in appearance, created by the precipitation of certain minerals. The impression of what looked like milk issuing from a natural spring was not uncommon: it was said to have occurred at St Winefride's Well in Holywell (see pages 212-219) for three days after the saint's death, as well as at St Illtyd's Well on Gower and Ffynnon Cegin Arthur (the Well of Arthur's Kitchen) in Llanddeiniolen parish in Gwynedd. In pagan times, the outpouring was thought to be a gift from the breasts of the Earth Mother.

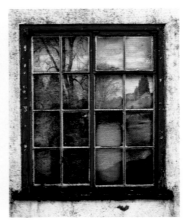

Left
The Dol-y-Coed Hotel started life as a humble farmhouse, but was modernised and extended in 1735 to satisfy the every need of the wealthy spa visitor.

Opposite Bottom
The wide tree-lined avenue leading to the spa buildings

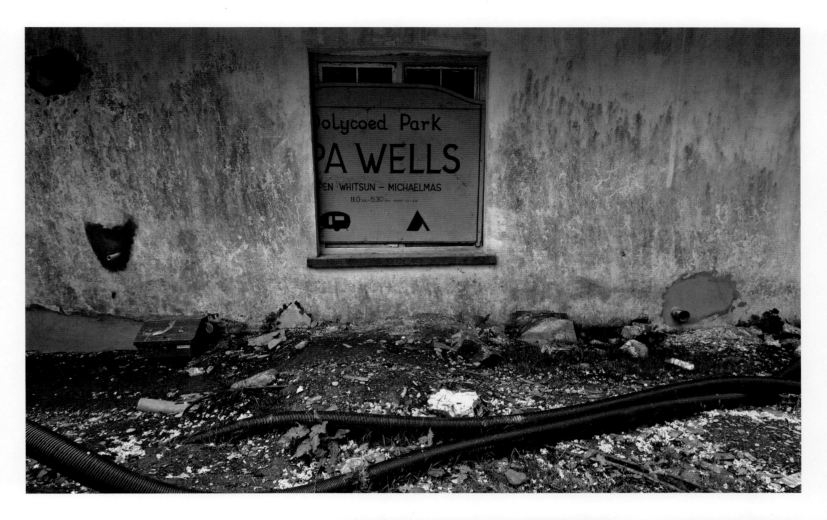

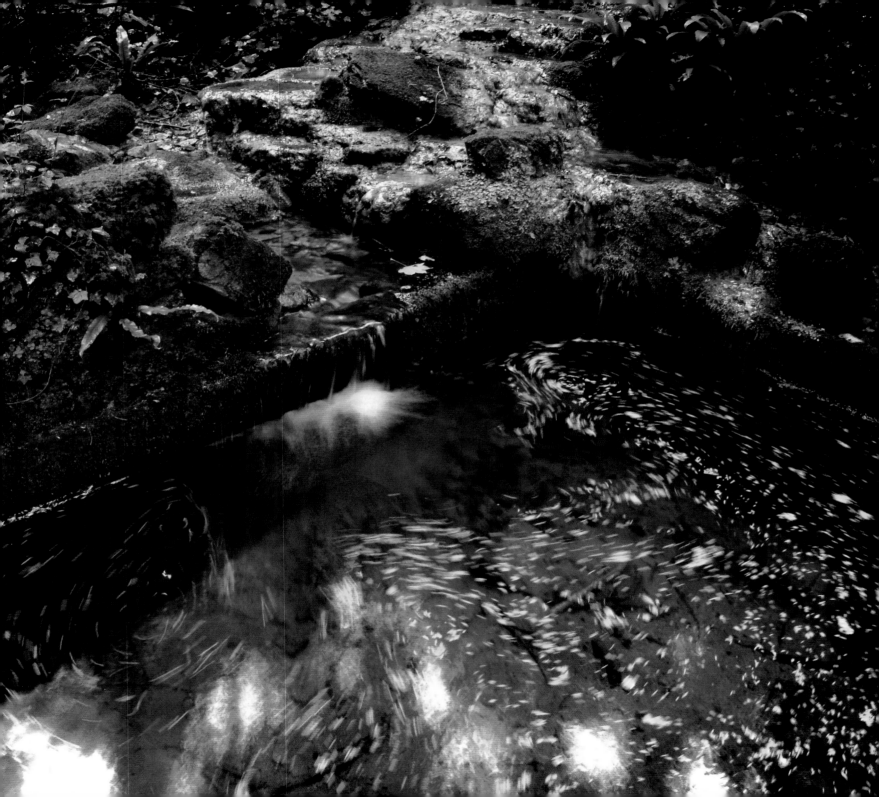

Ffynnon Ddyfnog
St Dyfnog's Well

Llanrhaeadr

near Denbigh

Denbighshire

*OS Landranger
Map No 116
SJ 081 633*

The oblong eighteen-inch-deep pool of St Dyfnog's Well is filled by a number of springs that flow from the hillside at the head of its beautiful tree-lined little valley.

St Dyfnog was the Welsh confessor of the Caradog family, and venerated throughout Clwyd. The story is told that the spring only received its healing powers after the saint stood in its cold waters as a penance for some undisclosed misdemeanour. It specialised in relieving "scabs and itch".

In the eighteenth century, the site was blessed with changing rooms for the many visiting bathers, and the spring was "enclosed in an angular wall, decorated with small human figures" – Thomas Pennant.

Left
Stained glass window, St Dyfnog's Church

131

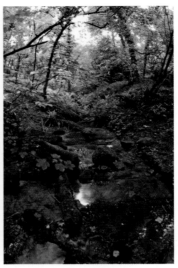

Left

Two of the sources of water that fill the Dyfnog pool

Left

The huge baptismal pool of Ffynnon Ddyfnog

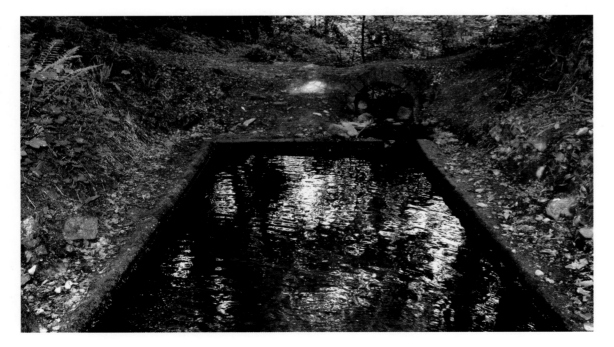

Right & above

William Shakespeare described churches as "sermons in stone", and it was the donations from pilgrims to St Dyfnog's well that helped to build the impressive church dedicated to the saint with its double aisles and its 1533 Jesse window that depicts Jesus's family tree from Jesse, the father of King David, and which is among the most impressive late medieval stained glass windows in Wales.

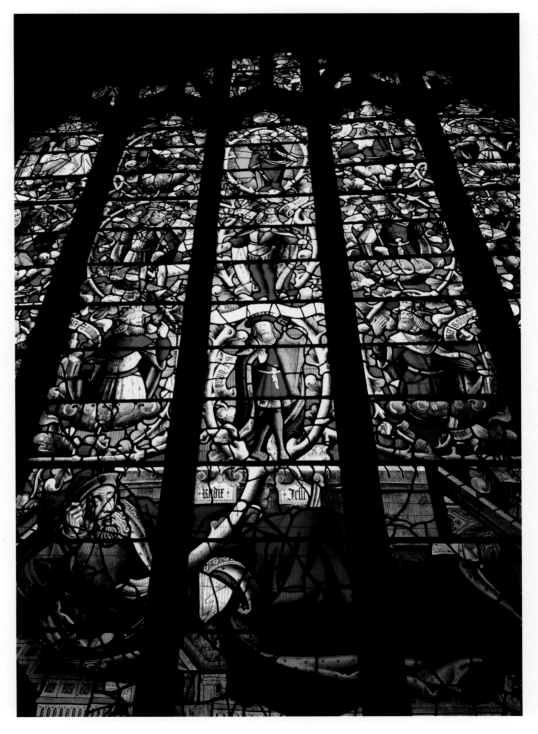

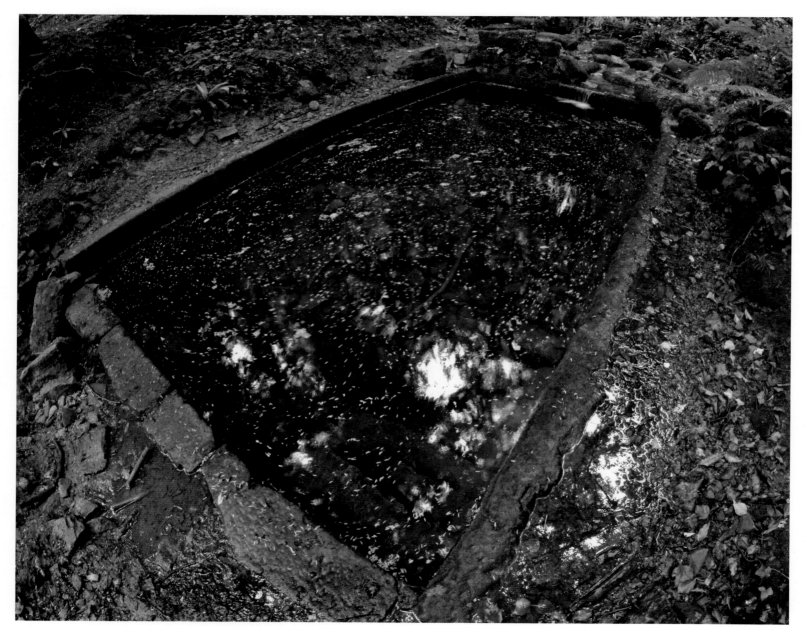

Above
Llanrhaeadr Almshouses 1729
(restored and modernised 1963)

Right
Altar at St Dyfnog's Church, Llanrhaeadr

Below Right
The wooden flower-garlanded porch
of St Dyfnog's church

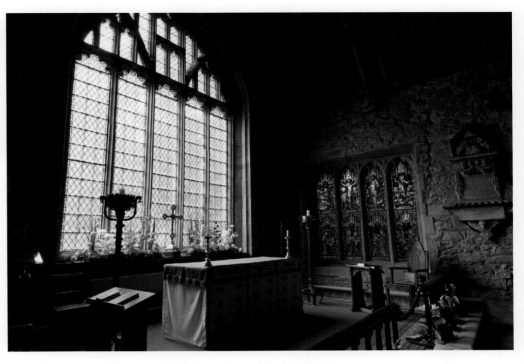

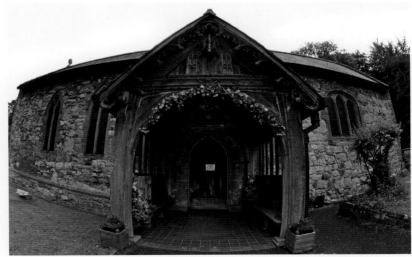

Ffynnon Maen-Du
Maen-Du Well

Brecon

Powys

OS Landranger
Map No 160
SO 038 297

Sleeping peacefully next to a modern housing estate north of Brecon, Maen-Du – a wishing well for lovesick maidens according to Francis Jones – is a hidden gem.

Although the wellhouse's design seems ancient, resembling that of early Irish Christian monastic cells, an inscription on its entrance offers a date of 1754. But this was almost certainly the year of its latest renovation.

A channel runs from the wellhouse to a large circular bathing pool, nowadays usually choked with weeds. The size of the site and of the pool, and the substantially-built wellhouse, suggest the importance of Maen-Du to previous generations.

Left
The waters from Maen-Du wellhouse, shaded in the trees, flow in a winding channel into the large bathing pool now choked with weeds.

Right
Welhouse doorway inscription, 1754

137

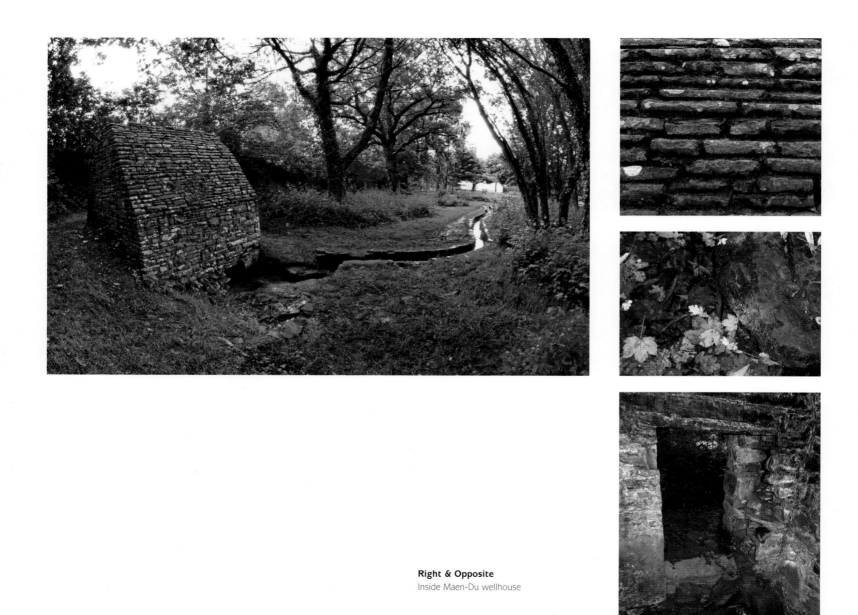

Right & Opposite
Inside Maen-Du wellhouse

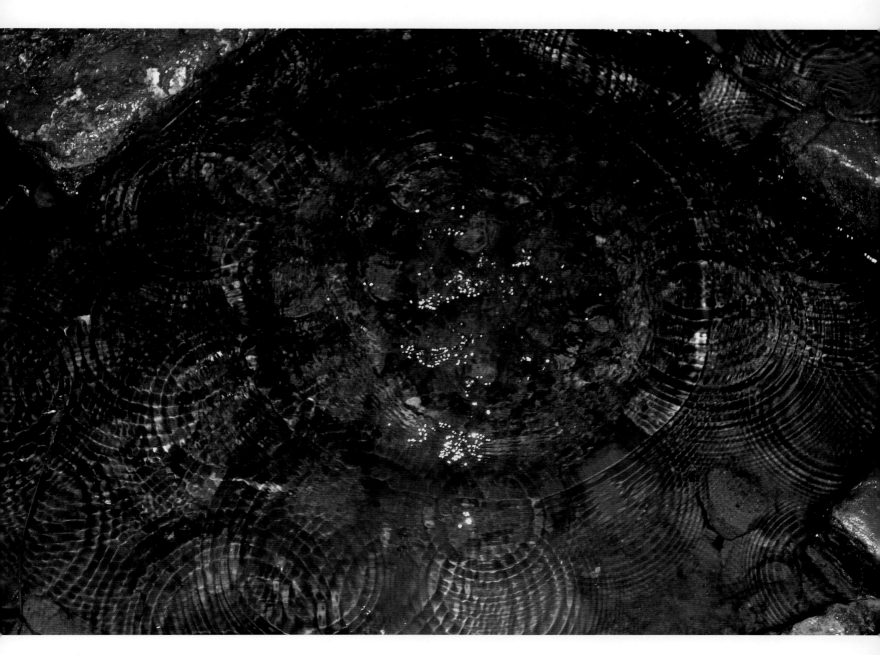

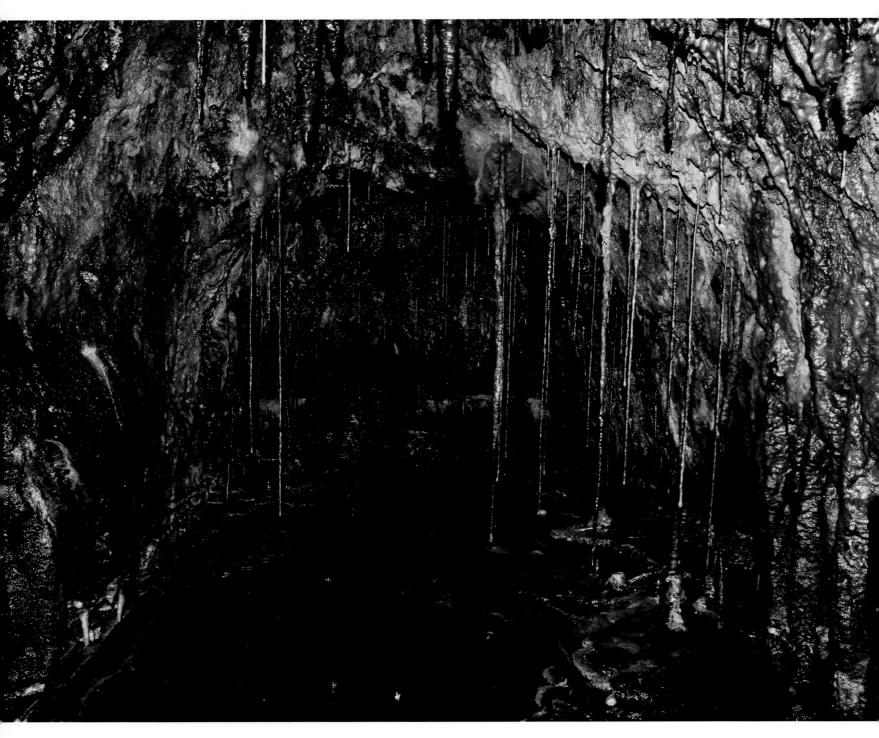

Ffynnon Ddurol Trefriw
Trefriw Wells Spa

Trefriw

near Betws-y-Coed

Conwy

OS Landranger
Map No 115
SH 778 652

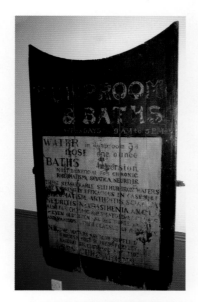

"... inestimable value in the successful treatment of that numerous and obstinately troublesome class of diseases whose Protean powers depend upon a deranged state of the nervous system, caused by a proportional inequality or deficiency in the blood of those inorganic elements which are indispensably required to render the assimilation of nutritive inorganic substances available for the healthy sustenation of the animal machine" Dr O O Roberts of Bangor; or to put it more simply: *"As sulphate chalybeates are the best of all chalybeates, the Trefriw is the finest chalybeate water in Great Britain."* Dr Hayward

The Trefriw springs were believed to have been 'found' originally by soldiers of the XXth Roman Legion billeted in this part of Wales between 190-250AD while prospecting in the zinc, lead, copper, silver and gold-rich hills of the Conwy Valley. Baths, hewn from the bare rock sides, for use perhaps by exhausted or injured soldiers, can still be seen here.

The waters were 're-discovered' during the Victorian craze for health spas and a complex of pump rooms, bath-houses, tea rooms, restaurants and hotels were constructed to accommodate the new visitors to the valley. Situated on the banks of the Conwy River, the chalybeate and sulphur-rich waters of Trefriw ("the Town of Healing") were beneficial, according to T R Roberts, for treating "melancholia, hypochondriacism, indigestion" and "chronic jaundice" (1897). The mineral concentration of the waters here is said to be the highest of all of the springs in Wales.

In those days, the river Conwy was navigable as far as Trefriw, and paddle steamers and other boats ferried the eager health pilgrims from the North Wales resorts of Llandudno, Conwy and Deganwy to 'take the waters'. The coming of the railway to Trefriw increased interest in the spa even further.

Today, a thriving business, *Spatone*, is based at the well, bottling and distributing their *'Iron+'* products internationally, continuing the practice of the Victorian period when records show that a two-month's supply shipped anywhere in the world cost forty-two shillings.

Right
Wooden sign saved from the heyday of the spa industry

Opposite
The ferrous stalactites in the 'Roman' well at Trefriw

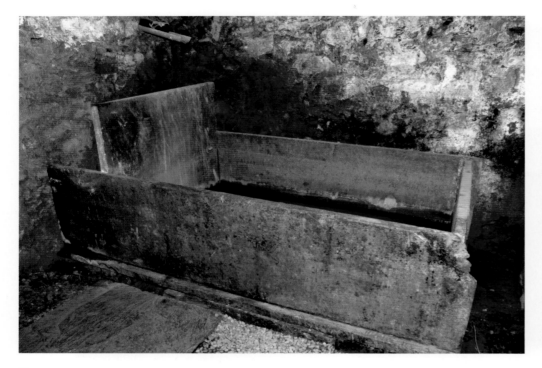

Above
Slate bath in old bath house

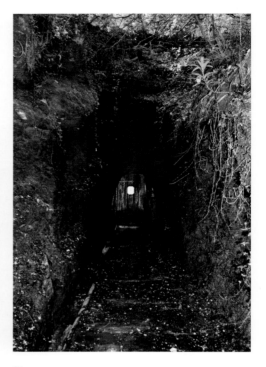

Above
The tunnelled entrance to the
'Roman' baths

Right
Elbow bath and weighing
scales with notice that reads:
"To WEIGH oneself OFTEN
Is to KNOW oneself WELL
To know oneself WELL
Is to BE WELL"

Below
Ancient directional stones?

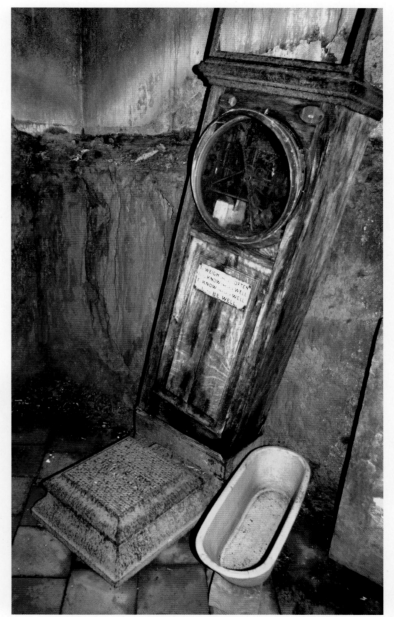

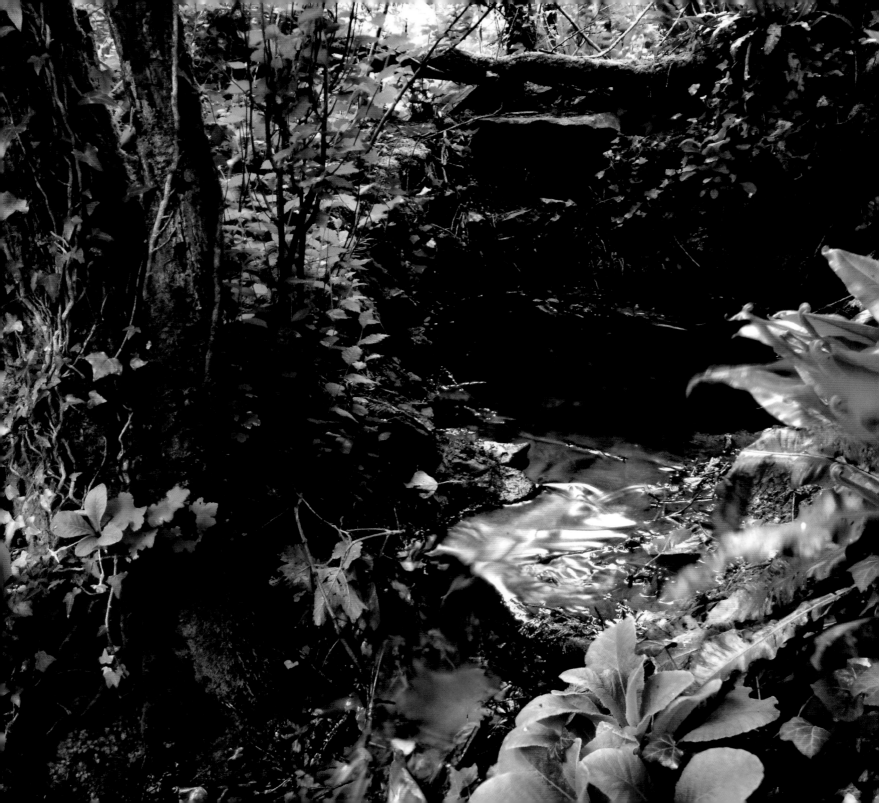

Ffynnon Sant Caradog
St Caradoc's Well

Haverfordwest

Pembrokeshire

*OS Landranger
Map No 158
SM 940 142*

Caradoc was a native of Brecon who, as a young man, played the harp in the court of Rhys, the Prince of South Wales. After losing the prince's favourite greyhound, so the story goes, he was dismissed, broke his lance to use as a walking stick, and made his way south to serve the Bishop of Llandaff. He chose the hermit's life, first in the Gower, then at St Davids, and finally on an island off the Pembrokeshire coast. It is from this last address that his involvement with this well in Haverfordwest must have arisen.

It was believed that a young woman could see the face of her future husband in this well if, on Easter Monday, she threw three pins into the water. One disappointed soul saw "the evil face of a hairy monster"!

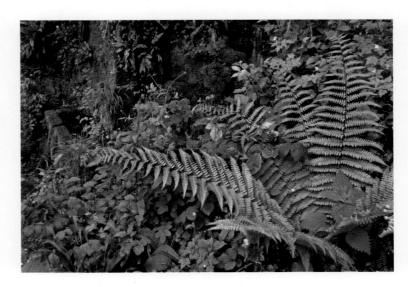

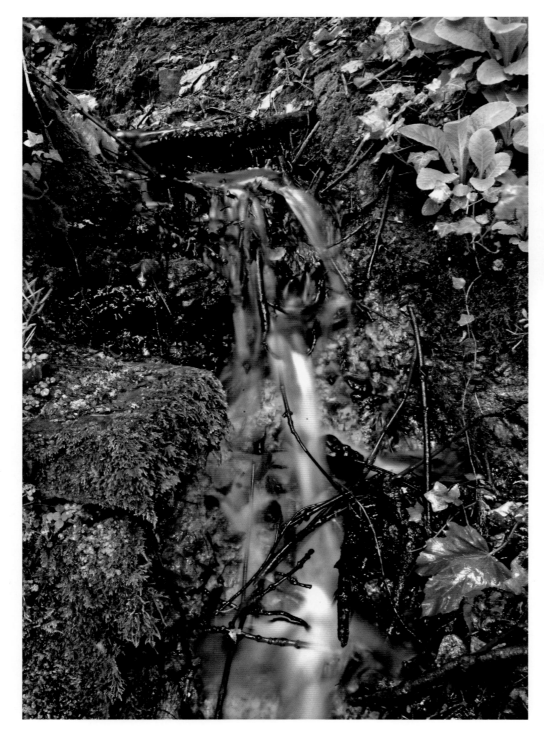

Opposite
St Caradoc's Well drains into Merlin's Brook.

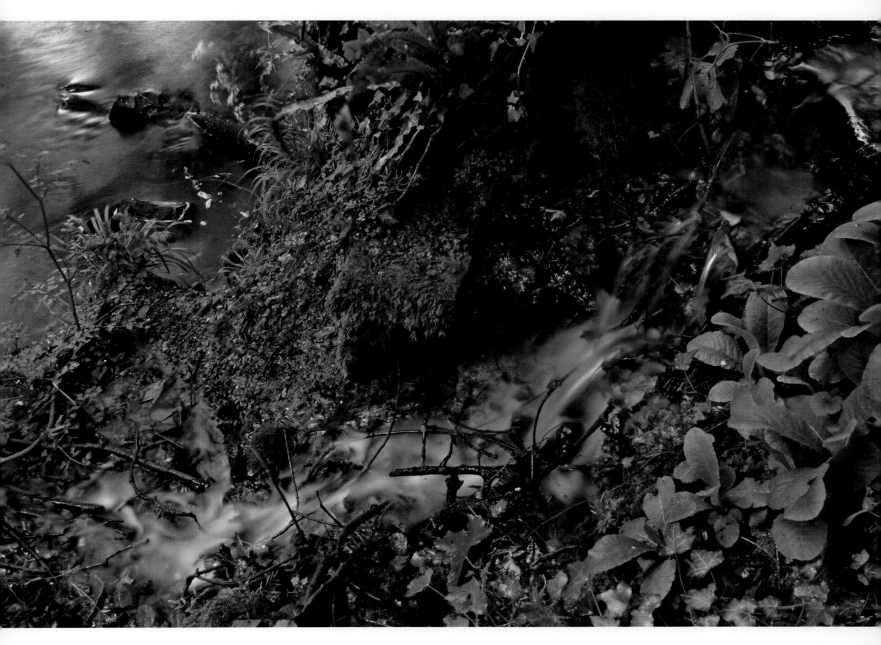

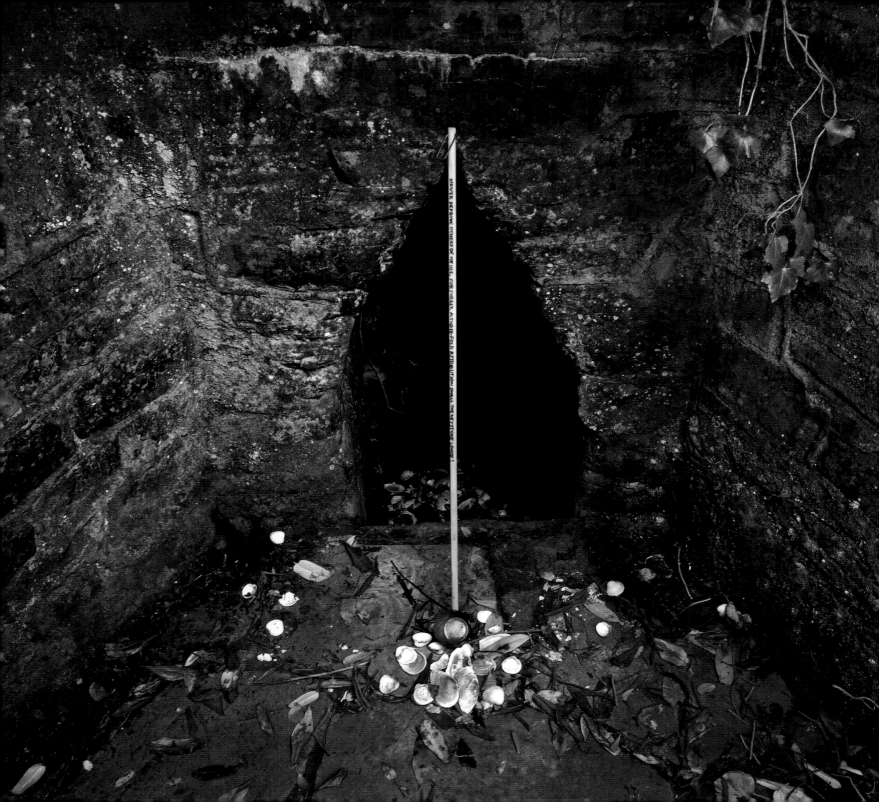

Ffynnon Antwn
St Anthony's Well

Scott's Bay

near Llanstephan

Carmarthenshire

OS Landranger
Map No 159
SN 346 099

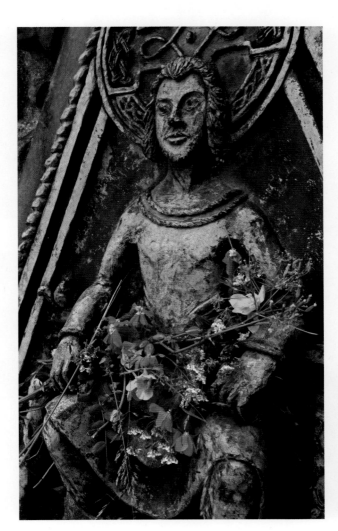

Right
A contemporary representation of
St Anthony set into the walls of his well

Opposite
A long-handled ladle left for pilgrims' use at
Ffynnon Antwn, with the inscription "Never
deprive others of my use, for surely, a three-
fold retribution shall the keystone loose!"

It is believed that the sixth-century Welsh hermit, Antwn, took his name from the first Christian hermit, St Anthony of Egypt (c.251-356), whose ascetic teachings had a massive influence on the early Celtic Church in Wales.

The Welsh saint settled at this peaceful spot on Carmarthen Bay and probably used the sacred waters to baptize new converts to Christianity, since which time it has become famous for its healing properties and as a wishing well for lovers.

Scallop shells, still left here as votive offerings, became the symbol for pilgrimage after St James, one of Jesus' original disciples, was said to have used one on which to travel to Spain in the first century. Pilgrims used them to scoop water and as a simple plate for food, and to signify their poverty. St Anthony has now become the patron saint of all Welsh pilgrims.

149

Left
Entrance and steps down to
Ffynnon Antwn

Above
On the cliffs above the well,
overlooking the sandy shore and
waters of Carmarthen Bay

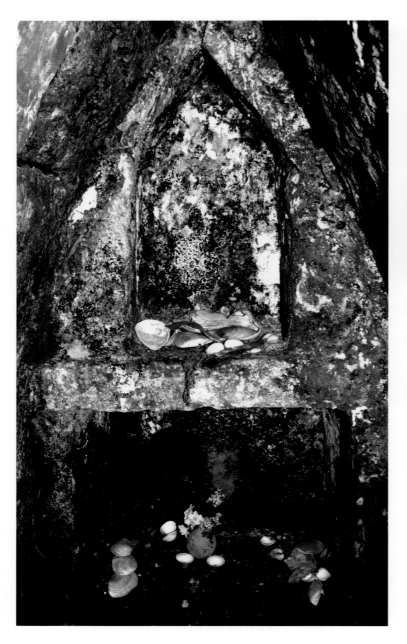

Above
Sculpture in the garden of the house next to the stream into which flow the waters from St Anthony's Well

Left
Shells, the symbol of pilgrimage, left by present-day visitors to St Anthony's Well

Opposite
A sea-cut cave in the shoreline near St Anthony's Well on Carmarthen Bay bears a close resemblance to the design of the wellhousing.

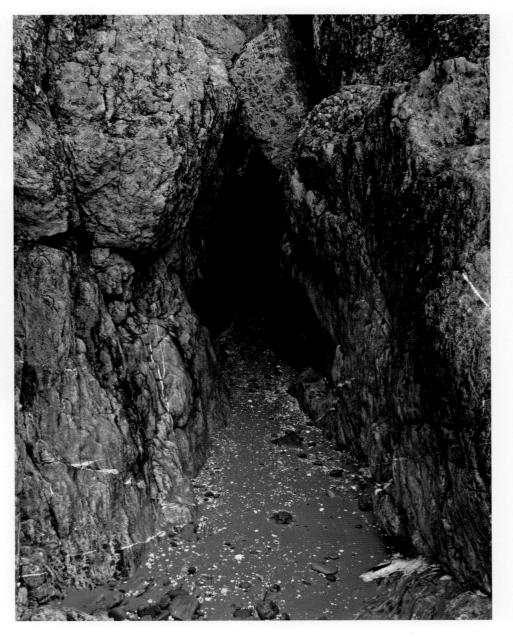

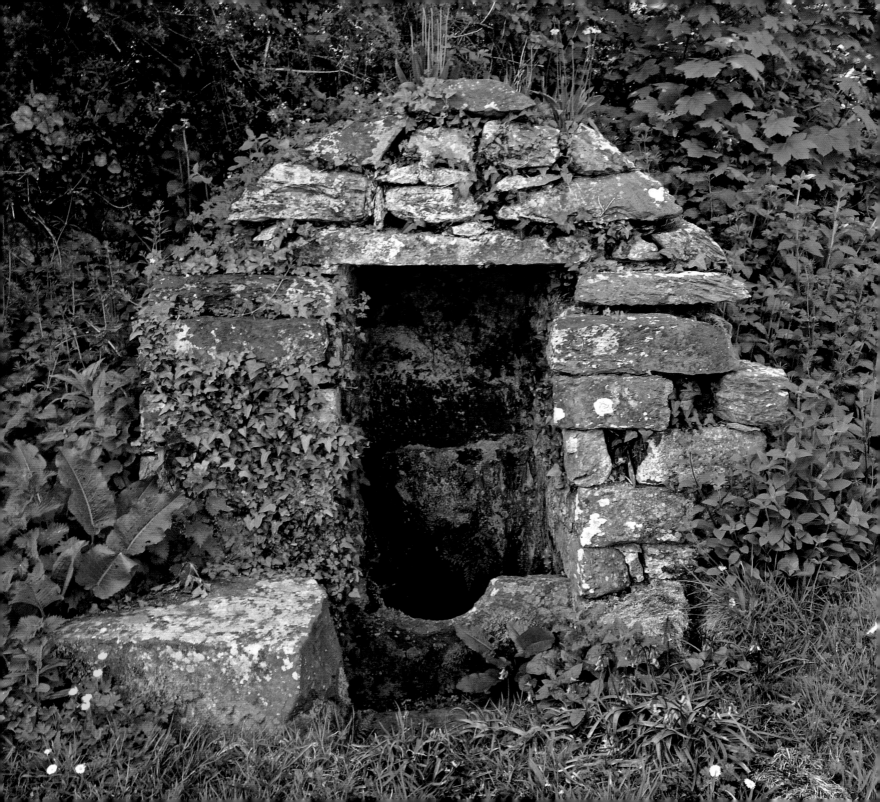

Naw Ffynhonnau
Nine Wells

Nine Wells

near Solva

Pembrokeshire

OS Landranger
Map No 157
SM 786 248

"Last Wells Before St Davids!"

These nine Wells provided the last resting place for pilgrims before arriving at their main destination, the shrine of the patron saint of Wales, at St Davids.

One can imagine the scene here as prayers were chanted, masses celebrated, candles lit, rosaries dipped in the various waters, food and drink served, water-bottles filled, horses fed, watered and rested, and sick and weary pilgrims bathed in ecstatic anticipation of the final leg of their spiritual journey.

Right
Capped wellsprings

Opposite
The single surviving wellhouse
at Nine Wells

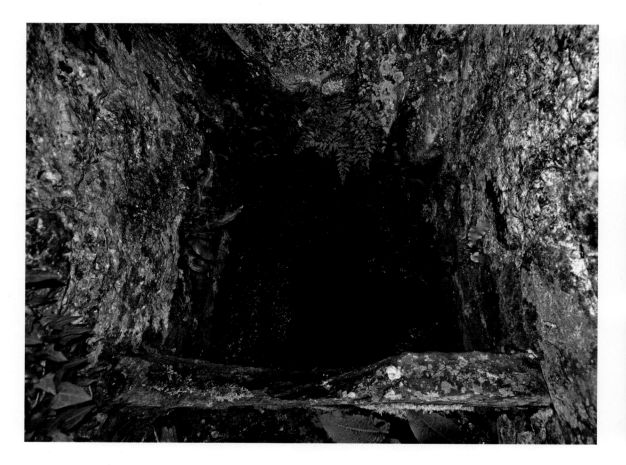

Above
More capped wellsprings

Above left
Looking into the one remaining wellhouse

Opposite
The meeting of the waters from the
Nine Wells

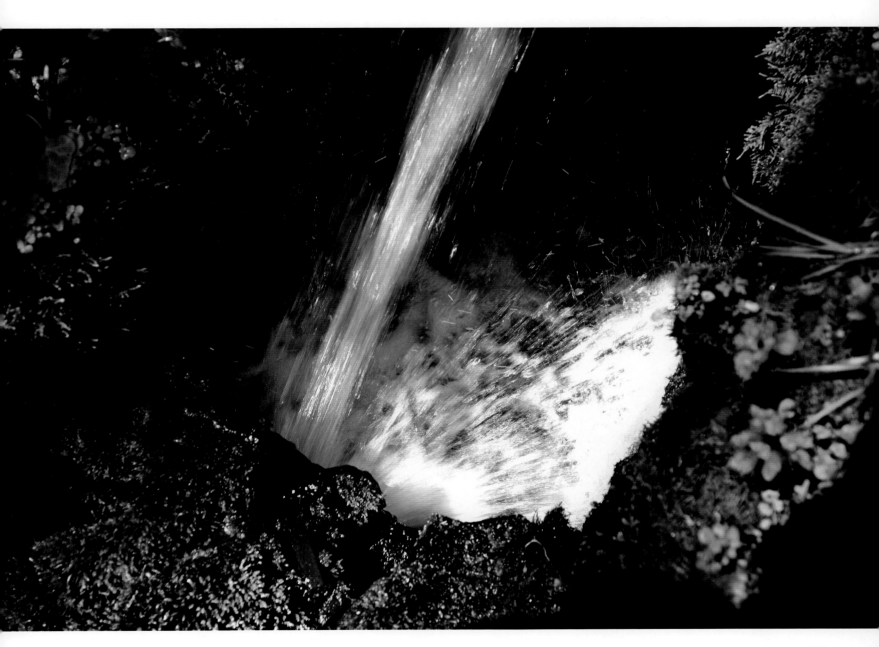

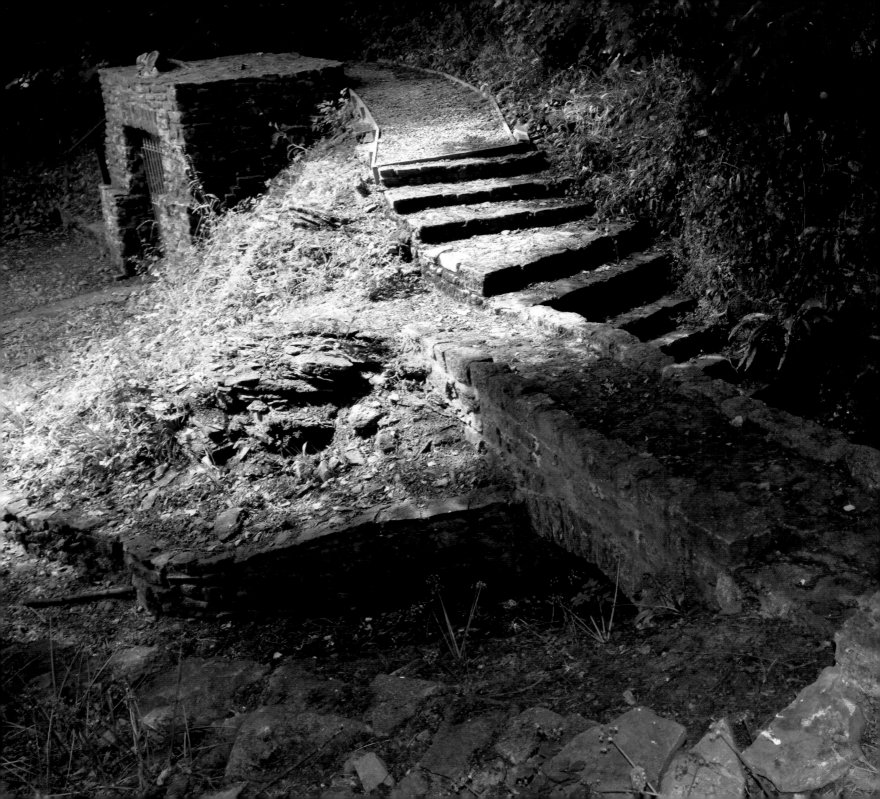

Ffynhonnau Y Pentre
Salmon's Wells

Penllyn

near Cowbridge

Vale of Glamorgan

*OS Landranger
Map No 170
SS 973 767*

Left
Cross in niche of second wellhouse

These three natural springs have provided fresh water for the inhabitants of the village of Penllyn for more than six centuries. The first well is known to have been in existence in the fourteenth century; and the second, with its 'Saint's Niche', is recorded to be sixteenth-century; while the third well was created in 1911 to meet the need for an increased use of water to improve local standards of hygiene.

The wells' name comes not from, as might be imagined, the presence of a fortune-telling fish in the waters, but from Dr William Salmon, the then occupant of Penllyn Court, who, in 1883, repaired the first two wells, paving their frontages and laying out a system of drainage.

The wells fell into disrepair after 1940, soon to be completely covered by trees and bushes. All three of the Salmon wells are Grade II listed buildings and have now been archaeologically recorded by local residents and fully restored through financial support from Cadw, the Heritage Lottery Fund, the Prince's Trust, the Craig and Penllyn Residents Association and the community council.

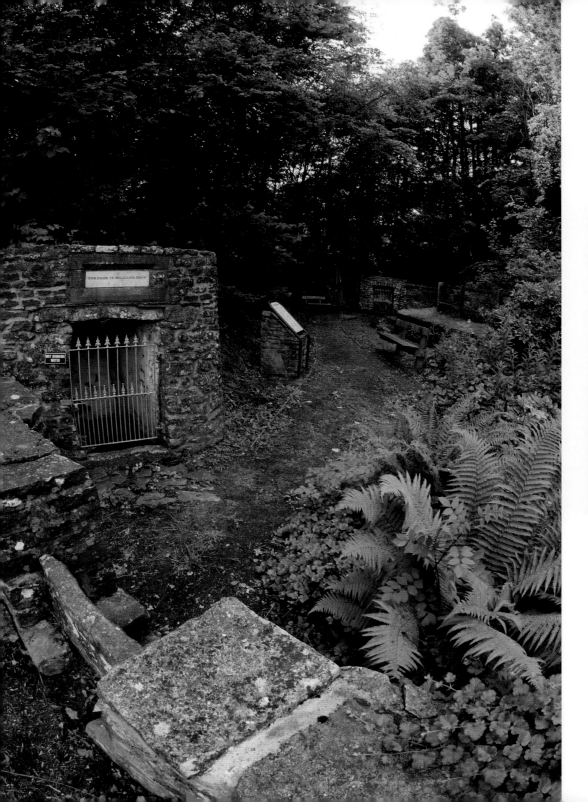

Left

View of two of the three Salmon's wells

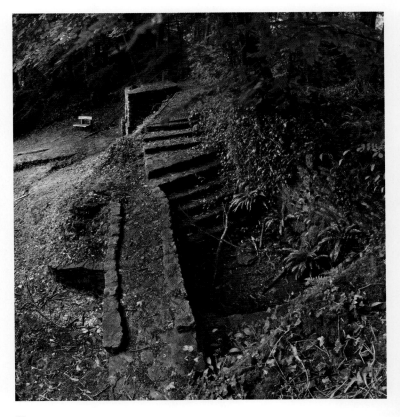

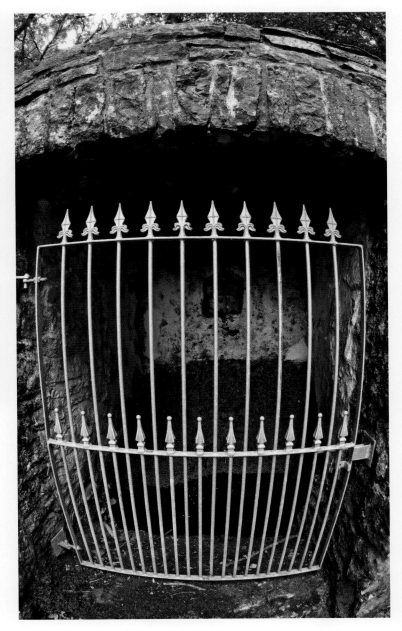

Above
Well three

Right
Well two

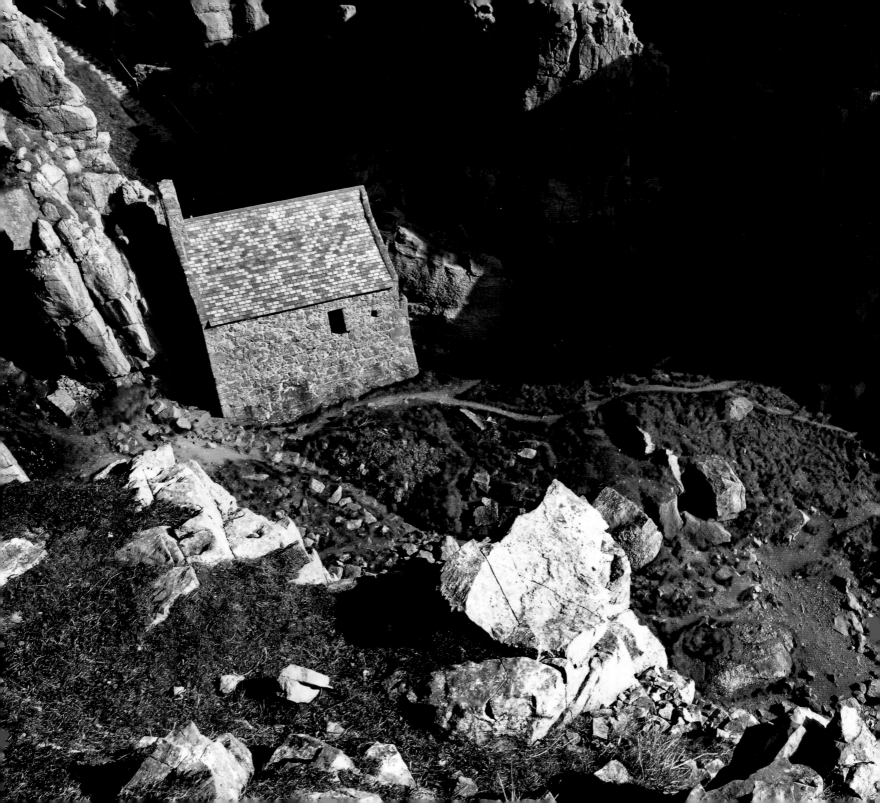

near Bosherston

Pembrokeshire

OS Landranger
Map No 158
SR 967 928

Ffynnon Govan
St Govan's Well

The history of St Govan and of his chapel and holy well is as shrouded in mists as is, on regular occasions, this exposed and sometimes-savage, washed by the wild sea, part of the Pembrokeshire coast.

Govan may have been the sixth century Gobhan of Wexford or perhaps even Gawain of Arthurian fame. If the former, then he was an Irish abbot who chose to retire here and live out the last years of his life as a hermit, personally building the first chapel, and dying in the year 586. However, no-one really knows. Some say that hand prints in the rock floor of the cave behind the chapel's altar – used perhaps as a rough shelter before the chapel was built – are those of the saint. Others believe that his body is buried beneath the altar.

The tiny vaulted chapel we see today, set fast within the rocks, is thought to have been built some time between 1300 and 1500, based on St Govan's original plan. The well, now sadly dry, is further towards the sea. Tradition suggested that its waters were good for rejuvenating ageing eyes, combating rheumatism and curing lameness – the crutches of the latter sufferers being happily discarded upon the chapel altar to prove the well's efficacy.

What *is* certain, however, is that this isolated setting, hidden between rocks and the sea with only birds, fish and seals for company, would have provided a perfect hermitage for the devote believer.

Left

St Govan's chapel from the cliffs above

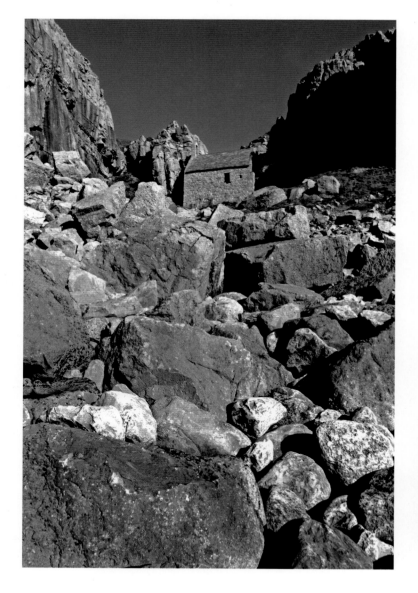

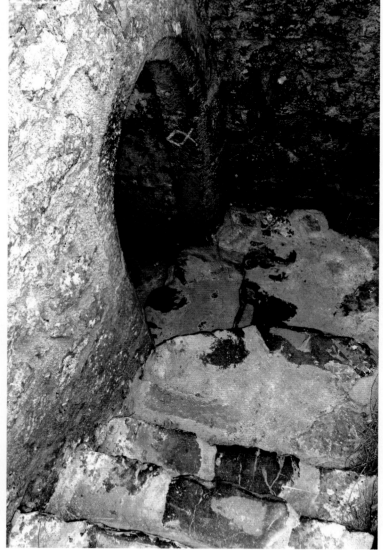

Right
The small wellhouse of Ffynnon Govan amongst the rocks, seen through the window of St Govan's chapel

Opposite right
Steps leading down into St Govan's chapel – notice the sign of the fish, a symbol of Christianity, at the entrance

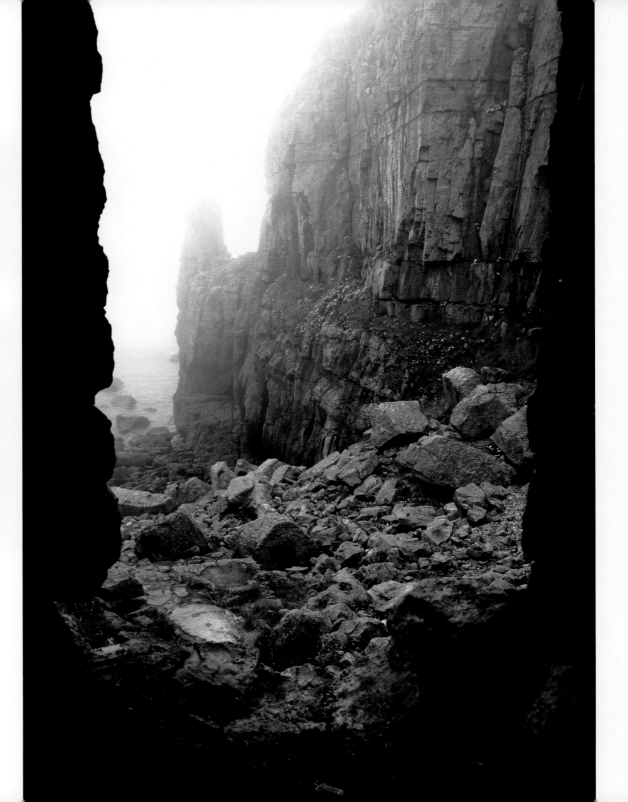

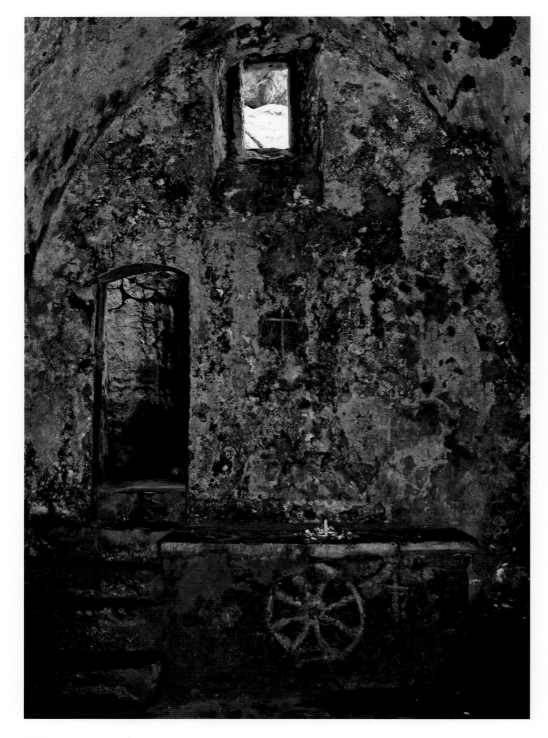

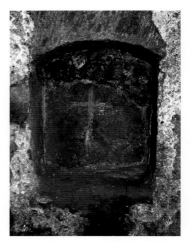

Above
Cross-inscribed niche for offerings
in St Govan's chapel

Left
The altar in St Govan's chapel

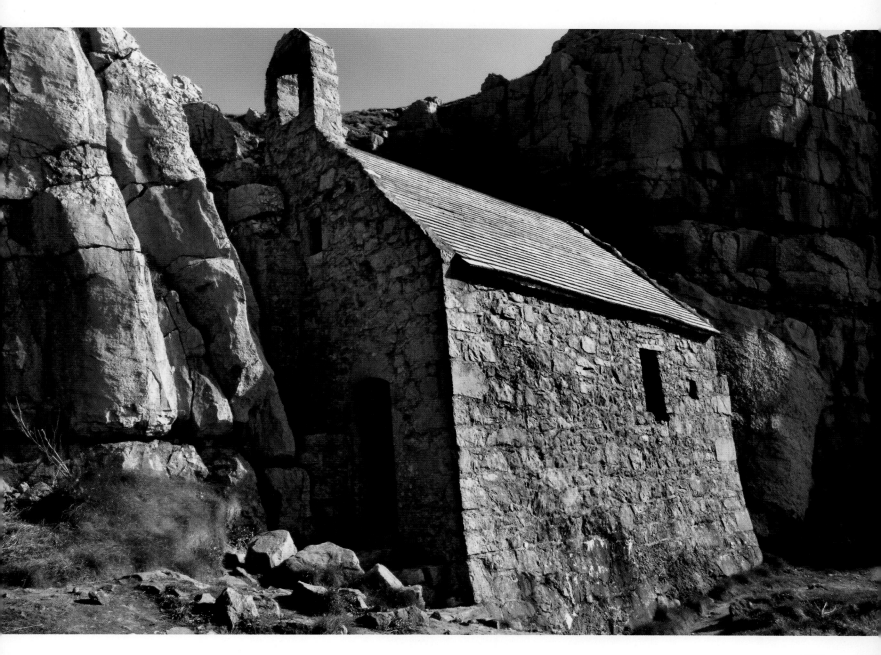

Ffynnon Elen
St Helen's Well

Betws-y-Coed

Gwynedd

OS Landranger
Map No 115
SH 484 613

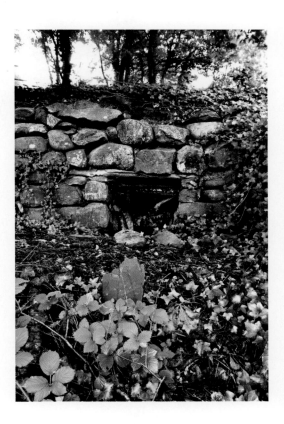

Elen was the formidable warrior wife of Maximus, the chief of the Roman fortress of Segontium in today's Caernarfon, and the mother of Constantine and Peblig, both of whom were also granted the honours of 'Welsh sainthood'. After the death of Maximus, Elen took over the rule of the area from her fort at Dinas Emrys.

Her importance is attested to by the many references to her, both in this part of the world and throughout Wales. However, though her life is well chronicled, the history of her well – the date of and reason for its construction, its usage, and so on – is sadly not.

169

Right
The gateway entrance to
Ffynnon Elen, with the well
grotto set into the wall beyond
the large tree

Ffynnon Wenfaen
St Gwenfaen's Well

near Rhoscolyn

near Holyhead

Isle of Anglesey

OS Landranger
Map No 114
SH 259 753

"Full oft have I repaired to drink that spring,
Waters which cures diseases of the soul
As well the body! And which always prove
The only remedy for want of sense.
Two white spar stones is all thou dost expect
As a free offering both for sense and health."
Lewis Morris (1701-1765) on St Gwenfaen's Well.

This exposed well, sunken into the ground on a remote and wild headland on the southern-most tip of Holyhead, was once famous for its cures of mental illnesses and depression. 'Wenfaen' in Welsh means 'white stone', and after drinking the water, two pieces of quartz were dropped as payment into the well.

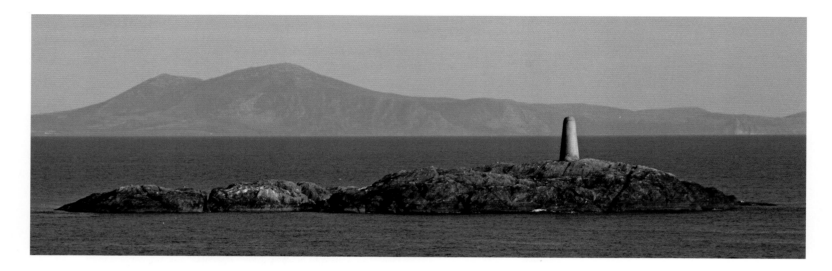

Above
The Rhoscolyn Beacon

Left
The rocks and sands of Borthwen beach, near Ffynnon Wenfaen

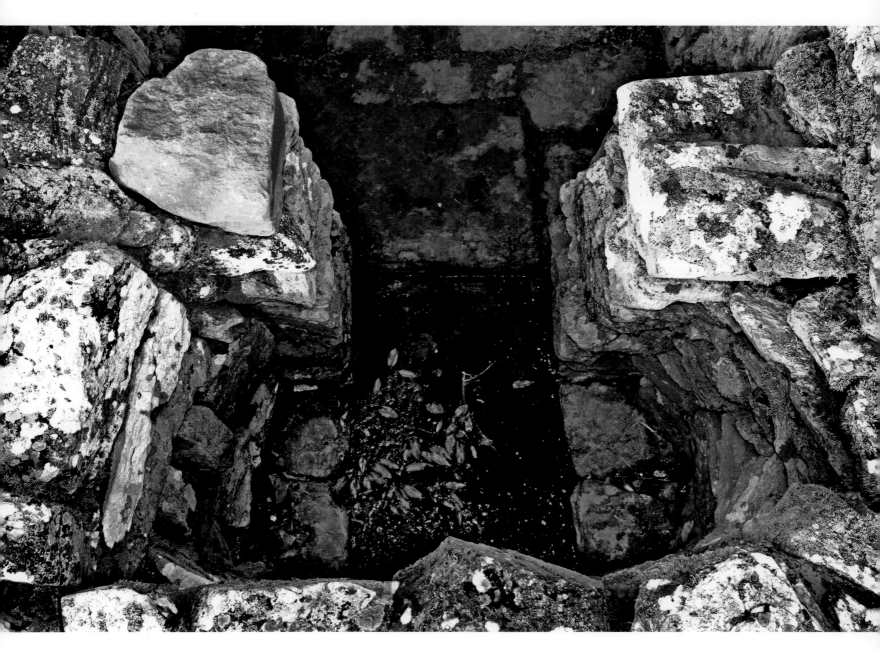

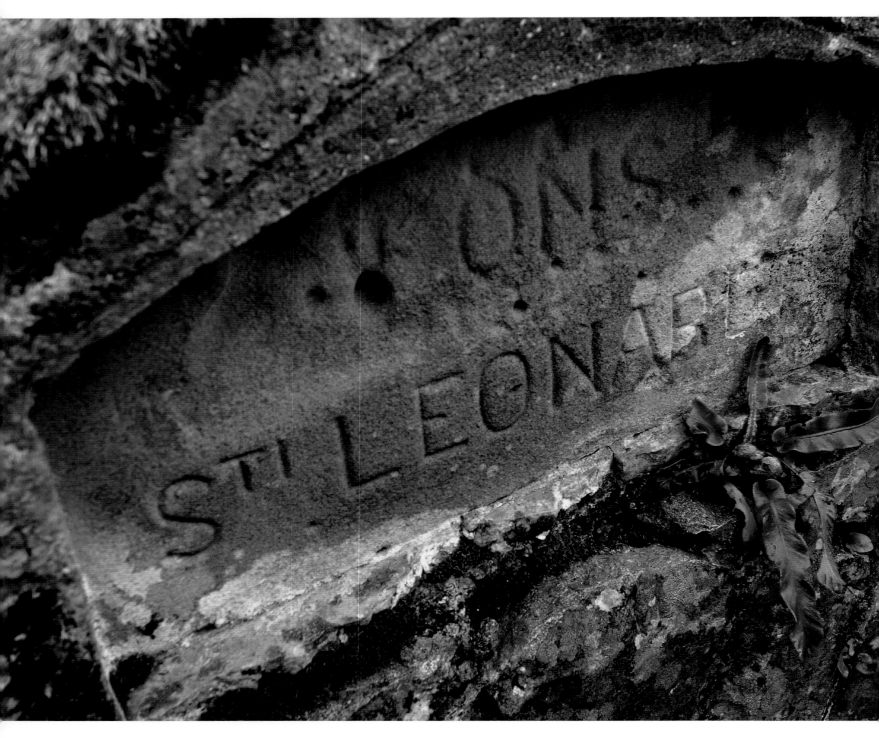

Ffynnon Sant Leonard
St Leonard's Well

near Crundale

near Haverfordwest

Pembrokeshire

OS Landranger
Map No 158
SM 985 188

S ituated high up on the north-east slope of an Iron Age hill-fort on Crundale Rath, the presence of a pure and reliable source of water was undoubtedly one of the main arguments for the decision to create a settlement here.

The christianised St Leonard's Well specialised in eye cures. A chapel or hospice dedicated to the saint once stood nearby by but nothing of it now remains.

Far right
View from Ffynnon Sant Leonard

Right
The Iron Age hill-fort of The Rath

Opposite
The letters carved into the headstone above St Leonard's Well read 'Fons Sti Leonardis'.

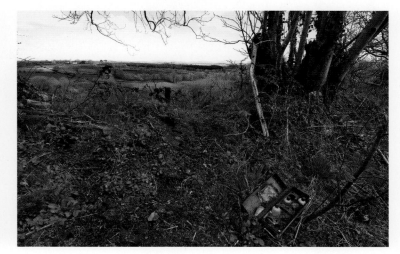

Above
Inside the Ffynnon Sant Leonard
wellhousing

Right
St Leonard's well set into the bank
of an Iron Age hill-fort

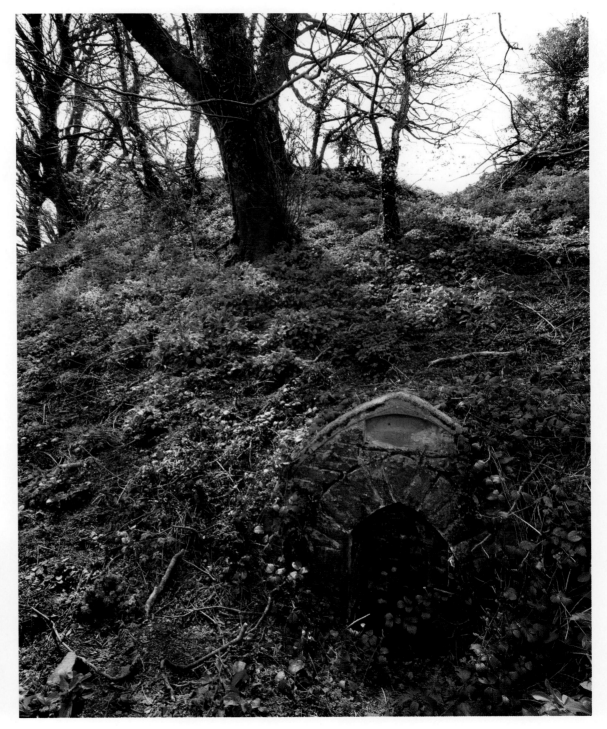

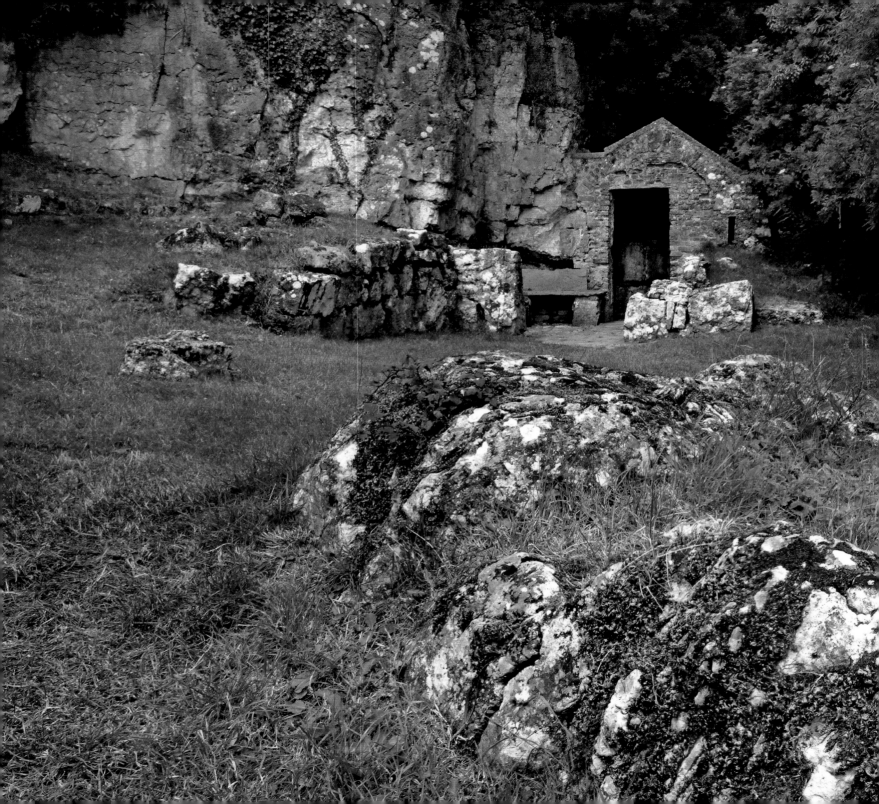

Ffynnon Sant Seriol
St Seriol's Well

Penmon

Isle of Anglesey

OS Landranger
Map No 114
SH 631 808

Originally known as Ffynnon Fair ('Mary's Well'), this fine well building, set into the rock wall at Penmon in the north-east corner of Anglesey, seems to have acquired its new name to mark the arrival of St Seriol as the first abbot of the local priory in the sixth century.

An impressive complex of religious and secular buildings – the church, dovecote and priory – still survive in various states of decay alongside the well that was last renovated in the eighteenth century.

Seriol's image cured disorders of the eyes, a fact reflected in the name for a periwinkle on Anglesey: 'llygad Seiriol' or Seriol's eye!

During the 2003 Island Games in Guernsey, athletes from Anglesey took a vial of water from St Seriol's Well with them to mix with waters from all of the other participating islands.

Left
St Seriol's wellhouse and garden. At the top left of the picture, at the foot of the rocks, is thought to have been the site of the saint's original cell.

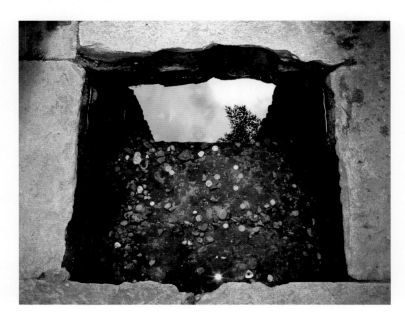

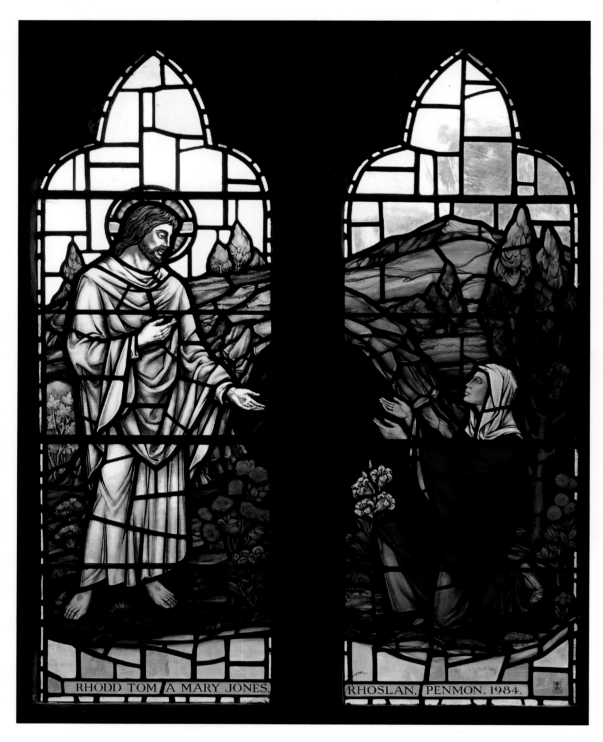

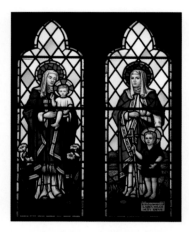

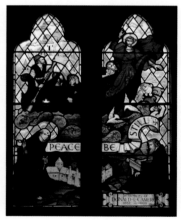

Left
Stained glass windows in the Penmon
Priory Church of St Seiriol, next to the well

Above
Interior of the church

Right
The priory's impressive dovecot – the central pillar supported a ladder to access the nests

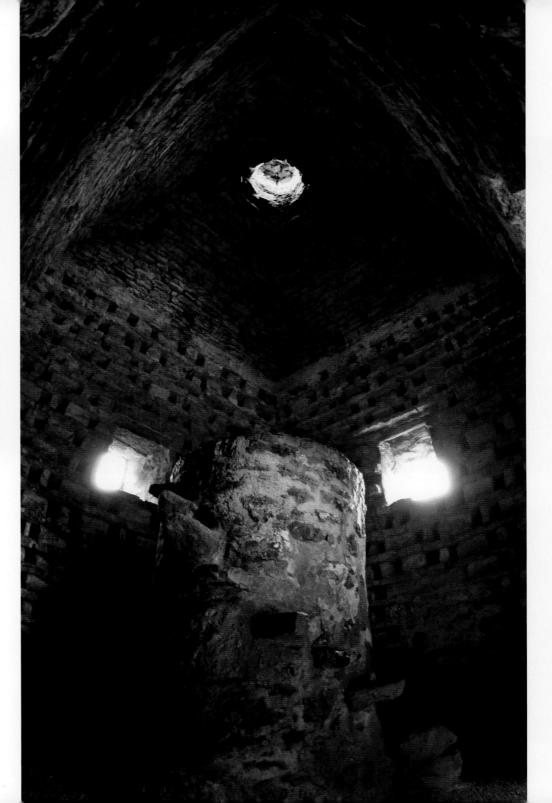

Top left
Niches for offerings at St Seriol's well

Bottom left
Pilgrims' graffiti

Below
Ornate Celtic knotwork carving on a
tenth-century stone cross in the priory

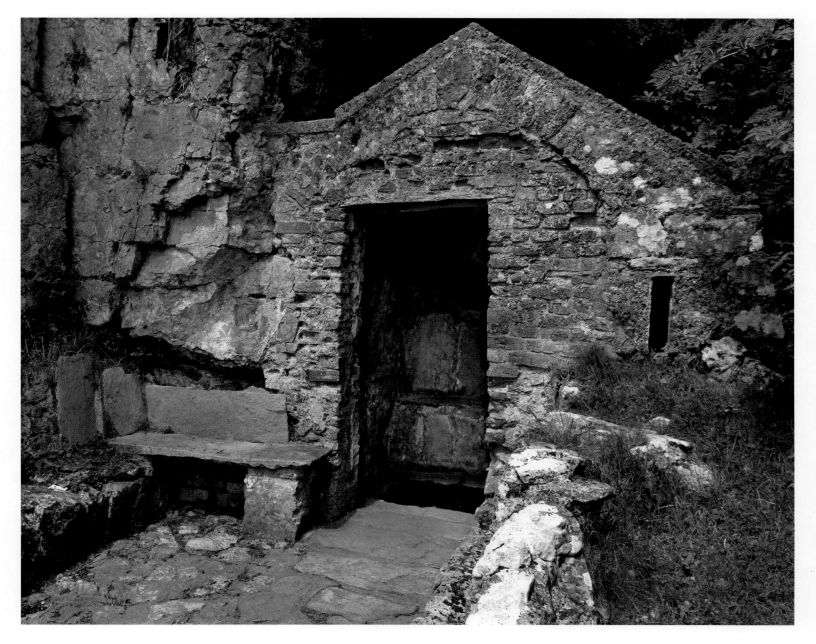

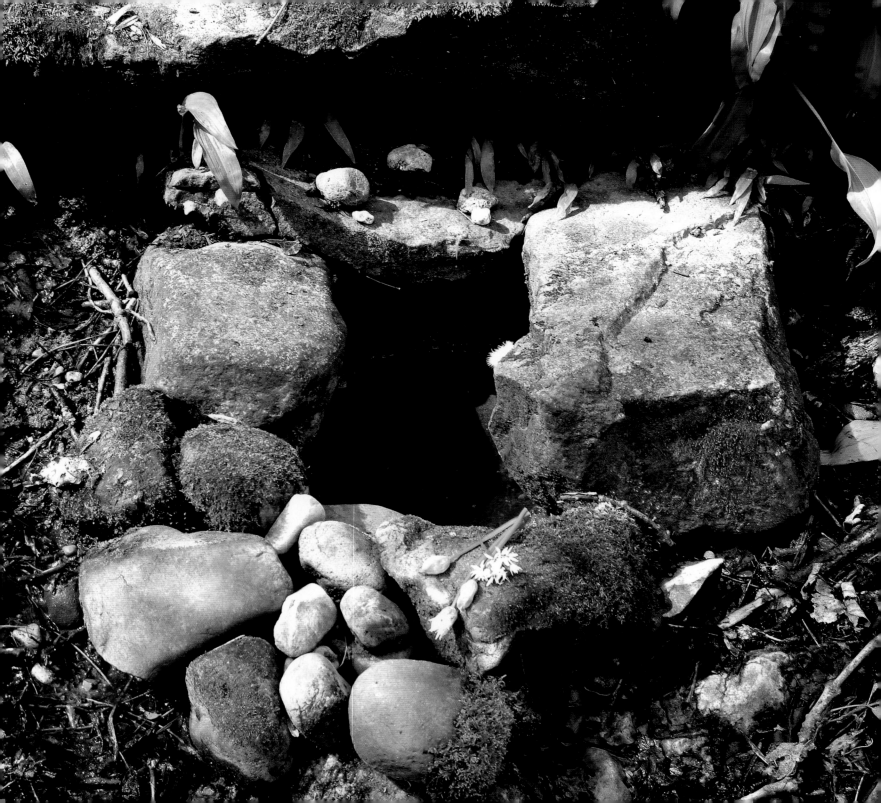

Caswell Bay

near Murton

Gower Peninsula

Swansea

*OS Landranger
Map No 159
SS 590 884*

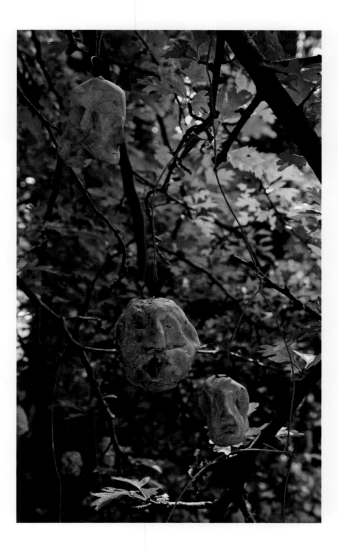

"St Peter's well is very firm walled and stone benches and pavement belonging to it, it never friezeth, it continueth the stream be the weather wet or dry."
Local historian, Isaac Hamon, writing in the late seventeenth century

The tumbled ivy-clad medieval stone ruins of St Peter's once-elaborate chapel and house contrast starkly with the two springs here that burst out of the hillside promoting an explosion of greenery and continue to flow to the sea ... never drying, demonstrating silently, without ostentation, the transience of our human constructions and the quiet eternal power of nature.

Right
Clay heads of friends and relatives who have died or with whom the makers have lost contact hang on the branches of a thorn tree between St Peter's chapel and well.

Opposite
One of the two springs that feed Ffynnon Bedr

187

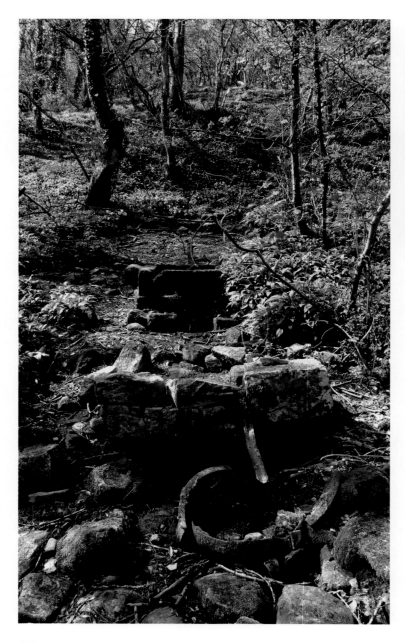

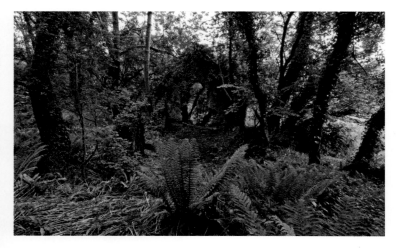

Above
The ruins of St Peter's chapel

Right
Evidence of the uses of the well over
the centuries

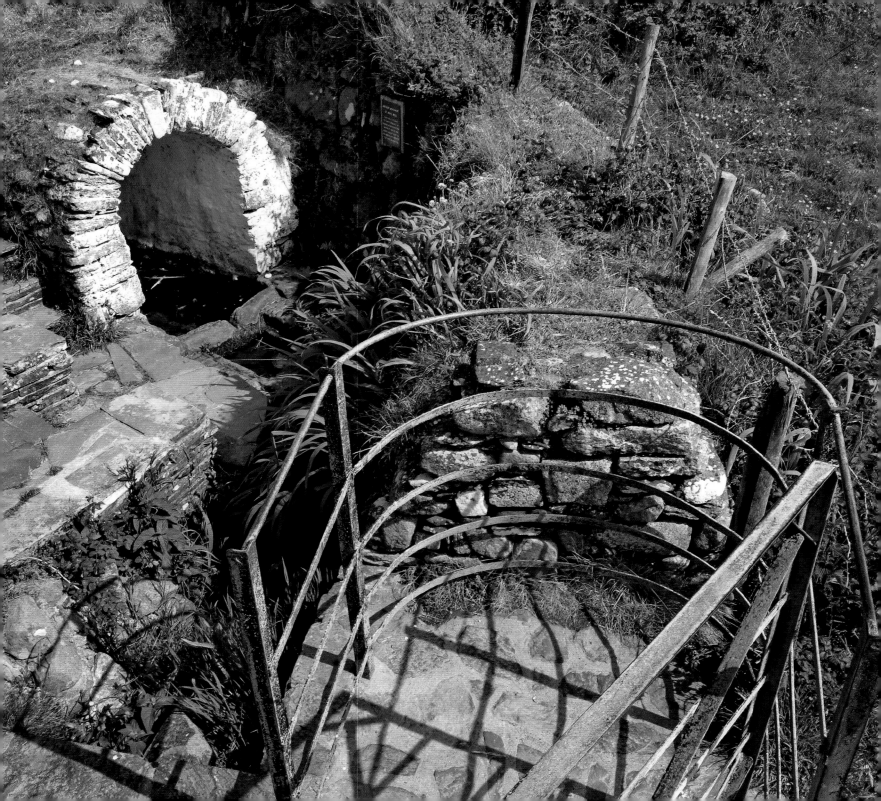

Ffynnon Non
St Non's Well

near St Davids

Pembrokeshire

OS Landranger
Map No 157
SM 751 243

"Some old simple People go still to visit this Saint … expecially upon St Non's Day, which they keep holy, and offer Pins, Pebbles, Etc."
Browne Willis writing in the early eighteenth century

"the bottom of the well shone with votive brass"
R Fenton writing in 1903

This already magical site of pagan circles and standing stones was the place where Nonnita, Nonna, Nun, Nonni, or, as she has come to be more generally known, St Non is said to have given birth to David, sometime around the year 589AD (although the date of 462 has also been suggested). There are almost as many versions of her story as there are of her name. One claims that she was the grand-daughter of the powerful chieftain, Brychan Brycheiniog, whose twelve sons and twelve daughters played a major role in spreading Christianity throughout South Wales, and that she was married to Sandde or Sant, the King of Ceredigion, and one of the grandsons of Cunedda Wledig. Another claims that Sandde had taken her against her will and that the birth of her son, who was to become the patron saint of the Welsh, occurred, appropriately, during a violent thunderstorm. All agree, though, that at the moment of David's birth the spring that was to bear her name burst forth from the ground.

The well in earlier times had been enclosed in a larger building with a stone roof and benches. Its present form is the product of an eighteenth-century ecclesiastical imagination. Only the ruins of St Non's tiny chapel now remain, along with a beautiful medieval ring-cross that was found embedded in the wall.

After an extensive renovation, the well was rededicated in July 1951 and is now the destination for regular pilgrimages. Above the well and the chapel ruins, overlooking Skomer Island, is a new small Catholic chapel with fine stained glass windows of the saints Bridget, Catherine, Margaret and Non, all believed by some to be aspects of the Goddess.

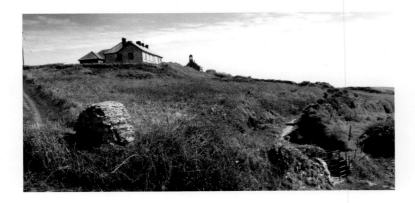

Above
The new chapel and residential centre above the holy well

191

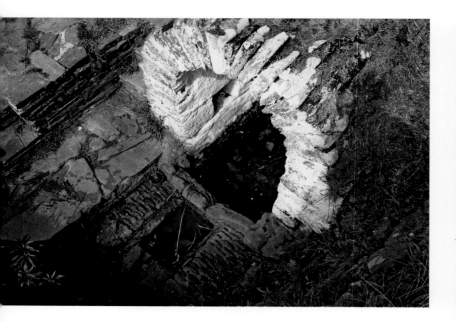

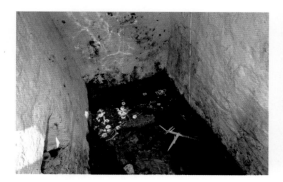

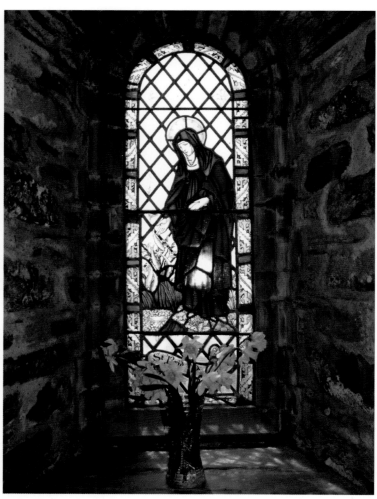

Above
Stained glass window of St Non in the
new Catholic chapel above the well

Right
Medieval ring-cross found in St Non's
fourteenth century chapel

Right
Well niche with candle

Right
Detail from well floor

Far Right
Coins offered to St Non

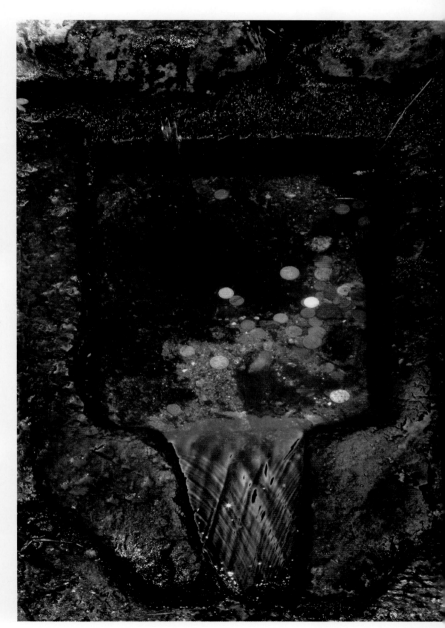

Ffynnon Dwym
Taff's Well

near Cardiff

OS Landranger
Map No 171
ST 119 837

Opposite
The waterlogged and barred
entrance to Taff's Well

Below
Modern graffiti on the walls
of Ffynnon Dwym

The Ffynnon Dwym hot springs are warmed by natural geothermal heat from deep within the earth. Its curative properties were recognised as far back as Roman times, attested to by the discovery of Roman masonry when a flood in 1799 washed away part of the floor. In later days, crutches were regularly left behind in recognition of the water's ability to cure rheumatism and lameness within just one month of bathing here.

Ffynnon Dwym also seemed to have had stimulating properties for those of fit body and mind, offering protection perhaps from future potential illnesses, too. During the nineteenth century, young people assembled here on the eighth Sunday after Easter and "dipped their hands in the well, and scattered drops of water over one another, and then repaired to the nearest green space to spend the remainder of the day in dancing and merriment".

Hall's 1861 guide to South Wales says that the springs were "tepid, and have a slight mineral tinge". Francis Jones tells us that a "corrugated iron structure" was erected over the well "to preserve the modesty of the bathers. When a man bathed, it was customary to hang a pair of breeches outside to indicate the sex of the bather within; women hung up an essentially feminine garment."

Taff's Well is believed by some to be haunted by a grey and slender female ghost longing to be released from her bondage by a man holding her by the waist and making no sound, an instruction that was invariably disobeyed.

Following the decline of the Welsh spa industry, Taff's Well was neglected. Local people built an open-air swimming pool on the site, fed by the warm spring water, which was still in use in the late 1950s, but the regular flooding of the river Taff made closure inevitable.

Despite some landscaping, Taff's Well is currently once again in a very poor state of repair, regularly vandalised, a favourite haunt for the graffiti artist, and closed to the public. Moves are afoot, however, to restore this once proud building and make its warming waters accessible once more to local people and visitors alike.

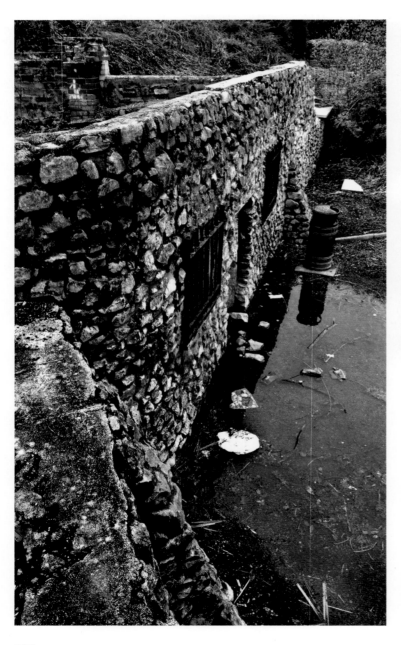

Opposite
The once impressive but now neglected
pool of Taff's Well – notice the steps
leading down into the water's hot depths

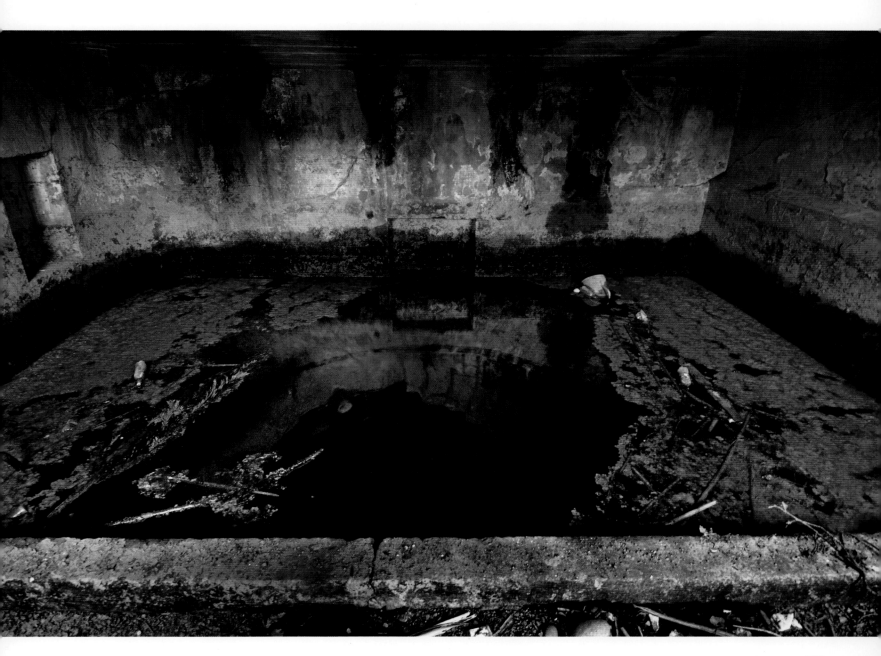

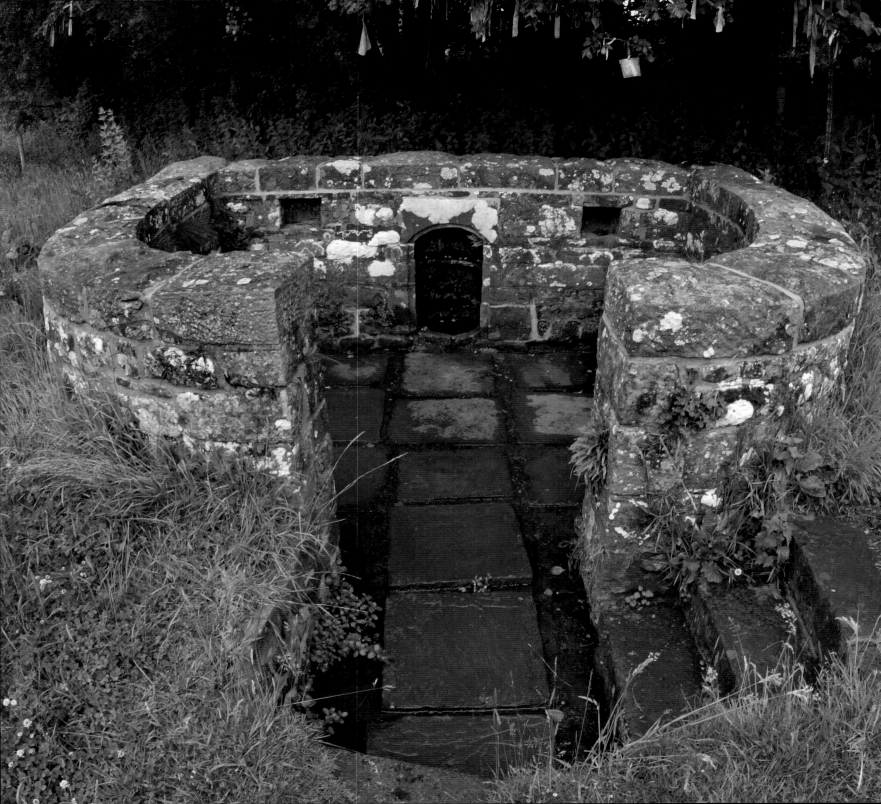

Trellech

near Monmouth

OS Landranger
Map No 162
SO 503 051

Right
The small well pool

Opposite
The large number of rags attached to the
overhanging hawthorn bushes attest to the
continued importance today of the
Virtuous Well as a place of pilgrimage and
healing. Rags and pieces of wool were
hung on branches to encourage the
intervention of spirits or to confirm cures
had been received.

Ffynnon Rhinweddol
Virtuous Well

*"very medicinall to such as have the scurvy,
collick and other distempers"*
Edward Lluyd, 1660-1709

The area around the village of Trellech
has a spiritual significance that has been
recognised for millennia, evidenced by its
'Three Wonders': the well, a tumulus known as
Tump Terret and Harold's Stones. In medieval
times, Trellech was one of the largest and most
important settlements in South Wales.

The medicinal (and, therefore, 'virtuous')
qualities of the iron-impregnated waters of this
well dedicated to St Anne were thought to be
particularly beneficial for eye ailments, and for
those with scurvy, colic, and "complaints peculiar
to women".

In addition, it was believed to be inhabited by
fairies who drank at the well at night from
hairbells that were often found discarded the
following morning. Collected by local folk, these
were dried and used to treat certain ailments. The
fairies sometimes granted wishes. The quantity of
bubbles that rose from the well when a small
white stone was deposited demonstrated the
successfulness or otherwise of the request: a
mass of bubbles meant the wish was granted, a
few suggested a delay in the gratification and the
absence of bubbles indicated a definite 'no'.

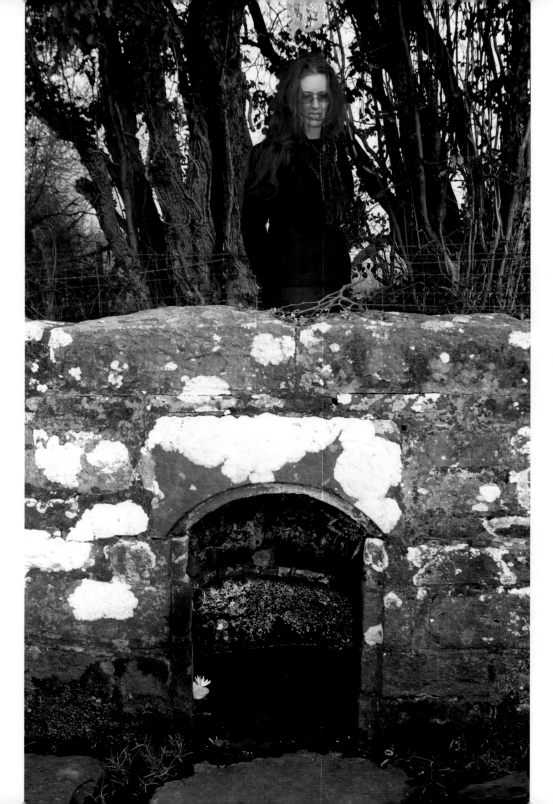

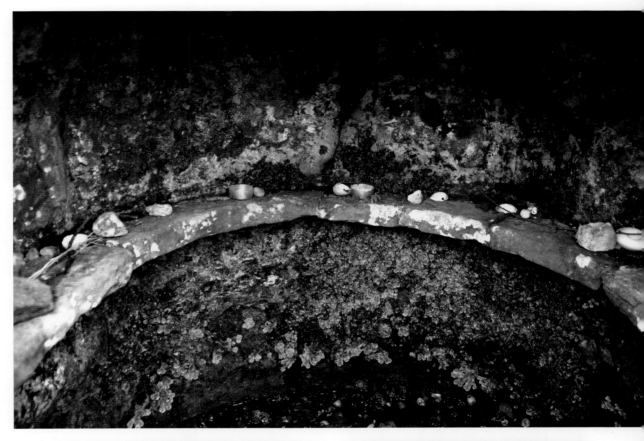

Above left & middle left
Intimate articles of clothing left in the branches of trees above the well …

Bottom left
… and a votive offering at the Virtuous Well of mistletoe, associated with fertility and love

Far left
Some wells hid treasure that could only be found by a red-headed girl tending a flock of sheep!

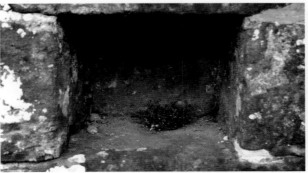

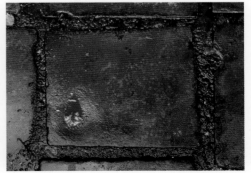

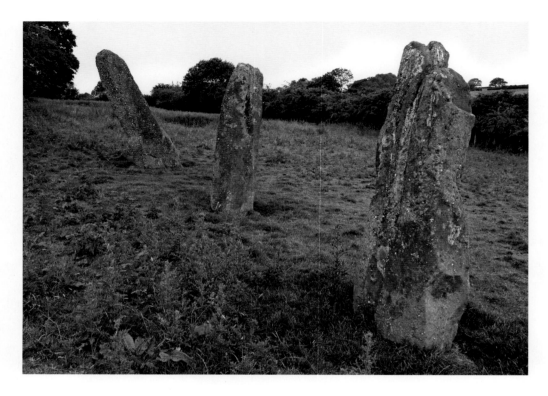

Above
Nearby Harold's Stones, three Bronze Age
megaliths which give Trellech ('stone town')
its name

Left
The old sundial in Trellech church, erected
in 1689 by the Probert family of Pant Glas,
depicts the Virtuous Well, Harold's Stones,
and the Tump Terret, the remains of a
Norman castle.

The Virtuous Well
St. Anne's, Trellech

Bare branches. Rags
bright among the catkins.
All those hopeful hands
elsewhere with their secrets.

We too take the steps
from long wet grass
to these shadowed stones,
flags floating on wet.

The water set in the wall
seems crusted with ochre
till sight suddenly plummets,
liquid invisibly clear.

Her springs have welled like this
through the centuries – they blend
to lie as if motionless,
cold in their ochre cup,

but fall to shine round our feet,
free of the depth, and pass
by a glitter of frogspawn
to nourish the rushy fields

A goldcrest flits, rare
in her silence, repeating
a watchful arc, while we dip
our hands, now, into the cold.

Anne Cluysenaar

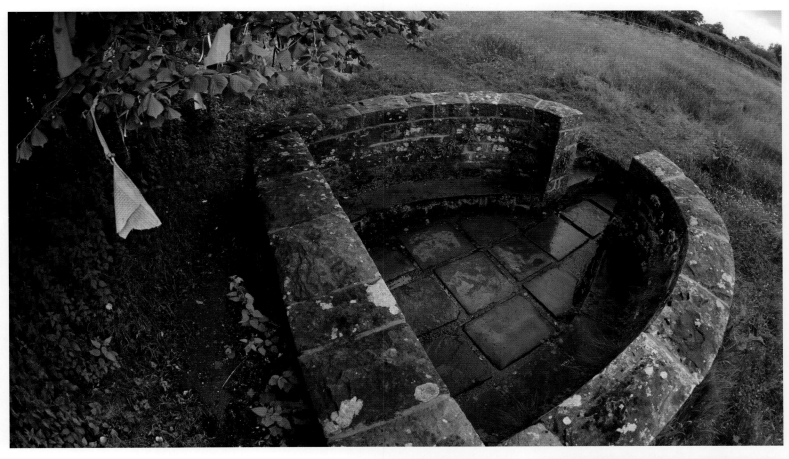

Right
The well pool in the old sundial, Trellech church

Far right
A frog in the well (or perhaps a fairy which had taken frog form?)

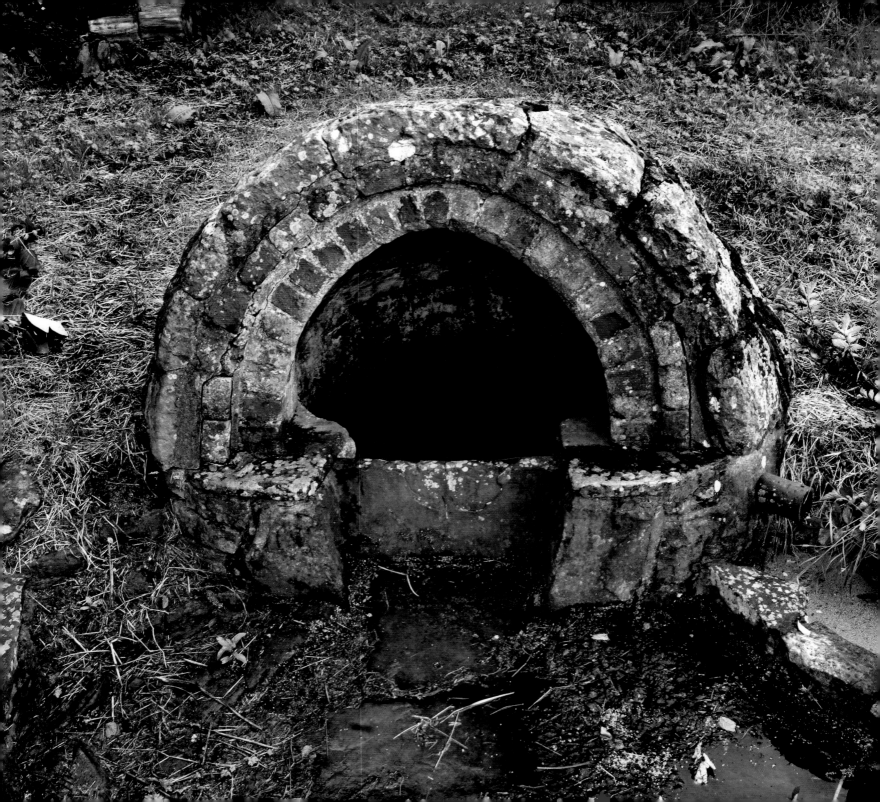

Y Ffynnon Ofuned
The Wishing Well

Wilcrick

near Magor, Newport

OS Landranger
Map No 171
ST 409 879

"From urns that never fail …"
William Cowper, poet (1731-1800)

Above
Wishing Well weeds

Although the so-called Wishing Well at Wilcrick lays beneath a large Iron Age hill-fort, suggesting a very early genesis, little is known of this spring.

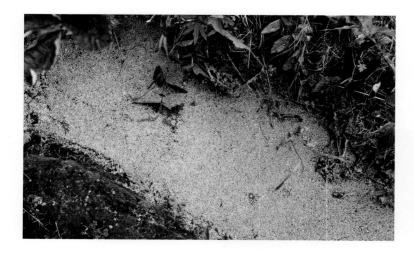

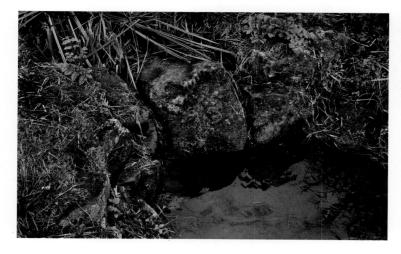

The Wishing Well

An ancient creature encircles my legs
Drawing me to the edge
Of the pure unruffled water's turbulent memory.

Pinned like a museum butterfly
By the palms and by the feet,
At the headless site of an old crime

Its sulphurous breath
Carries the intimacy of
Every hard rock it has passed and changed.

Part fish, part eel, woman, dragon
Griffin, serpent, fairy, saviour,
Singing a whale song of the sun's night shelter;

Offering cures and curses, miracles and messages
On a rich bed of copper and iron, and white crystal stones,
Clothed in rags

You appear, male and female,
Ageless womb and breast of first life,
Harsh hermit saint

At the borderland portal to other worlds
Abandoning unnecessary crutches
On your snaking journey along the earth's belly to the sea.

On flagstone steps, stained
With the fallen head or struck by staff or hoof
I stand, ankle deep, in your icy bubbling,
Dwarfed by each molecule,
Awaiting new miracles.

Phil Cope

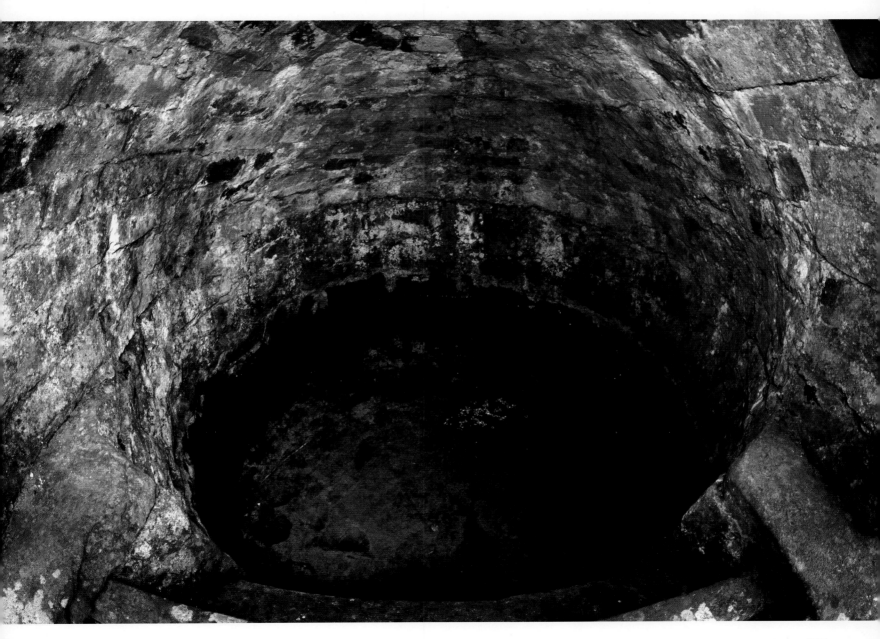

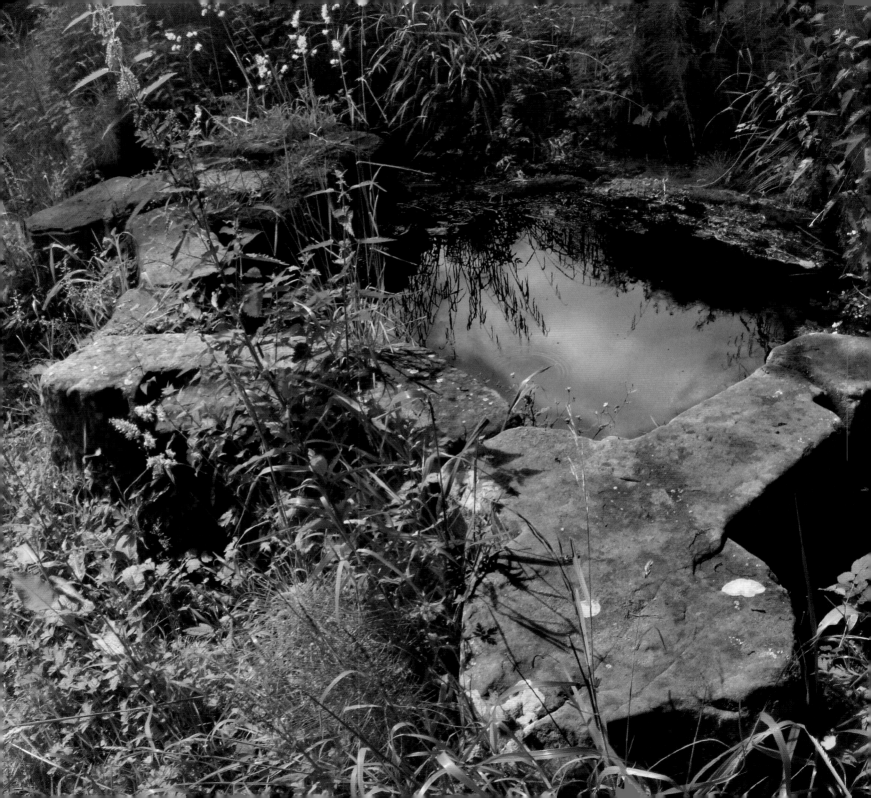

Ffynnon Fair
St Mary's Well

Trefnant

near St Asaph

Denbighshire

OS Landranger
Map No 116
SJ 031 709

"The ivy that mantles its walls with incredible thickness of leaves – the spring flowers and the green turf, the sparkling waters bubbling along their pebbly course – the never ceasing songs of the woodland choristers … all these compensate, in the mind of the contemplative pilgrim, for the damage so ruthlessly and so needlessly done, and even make the place more lovely than could all the trickeries of sculptured stone, and painted roof and storied glass."

The Rev H Jones' 1847 evocation of and regret for the destruction of Ffynnon Fair perfectly encapsulates both the site's central importance once within the spiritual imagination of Wales and the contemporary, seemingly undiminished, treasures that still remain within its ruined walls for the pilgrim in search of whatever denomination of inspiration or relief is required.

The elaborate structures that survive at Ffynnon Fair were constructed around 1550 and modelled upon those of their bigger northern neighbour in Holywell (see St Winefride's Well on pages 212-219), although a much earlier wellhouse is believed to sleep beneath, suggesting an even more enduring history of usage of its healing waters.

Opposite
The star-shaped pool of Ffynnon Fair

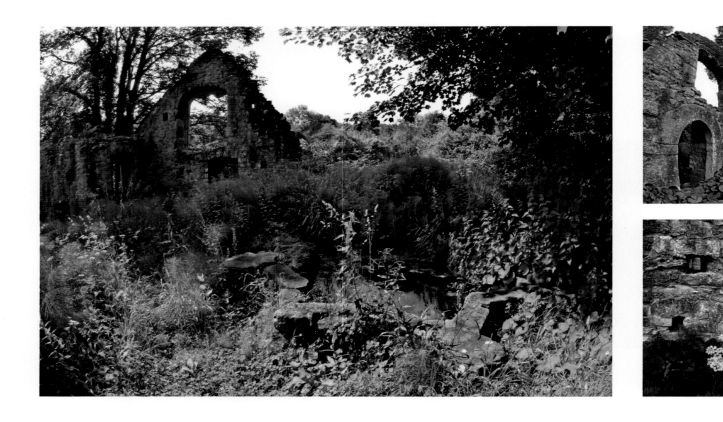

Opposite
The bubbling sacred waters
of Ffynnon Fair

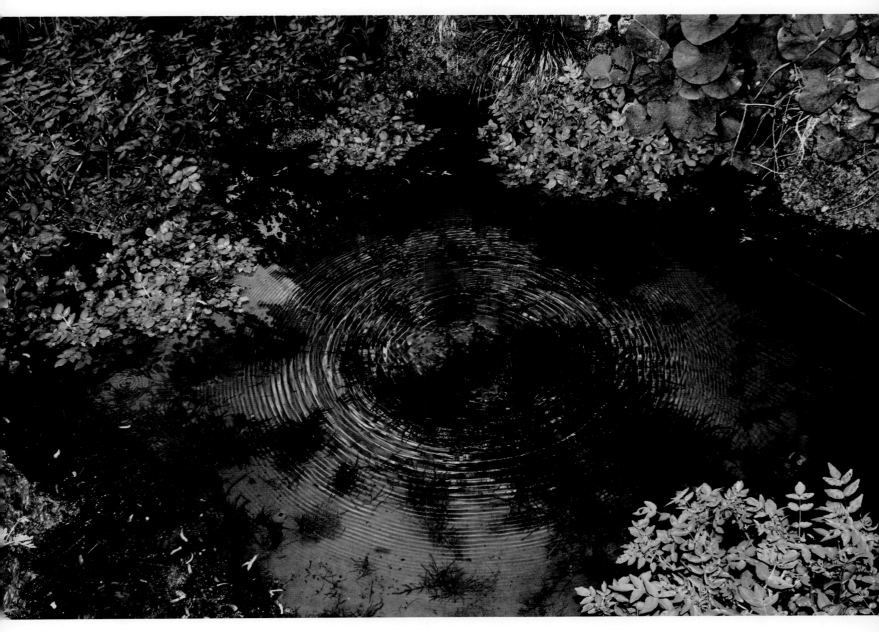

Holywell

near Flint

Flintshire

*OS Landranger
Map No 116
SJ 185 763*

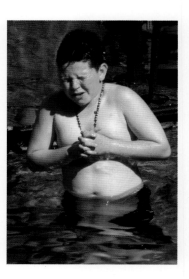

Above
A young pilgrim braves the freezing
waters of St Winefride's Well

Left
Tents awaiting bathers

Ffynnon Gwenffrewi
St Winefride's Well

"in water in deep devotion up to their chins for hours, sending up their prayers" Thomas Pennant, 1781

With more than 1,300 years of continuous recorded Christian usage, St Winefride's Well in Holywell is the grandest well building of all of the wells in the British Isles. Its elaborate and impressive two-storeyed late fifteenth and early sixteenth century Late Perpendicular Gothic construction with star-shaped well, large main bathing pool, and first-floor chapel have survived the regular anti-Catholic attacks that destroyed many other of the historic wells throughout Wales. It is still visited by some 30,000 pilgrims annually, and is known as 'The Lourdes of Wales'.

The legend of its genesis is a particularly interesting one. Gwenffrewi (or Winefride, Winifred or Wenefred), a seventh-century virgin and daughter of Teuth, was pursued by Caradoc, a local chieftain's son, who, enraged by her rejection, drew his sword and decapitated her. As a result, it is said, of her purity and goodness, a great spring immediately erupted out of the ground from the point where her head fell. Luckily, her uncle, Beuno, who was at the time taking mass in his small wooden chapel nearby, managed to replace the head, and St Winefride survived. It was reported that Caradoc, in contrast, sank slowly into the ground and was never seen again.

Maen Beuno ('St Beuno's Stone'), located at the base of the steps into the main freezing-cold pool, is where St Beuno was said to pray, and where modern-day pilgrims still kneel and immerse themselves after going through the inner pool three times.

There is a tradition that Maen Beuno could at one time float, and that once a year, on the anniversary of Winefride's beheading, she would place a new chasuble (an ornate garment worn by a priest to celebrate mass) which she had made for him on to the stone and that it would float to St Beuno down the river and over the sea to the monastery at Clynnog Fawr where he was living. One day, the stone would not begin its journey, and St Winefride knew that St Beuno was dead.

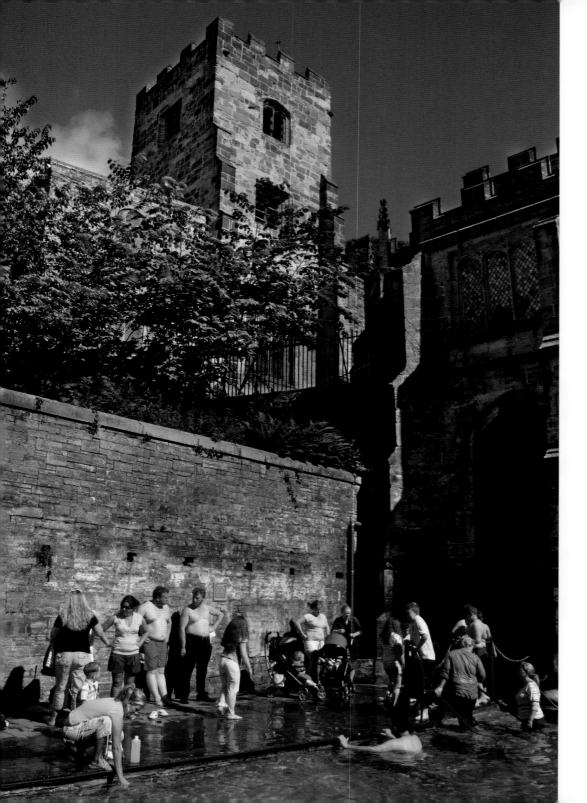

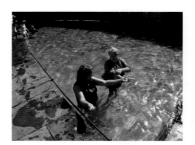

Above top & middle
Modern-day pilgrims, old and young. It has been claimed that pre-historic people dunked their newly-born babies into cold well waters to both cleanse and test them, the sickly perishing, the fit surviving.

Above bottom
Pilgrims from Ireland at the hand-pump at St Winefride's

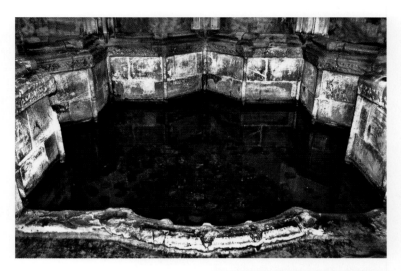

Above
The inner star-shaped pool in the crypt at St Winefride's

Right
A museum on the site offers documentation of hundreds of cures, and the 'evidence' of its piles of discarded crutches and surgical boots.

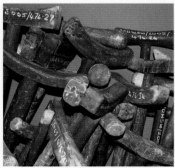

Opposite
The anti-Catholic attacks on Holywell were constant, and almost entirely unsuccessful, as these words by a frustrated Bishop Fleetwod of St Asaph of 1712 attest: "Great resort is had to Holywell by pilgrims (as they call them) from all the different corners of the Kingdom and even from Ireland … the enemy we have to deal with grows more numerous, is active, vigilant and daring, daily pushes on its conquests, is in good heart and under no discouragement but that of laws …" Contemporary pilgrim families from Ireland continue the tradition.

After her death, a major Winefride cult developed, although the earliest account of a pilgrimage to the well was not recorded until 1115. In 1138, her relics were moved to Shrewsbury Abbey and thousands visited both Shrewsbury and Holywell to pay their respects and seek healing. Legend tells of a miraculous cure during the journey to Shrewsbury when a man took a pinch of dust from St Winefride's skull, mixed it with water and gave it to a sick man to drink … with astonishing results.

In 1189, Richard I visited the calcium and iron-rich well, as, on later occasions, did his successors, Henry V (1416), Edward IV and James II, the latter in the company of his queen to ask for a son, a wish that was granted soon afterwards in 1688.

St Winefride's shrine escaped the violences inflicted upon other Catholic holy centres during the Reformation, such was its perceived importance, its money-generating potential, and the regularity of its delivery of seemingly-verifiable cures, although in 1637, the spring's iron posts were taken down and the image of St Winefride desecrated.

"Band y gwayd bendigedig
Dagrau fel kafod egroes
Defni Crist o fanau kroes."
("The drops of her blood are as the red shower
Of the berries of the wild rose
The tears of Christ from the height of the cross.")
Tudur Aled, writing in the late fifteenth century

The red stains present on the kneeling stone of St Beuno were said to have been evidence of the spilled blood of St Winefride and are reported to have on occasion shaped themselves into miraculous pictures or smelt of violets and incense, although biology, of course, offers an alternative interpretation – the moss, *byssus jolithus*, which grew in the water. A further explanation was offered by a G A Cooke writing in 1827 of the stones being taking from the bath and painted in order that "some degree of sanction might be given to the tradition". Another moss, *jungermannia asplenioides*, was known locally as 'St Winefride's Hair' and was collected by pilgrims for use as a poultice for the cure of sprains and other physical injuries.

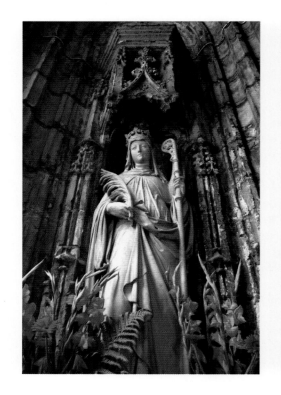

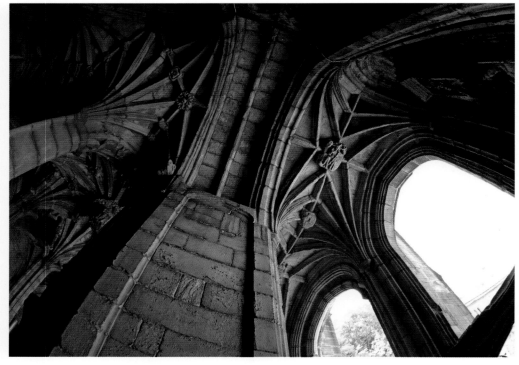

Above
The intricately-carved stone pillars, ceilings, bosses, fan vaultings and walls of the crypt of St Winefride's Well chapel

Top left
St Winefride went to live in a convent at Gwytherin for the last years of her life. This 1888 statue, set above the inner pool altar, shows her as an abbess carrying a crook and the palm of martyrdom; the marks of her decapitation are also clear.

Left
The inner bathing pool

St. Winefride's Well

After Winefride's raising from the dead and the breaking out of the fountain.

Oh now while skies are blue, now while seas are salt,
* While rushy rains shall fall or brooks shall fleet from fountains,*
While sick men shall cast sighs, of sweet health all despairing,
* While blind men's eyes shall thirst after daylight, draughts of daylight*
Or deaf ears shall desire that lipmusic that's lost upon them,
While cripples are, while lepers, dancers in dismal limb dance,
* Fallers in dreadful frothpits, waterfearers wild,*
Stone, palsy, cancer, cough, lung-wasting, womb not bearing
* Rupture, running sores, what more? in brief, in burden,*
As long as men are mortal and God merciful,
* So long to this sweet spot, this leafy lean-over,*
This dry dene, now no longer dry or dumb, but moist and musical
With the uproll and the downcarol of day and night delivering
Water, which keeps thy name, (for not in rock written,
But in pale water, frail water, wild rash and reeling water,
That will not wear a print, that will not stain a pen,
Thy venerable record, virgin, is recorded)
Here to this holy well shall pilgrimages be,
And not from purple Wales, only nor from elmy England,
But from beyond seas, Erin, France and Flanders everywhere,
Pilgrims, still pilgrims, more pilgrims, still more poor pilgrims
What sights shall be when some that swung, wretches, on crutches
Their crutches shall cast from them, on heels of air departing,
Or they go rich as roseleaves hence that loathsome came hither!
Not now to name even
Those dearer, more divine boons whose haven the heart is.
* As sure as what is most sure, sure as that spring*
primroses shall new-dapple next year, sure as to-morrow
morning, amongst come-back-again things, things with
a revival, things with a recovery.
Thy name Winefride will live.

Gerard Manley Hopkins
Poems (Oxford University Press, 4th ed, 1967)

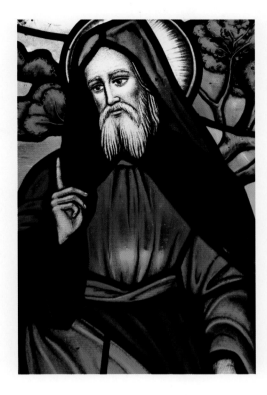

Above
A stained glass window representation
of St Beuno, in the small chapel

Above
This stained glass window of St Winefride
at her small well chapel shows the thin red
line of the cut marks of Caradoc's sword
on her neck.

At St Winefride's Well

We lean on the stone sill
to watch the water swallow itself
unravelling its slippery knotwork
between ice-ages

like reading the sea
turning its pages forever
for the word at the edge
of the mind.

It flowers with a small sob
on a powerful stem of water
from a tap-root deep in the dark
of a broken earth,

and a pulse that is almost
flesh, beats nakedly
as when the scalpel reveals
the drumming loudness of the heart.

I paddle at the step
beyond its turbulence
in a star of still water
and up it for drinking.

Overhead the wren builds
in the ruined mud-cup of the swallow
and a stone pilgrim bears
another on his shoulder.

Just to look is healing.
We stand in the porch of summer
to stare through water's broken window
into the dark.

Gillian Clarke

Further Reading

Wells in Wales

Christopher David, *St Winefride's Well: A History & Guide* (Llandysul: Gomer, 1969)

Paul Davis, *Sacred Springs: In Search of the Holy Wells of Wales* (Abergavenny: Blorenge Books, 2003)

Audrey Doughty, *Spas and Springs of Wales* (Llanrwst: Gwasg Carreg Gwalch, 2001)

Richard Fenton, *Tours in Wales, 1804-13 (ed John Rhys)* (London: Bedford Press for the Cambrian Archaeological Association, 1917)

Eirlys Gruffydd, *Ffynhonnau Cymru Cyfrol 1 (Llyfrau Llafar Gwlad)* (Llanrwst: Gwasg Carreg Gwalch, 1997)

Eirlys Gruffydd, *Ffynhonnau Cymru Cyfrol 2 (Llyfrau Llafar Gwlad)* (Llanrwst: Gwasg Carreg Gwalch, 1999)

Samuel Carter Hall and A.M.Hall, *The Book of South Wales, the Wye, and the Coast* (London: Virtue, 1861)

Francis Jones, *The Holy Wells of Wales* (Cardiff: University of Wales Press, 1954)

J.M. Lewis, *Carreg Cennen Castle* (Cardiff: Cadw, 2006)

E. Gwynn Matthews, *The Llanrhaeadr Jesse Window: Its Meaning and History* (Llanrhaeadr-yng-Nghinmeirch, Denbighshire: [Robertson Group], 2000)

Thomas Pennant, *A Tour in Wales (2 vols)* (London: Henry Hughes, 1778, 1783)

Thomas Rowland Roberts, *The Spas of Wales: Their Medicinal and Curative Properties, Embracing their Discovery and History* (London: John Hogg, 1897)

Chris J. Thomas, *Sacred Welsh Waters* (Milverton: Capall Bann Publishing, 2004)

Wells Generally

Janet Bord, *Cures and Curses: Ritual and Cult at Holy Wells* (Wymeswold, Loughborough: Heart of Albion Press, 2006)

Janet Bord and Colin Bord, *Sacred Waters: Holy Wells and Water Lore in Britain and Ireland* (London: HarperCollins, 1985)

Janet Bord and Colin Bord, *The Enchanted Land: Myths and Legends of Britain's Landscape* (Wymeswold, Loughborough: Heart of Albion Press, 1995)

Common Ground, *Rivers, Rhynes and Running Brooks: Local Distinctiveness and the Water in Our Lives* (Shaftesbury: Common Ground, 2000)

Christina Martin, *Holy Wells in the British Isles* (Glastonbury: Wooden Books, 2000)

James Rattue, *The Living Stream: Holy Wells in Historical Context* (Woodbridge: Boydell Press, 1995)

Edna Whelan, *The Magic and Mystery of Holy Wells* (Chieveley: Capall Bann Publishing, 2001)

Saints, Celts and Romans

Donald Attwater and Catherine Rachel John, *The Penguin Dictionary of Saints* (Harmondsworth, Middlesex: Penguin, 1965)

Alban Butler, *The Lives of the Fathers, Martyrs and Other Principal Saints (4 vols)* (London: Virtue, 1866)

Damian Walford Davies and Anne Eastham, *Saints and Stones: A Guide to the Pilgrim Ways of Pembrokeshire* (Llandysul: Gomer, 2002)

Gilbert H. Doble, *Lives of the Welsh Saints* (Cardiff: University of Wales Press, 1971)

Miranda J. Green, *The Gods of Roman Britain* (Princes Risborough: Shire, 2003)

Nigel Pennick, *Celtic Sacred Landscapes* (London: Thames and Hudson, 1996)

Elizabeth Rees, *Celtic Saints in their Landscape* (Stroud: Sutton, 2001)

Nona Rees and Terry John, *Pilgrimage: A Welsh Perspective* (Llandysul: Gomer, 2002)

Esyllt Nest Roberts, *Dwynwen (adapted by Siân Lewis)* (Llanrwst: Gwasg Carreg Gwalch, 1999)

Tony Rook, *Roman Baths in Britain* (Princes Risborough: Shire, 2002)

Charles Squire, *Celtic Myth and Legend* (Mineola, NY: Dover, 2003)

Catrin Stevens, *Santes Dwynwen / Saint Dwynwen (Cyfres Cip ar Gymru / Wonder Wales)* (Llandysul: Gomer, 2005)

Water

William Coles-Finch, *Water: Its Origin and Use* (London: Alston Rivers, 1908)

Masaru Emoto, *The Hidden Messages in Water* (Hillsboro, OR: Beyond Words Publishing, 2004)

Felix Franks, *Water* (London: Royal Society of Chemistry, 1983)

Stephen Halliday, *Water: A Turbulent History* (Stroud: Sutton, 2004)

Peter Swanson, *Water: The Drop of Life* (Minneapolis, MN: NorthWord Press, 2001)

The once regularly-visited Ffynan Elen
near Betws-y-Coed, in North Wales